Nikon® COOLPIX®
Digital Field Guide

Nikon® COOLPIX® Digital Field Guide

J. Dennis Thomas

Wiley Publishing, Inc.

Nikon® COOLPIX® Digital Field Guide

Published by
Wiley Publishing, Inc.
111 River Street
Hoboken NJ 07030-5774
www.wiley.com

Copyright © 2007 by Wiley Publishing, Inc., Indianapolis, Indiana

Published simultaneously in Canada

ISBN: 978-0-470-16853-0

Manufactured in the United States of America

10 9 8 7 6 5 4 3 2 1

For general information on our other products and services or to obtain technical support, please contact our Customer Care Department within the U.S. at (800) 762-2974, outside the U.S. at (317) 572-3993 or fax (317) 572-4002.

Wiley also publishes its books in a variety of electronic formats. Some content that appears in print may not be available in electronic books.

Library of Congress Control Number: 2007935014

WILEY

About the Author

J. Dennis Thomas, known to his friends as Denny, has been interested in photography since his early teens when he found some of his father's old photography equipment and photographs of the Vietnam War. Fortunately, he was able to take photography classes with an amazing teacher that started him on a path of learning that has never stopped.

Denny's first paying photography gig was in 1990 when he was asked to do promotional shots for a band being promoted by Warner Bros. Records. Although he has pursued many different career paths through the years, including a few years of being a musician, his love of photography and the printed image has never waned.

With the advent of digital photography, although he was resistant to give up film, Denny realized there was yet more to learn in the realm of photography. It was just like starting all over. Photography was fresh and exciting again. Realizing that the world of digital photography was complex and new, Denny decided to pursue a degree in photography in order to learn the complex techniques of digital imaging with the utmost proficiency.

Eventually Denny decided to turn his life-long passion into a full time job. He currently owns his own company, Dead Sailor Productions, a photography and graphic design business. He does freelance work for companies including RedBull Energy Drink, Obsolete Industries, Secret Hideout Studios, and Digital Race Photography. He continues to photograph bands, including LA Guns, the US Bombs, Skid Row, Quiet Riot, Echo & the Bunnymen, Dick Dale, Link Wray, and Willie Nelson. He has been published in several regional publications and continues to show his work in various galleries throughout the country.

He is also the author of the *Nikon Creative Lighting System Digital Field Guide* and the *Canon Speedlite System Digital Field Guide*.

Credits

Acquisitions Editor
Courtney Allen

Senior Project Editor
Cricket Krengel

Technical Editor
Sharlie Douglass

Copy Editor
Lauren Kennedy

Editorial Manager
Robyn B. Siesky

Vice President & Group Executive Publisher
Richard Swadley

Vice President & Publisher
Barry Pruett

Business Manager
Amy Knies

Senior Marketing Manager
Sandy Smith

Project Coordinator
Adrienne Martinez

Graphics and Production Specialists
Carrie A. Cesavice
Jennifer Mayberry
Ronald Terry

Quality Control Technician
Laura Albert

Proofreading
Broccoli Information Management

Indexing
Sherry Massey

Special Help
Alissa Birkel
Chris Wolfgang

Wiley Bicentennial Logo
Richard J. Pacifico

This one's for Henrietta...best dog ever.

Acknowledgments

Thanks to Cricket and Courtney; this would've never gotten done without your help. Thanks also to Robert at Precision Camera and Kat at ACC.

Contents at a Glance

Contents

Chapter 2: Navigating Your COOLPIX Camera 43

Chapter 3: Getting the Most Out of Your Nikon COOLPIX Camera 69

Chapter 5: Accessories and Additional Equipment 105

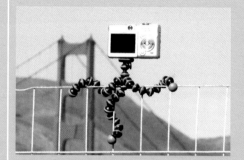

Chapter 6: Techniques for Great Photos 115

Chapter 7: Downloading and Printing 183

Part III: Appendixes 195

Appendix A: Resources 197

Introduction

Nikon has been leading the way with compact digital cameras since the introduction of the COOLPIX camera line. Nikon has recently revamped their entire line of compact digital cameras with the introduction of the P, S, and L series of COOLPIX cameras.

Whether you're a casual point and shooter, who only needs a camera that is designed to grab photos to preserve memorable occasions, or the photographic hobbyist looking for a camera that provides a little more creative control – Nikon has a COOLPIX camera for you.

With features such as Vibration Reduction, One-Touch Portrait, in-camera Red-eye Fix, a plethora of Scene modes, and Wi-fi, your pictures will be like never before once you learn to effectively use all the great features your camera offers.

The P or Performance-series cameras are at the top of the Nikon COOLPIX line. Providing automatic as well as fully manual settings, you can have complete control of how the camera captures the image. The P-Series flagship camera is the COOLPIX P-5000 which even lets you add Nikon Speedlight flashes for the ultimate in lighting control.

The S or Style-series cameras are Nikon's ultra small super-compact cameras. Some of these cameras are no bigger than a credit card and less than half an inch wide. They can fit perfectly right into your pocket or purse, so you never need be without a camera to capture those fleeting moments.

The L or Life-series cameras offer the ease of use of a point and shoot camera with some amazingly advanced features. The high-resolution sensor and Nikon's in-camera image processing provides you with accurate detail and stunning colors. All of this can be achieved without worrying about the settings — allowing you to focus on composition.

What's in This Book for You?

You're probably wondering if these cameras are so easy to use why do I need this book? Well, while these cameras can be used simply as a point and shoot, you may want to expand your creative horizons a bit to produce something more than snapshots.

If you're like me, the last thing you want to do is sit down and spend a few hours looking at an owner's manual that can read like stereo instructions. So, this book covers everything from setting up your camera from the get-go to real world applications and practical advice on shooting in a variety of situations. All of this is presented in an easy-to-understand and informative manner.

There are also dozens of tricks and tips on how to use the Scene modes properly and how to use the Scene modes to trick your camera into doing things for creative purposes.

You will find a section on composition that will help you to stretch you artistic wings, creating more expressive images and encouraging you to see the world in a different way — always thinking about what will be the best angle, the best light, the best subject, for the best shot.

The COOLPIX line of cameras are easy-to-use (which is why they are such great little cameras), and no matter which Nikon COOLPIX camera you are using, there is something in this book for you — from the very basics to information that will help you gain more confidence in your photography. This book's aim is to help you use your camera's diverse features to get the best pictures possible.

Quick Tour

I f you just bought a new camera, you're probably itching to get out there and start shooting. Regardless of which one of Nikon's new P, L, or S Series cameras you purchased, you can rest assured that you will be getting some great images. However, if you aren't sure where to begin, then the Quick Tour is for you. Here you will find just the basics outlined to get you shooting right away.

Getting Started

This first section gives a brief run-through of some of the basic setup tasks you should complete before moving forward and taking pictures. In fact, without doing these things, you really can't take pictures! After you take your camera out of the box and unpack everything, do the following:

✦ Charge the batteries

✦ Insert the batteries into your waiting camera

✦ Set the language, time, and date

To set the language, time, and date, follow these steps:

1. **Use the up or down portions of the multi-selector to highlight the desired language.**

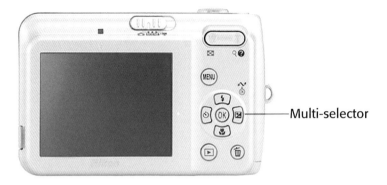

Multi-selector

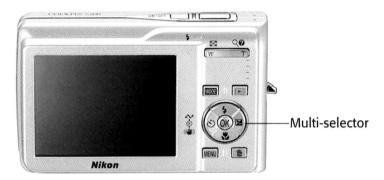

Multi-selector

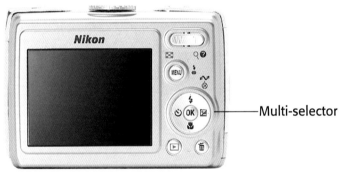

Multi-selector

QT.1 The multi-selector (L, S, and P Series from top to bottom)

2. Press the OK button. The camera asks whether you want to set the time and date. Highlight Yes, and then press the OK button.

3. If you are in a time zone that observes Daylight Saving Time, press the multi-selector down to highlight Daylight Saving and press the OK button. Once Daylight Saving Time is turned on, the menu automatically switches to the Home Time Zone menu.

4. If you do not observe Daylight Saving Time, press the multi-selector right to choose your time zone from the Home Time Zone menu.

5. Press the OK button. The Date menu then appears.

6. Use the up and down portion of the multi-selector to set the day, month, and year.

7. After setting the year, press the multi-selector to the right to set the hour and minutes. Use the multi-selector up and down buttons to choose the order in which you want the date to appear. The options are Y, M, D; D, M, Y; and M, D, Y.

8. Press the OK button.

Selecting a Picture-taking Mode

Before you start snapping away, you should select a mode. You have a few different modes to choose from. The L, S, and P Series cameras offer Auto, Scene, and Movie modes. In addition, the P Series cameras also offer Aperture Priority, Shutter Priority, Manual, and Flexible Program modes.

 These modes are all discussed in depth in Chapter 2.

As you learn your way around your camera, the best place to start so you can get out there and shoot pictures right away is to choose the Auto mode. On all the series, this mode appears as a green camera icon on the Mode selector or dial. For the L and S Series cameras, slide the Mode selector to the green camera icon; for the P Series cameras rotate the Mode dial on top of the camera body until the dial is set to the green camera icon.

QT.2 The Auto mode icon

The Auto mode is a point-and-shoot mode. The camera decides all of the settings for you, allowing you to take a photo without having to worry about any settings. You just compose the image on the LCD panel and press the Shutter Release button.

Although the camera decides the specific settings for you, you do have some other options. Using the multi-selector, you can change the Flash mode, set the self-timer, adjust the exposure compensation, and enter the Macro/Close-up mode. Don't be overwhelmed if this seems complicated now; I discuss all of these features at length in the following chapters.

If you're feeling a little more adventurous and perhaps you have some photography experience already, you can switch the camera to Scene mode. Scene mode optimizes the way the camera chooses the settings for a particular shooting scenario, or scene. In addition to the standard Scene modes, four Scene modes offer *Scene Assist;* these are sub-settings that provide guides to assist you in composition. However, to get your feet wet, start with the basics. Here are the various Scene modes:

✦ **Portrait mode**

✦ **Landscape mode**

✦ **Sports mode**

✦ **Night Portrait mode**

✦ **Party/Indoor mode**

✦ **Beach/Snow mode**

✦ **Sunset mode**

✦ **Dusk/Dawn mode**

✦ **Night Landscape mode**

✦ **Close Up mode**

✦ **Museum mode**

✦ **Copy mode**

✦ **Back Light mode**

✦ **Panorama Assist mode**

 Cross-Reference *Scene modes are discussed in depth in Chapter 2.*

Taking the Picture

Taking a picture with your Nikon COOLPIX camera is very simple indeed. At the most basic level, you just point the camera at the subject and compose the image in the LCD panel. Press the shutter Release button and that is it.

Nikon COOLPIX cameras are equipped with optical zoom lenses. Before you shoot, play with the zoom lens, choosing between a wide-angle setting that enables you to capture a wide area or a telephoto setting that allows you to get close-up photos of far-away subjects. The Zoom button is marked on the left side with a W for wide-angle (zoom out) and on the right with a T for telephoto (zoom in).

Next, press the Shutter Release button halfway down to initiate the autofocus (AF). Once the image is in focus, the camera displays a green AF icon at the top of the screen. If the camera cannot achieve focus, the AF icon appears in red.

When you are satisfied with the composition and the camera has locked focus, depress the Shutter Release button fully and take the picture.

Zoom
button

Zoom
button

Zoom
button

QT.3 The Zoom button (shown on the L, S, and P Series from top to bottom)

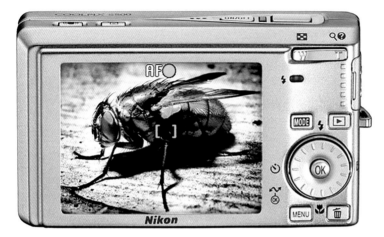

QT.4 The AF lock on appears as a green icon (top) and the AF no focus appears as a red icon (bottom).

Reviewing the Image

After the image has been recorded to the memory card, the camera displays it on the LCD panel for you to review. If you want to take a closer look at the image, you need to switch the camera into Playback mode. All COOLPIX cameras have a dedicated Playback button.

Once your camera is in Playback mode, use the multi-selector to scroll through the images. Pressing the multi-selector to the right or down allows you to review the images in the order that they were taken. Pressing the multi-selector to the left or up allows you to review the images in reverse order.

To view thumbnails of the images, press the Zoom button to the left. You can choose four, twelve, or sixteen thumbnails per page.

Press the Zoom button to the right to zoom in for a closer look at the details of an image. You can also use the multi-selector to scroll left, right, up, and down while you

QT.5 Getting started with my L5 set to Auto mode

are zoomed into the image. When you are done looking at the details, press the Zoom button to left to return to the full image.

When reviewing image, if you see a picture that is out of focus, too dark, or light, or one you just don't like, you can delete the image, freeing up space on your memory card for better shots. To erase the image, simply press the Delete button, which looks like a trashcan. To avoid any accidental deletions, the camera asks you if you want to

erase the image. Press the multi-selector down to highlight YES, and then press the OK button.

When you are in *full-frame* Playback mode, you are not zoomed-in to the image or looking at thumbnails. There are a variety of functions that you

QT.6 The Playback button icon

QT.7 When you press the Zoom button to the left, you can view thumbnails on the LCD panel.

can access. These functions can include Quick playback zoom, recording and playing memos, and D-Lighting.

> Cross-Reference *For detailed information on the Playback menu, see Chapter 2.*

When you have finished reviewing your images and are ready to start shooting again, all you have to do to return to the Shooting mode is press the Playback button. This returns you to the Shooting or Scene mode you were in before you switched to the Playback mode.

QT.8 Press the Delete button to remove an image from the memory card.

Transferring Images to the Computer

Once you've filled up your memory card or you're ready to edit some of your images, it's time to transfer the images to your computer. There are a couple different methods that can be utilized to set up for the transfer.

✦ **Use the USB cable that was supplied with your camera and plug it directly into your computer.** This is the simplest method; however, in order to transfer the images, the camera must be on. This can deplete your batteries very quickly.

QT.9 The USB port on a COOLPIX camera. The location varies by series.

✦ **Take the memory card out of the camera and insert it into a memory card reader that you've plugged into your computer.** This is the method I prefer. Card readers can be either USB or FireWire.

Once your camera is connected or your memory card is in a reader, an ideal way to transfer the images to your computer is to use the Nikon PictureProject software that is supplied with your camera. PictureProject is an easy-to-use program that allows you to transfer, organize, and edit your images. Follow these steps:

1. **Open the PictureProject software.**

2. **Connect the camera directly to your computer with the USB cable.**

3. **Press the OK button on the camera.** The transfer of images from your camera to the computer starts.

 Note *By default the camera automatically marks all the images on your card for transfer. The camera can also be set up not to automatically mark the images for transfer. You can also manually select images for transfer. This is done in the Playback mode Setup menu. This is covered in more detail in Chapter 2.*

You can also control the transfer of images in the PictureProject software window instead of the camera.

1. **Open the Picture-Project software.**

2. Connect the camera directly to the computer with the USB cable.

3. Click the Transfer button in the upper left-hand corner of the PictureProject window.

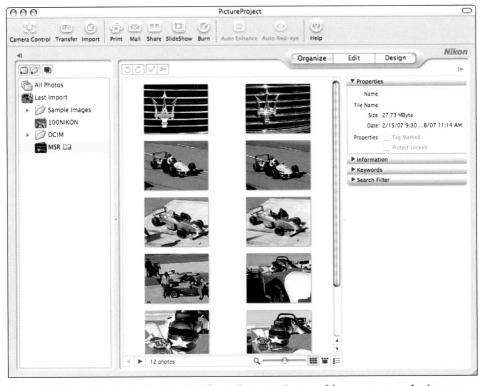

QT.10 Clicking the Transfer button in Nikon PictureProject enables you to transfer images from your camera to your computer.

Using Your Nikon COOLPIX Camera

◆ ◆ ◆ ◆

In This Part

◆ ◆ ◆ ◆

Exploring the COOLPIX Cameras

In this chapter you explore all the details of the different camera series and some of the specifications and features that each has to offer. We also cover the layouts and where to find the certain parts and buttons that make up the camera. This chapter is intended to help you learn the layout of the camera so you know where each part of your camera is and what it does.

The L Series

Nikon calls its COOLPIX L Series the "Life" series of cameras because they are designed to "capture your life, easily." These cameras are sophisticated, yet very simple to use: The camera controls almost all of the shooting functions, allowing you to concentrate on composing the image in the LCD viewfinder.

An L Series camera, although not as compact as an S Series one, is small enough to fit in your pocket so you can always have it with you. And although the L Series cameras are the most affordable in Nikon's lineup of point-and-shoot cameras, even these entry-level models offer an amazing array of features.

The L-series cameras start out with the L4's 4-megapixel image sensor, which is enough to print photos up to 8 × 10 inches in size, and go all the way up to the L5 and L12's 7-megapixel sensor, which allows you to print flawless-looking images as large as 16 × 20 inches!

The cameras in the L Series have at least a 3X optical zoom lens. The L5 has a 5X optical zoom, which offers plenty of zoom for those far-off subjects. All the cameras also offer an additional 4X digital zoom for extra reach when the subject is extremely far away.

Basic camera layout

In this section, I discuss the various buttons on the camera and give a brief description of what each button does. Although there are some minor variations on the layout between the different camera models, everything is nearly the same.

Top of the camera

On the top of the L Series cameras, you have the On/Off button and the shutter release button. With the L5 and L12 cameras, the top of the camera is also where the Image Stabilization/Vibration Reduction (VR) and the One-Touch Portrait and D-Lighting buttons are located.

On cameras that offer a voice recording option, the speaker is also located on the top of the camera.

The On/Off button powers up the camera when you push and hold it for about three quarters of a second. The reason you need to press and hold the button is that otherwise it would be hard to prevent the camera from accidentally turning on in your pocket, purse, or camera bag if the button was momentarily pressed.

The Shutter Release button is the button you press to engage the autofocus and to make the picture.

For cameras equipped with this feature (L5), the VR button allows you to activate the Vibration Reduction. You can choose between VR off, VR normal, and VR active by pressing the button.

Optical Zoom versus Digital Zoom

Most compact digital cameras these days offer two types of zoom, optical and digital. There are some very big differences between the two. You may think that an extra 4X digital zoom is a good thing. Actually, it's not necessarily.

An *optical zoom* is the actual image that is produced by the optics, the lens, of the camera. Lenses are designed to give the sharpest images possible with the cameras they are paired with.

Digital zoom is not actually zooming at all. What digital zoom does is take a portion of the optical image and enlarge it. Essentially, what the camera is doing is taking the original image and cropping a piece of it out. Usually this leaves you with a grainy, pixilated-looking image. This same level of cropping can be done later with image editing software and yields much better results for you.

That being said, digital zoom is not all bad. It may be necessary for you to use if you don't use a computer to edit your images or if you print directly from the camera or memory card. Also, if you're not going to print your images any larger than 4 × 6 inches, you may not be able to notice the pixilation caused by the camera cropping into the image.

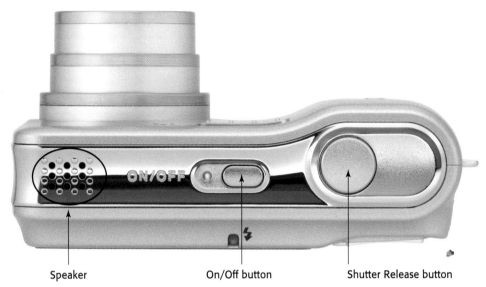

Speaker On/Off button Shutter Release button

Image courtesy of Nikon, Inc.
1.1 **Top view of the L6**

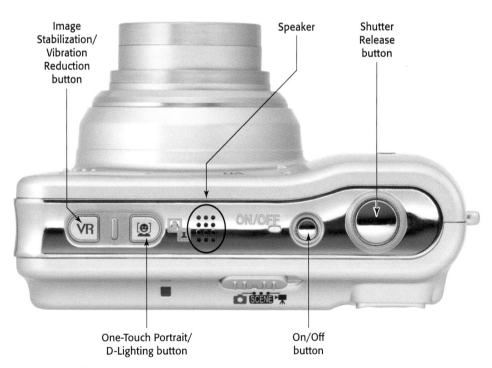

Image
Stabilization/
Vibration
Reduction
button

Speaker

Shutter
Release
button

One-Touch Portrait/
D-Lighting button

On/Off
button

Image courtesy Nikon, Inc.
1.2 **Top view of the L5**

Cross-
Reference *For more information on Vibration
Reduction see Chapter 3.*

Another button that is only available on certain models is the One-Touch Portrait button. When you press this button, the camera switches to Face-Priority AF and applies In-Camera Red-Eye Fix in the next shot you take. If the camera is in Playback mode and you press this button, it is activates the D-Lighting button function. *D-Lighting* is a function within the camera that can fix the underexposure that can often happen to images that are backlit.

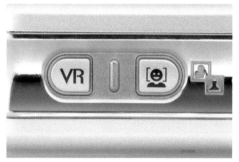

1.3 Close-up of the VR and One-Touch Portrait buttons

Front of the camera

The front of the camera is where the lens, the flash, and the AF-Assist illuminator and self-timer lights are located. On cameras with the sound recording function, the front of the camera is also where the built-in microphone is located so that you can record sound with your images or movies.

Nikon has been known for making some of the best lenses in the industry for going on seventy years. All Nikon COOLPIX cameras come equipped with high-quality Zoom-Nikkor lenses.

Located above the lens is the flash, or in Nikon terminology, the Speedlight. While there are all sorts of different reason to use flash, the main function of the flash is to provide ample illumination when the lighting is too dim to take a photograph.

The AF-Assist illuminator/Self-timer lamp lights up when there is not enough light for the camera to focus properly. The lamp provides enough light for the camera to detect enough contrast to focus. It also functions as a self-timer light. The self-timer light blinks, letting you know that the timer is activated and the shutter will fire.

There is a small microphone located just above and to the side of the lens area, if your camera has this feature, for recording sound when using the movie mode, or for recording notes to a still image.

Note *Not all L Series cameras have the AF-assist illuminator. Check your owner's manual for your specific model.*

Back of the camera

The back of the L Series cameras is where most of the controls and option buttons reside. Everything from the zoom to exposure compensation is controlled from here. This is also where the LCD panel is.

✦ **LCD screen.** The most obvious feature on the back of the camera is the LCD screen. The L Series cameras have anywhere from a 2- to 2.5-inch LCD screen. The LCD screen is where you compose and view your images, view the menus to change your settings, and, do any in-camera editing to your images such as in-camera cropping and D-Lighting adjustments. The

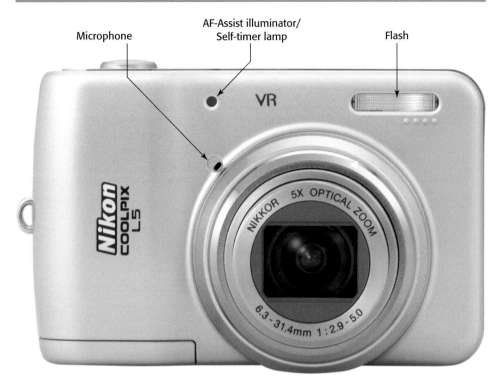

Microphone

AF-Assist illuminator/
Self-timer lamp

Flash

Image courtesy of Nikon, Inc.
1.4 Front view of the L5

LCD screens on the COOLPIX cameras are bright, easy to see, durable, and scratch-resistant.

✦ **Mode selector button.** At the top of the back of the camera is the Mode selector button. This button slides left and right, allowing you to choose the shooting mode to which you want to set your camera. The modes are Auto, Scene Mode, and Movie Mode.

✦ **Flash lamp.** Above the LCD panel is the flash lamp. This light indicates if the flash is ready and will fire or if the flash is charging. When the flash lamp is glowing solid, the flash is ready to fire. If the flash lamp is blinking, the flash is still charging, and will be ready in a

few seconds. If the flash lamp is not lit, the flash will not fire.

 The Shutter Release button must be half-pressed in order for the flash lamp to come on.

✦ **Zoom button.** The Zoom button is a two-way rocker switch that allows you to zoom the lens in or out. To the left on this button is the wide-angle setting, marked with a W, which allows you to fit a lot of the scene into the image; the right button, marked with a T for telephoto, allows you to zoom in close to capture faraway subjects or to focus on a specific detail of a subject. The Zoom button also has two other uses, depending on the mode the camera is in:

- **In Playback mode.** Under the button on the left-hand (W) side is a small checkerboard pattern. When you press it in Playback mode, the LCD plays back your images as small thumbnails. Under the right-hand (T) side of the button is a magnifying glass icon. When you press this side of the button, you're able to zoom into the image that is being played back for closer inspection.

- **In Menu mode.** Next to the magnifying glass icon is a question mark symbol. When your camera is in Menu mode, you can press this button on the T side to display a brief description of whatever menu item is currently selected.

✦ **Menu button.** When you press this button, a menu where you can change settings appears on the LCD screen. Each menu is different depending on which mode you're in. For example, if your camera is set to Auto mode when the Menu button is pressed, you see the Shooting menu; if you're set to the Scene mode, you see the Scene menu, and so on. There is also a menu for the One-Touch Portrait mode on cameras with this feature.

✦ **Multi-selector in Shooting mode.** The multi-selector control is probably the most important and complex control on the camera because it is really a conglomeration of five buttons, with more than one function for each button. When you're in Shooting mode, whether you're in Auto or Scene mode, the primary function of the

multi-selector is to enable you to change the most important features quickly. For ease of use, each button is marked with the icon of what it does.

- **Flash mode button.** This button is at the top of the multi-selector and is represented by a small lightning-bolt icon. When you press this button, the flash mode options appear on the LCD panel. Use this button to change the flash mode, choosing the one that is more suited to your needs.

- **Exposure compensation button.** Use the right button on the multi-selector to adjust the exposure compensation to fine-tune the image. It is represented by a plus and minus icon. After you preview the image, if it looks too dark or too light you can adjust the exposure compensation and re-shoot the picture with the adjustments in place.

- **Focus mode button.** You use the Focus mode button, which looks like a flower, to enable the close-up function. This allows you to focus very close to the subject to get greater detail in your images.

- **Self-timer button.** The left button, which looks like a clock or a timer, is used to set the self-timer. The self-timer puts a ten-second delay on the shutter so you can set your camera up for shooting self-portraits.

- **OK button.** The center OK button sets the selection of the function being modified.

 All of these features and more are discussed in greater detail in Chapter 2

✦ **Multi-selector in Playback mode.** When you are in Playback mode, you use the multi-selector to navigate through the images. The top button and the button on the left display previous images and the bottom button and right button display the next images in the order you took them. The OK button takes you into the Quick Playback Zoom mode, which divides the current displayed image into nine sections, initially zooming in on the center section. You can then use the directional button on the multi-selector to move to another section

of the image. While in Quick Playback Zoom mode, you can also use the Zoom button to zoom in further or to zoom out.

 When you've connected to a computer via USB cable, press the OK button to start downloading all pictures that have been marked for transfer.

✦ **Playback mode button.** Press this button to view a full-frame playback on the LDC screen of the images you have taken. Once in Playback mode, you can use the multi-selector to view the images as noted in the previous bullet. To return to the Shooting mode, press the Playback mode button again.

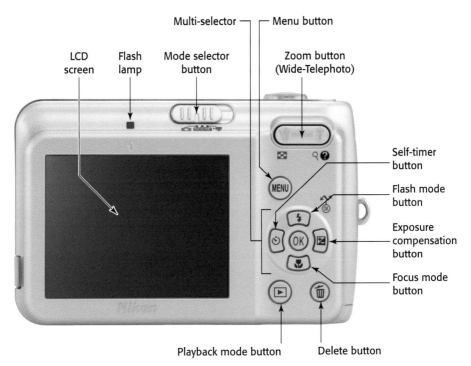

Image courtesy of Nikon, Inc.

1.5 Back view of the L5

✦ **Delete button.** This button is marked with an icon that looks like a trash can. If you're in Playback mode and you press the delete button, the image that appears in the LCD screen is permanently deleted. To save your images from accidental deletion, the camera asks whether you want to erase the image. Use the multi-selector up or down to select Yes or No, and then press the OK button.

The sides and bottom of the camera

The right side of the camera is where the USB port is located that you use to connect your camera to your computer to download your images; you can also use the USB cable to connect to a PictBridge compatible printer to print directly from the camera.

The left side of the camera has an eyelet that is used to attach the strap that is supplied with the camera.

On the bottom of the camera are the battery door cover and the tripod socket. The battery door cover opens to insert the batteries and also the memory card. The tripod socket is used to screw in the quick-release plate of a tripod or to connect the camera directly to a tripod head.

The S Series

Nikon calls its S Series cameras its "Style" series. These cameras are ultra-compact, yet are packed with features such as Vibration Reduction, and some models even include Wi-Fi. They have a high sensitivity ISO that

allows you to take pictures in even the lowest light without using a flash. The S Series has a sleek and stylish look: Some models have brushed aluminum casings, some have a sleek wave design, and others have a sophisticated black finish.

An S Series camera is so compact that it can fit unobtrusively into your pocket, allowing you to have it with you at all times so you don't miss that once-in-a-lifetime shot.

All of the S Series cameras have a 3X optical zoom. The S4 and S10 cameras even have a 10X optical zoom. This is perfect if you're shooting wildlife and birds or any subject that you just can't get to close to. The S4 and S10 also have a swiveling lens that allows you to compose your images up high and down low; this way you don't have to resort to getting into an awkward position and are still able to view the LCD screen perfectly.

Basic camera layout

Cameras in the S Series vary widely, so there may be some differences in the basic layout of the cameras shown and the camera you own, but for the most part the descriptions are accurate for all S Series cameras.

 Note *Any major differences between the camera layouts are addressed separately.*

Top of the camera

On the top of the S Series cameras, you have the On/Off button and the Shutter Release button. On models such as the S5, S6, S7c, S9, and S10, the Zoom button is also located on the top. On models S50, S50c, S200, and S500, the zoom button is located on the

back panel. The top of the camera is also the location of the One-Touch Portrait mode button on cameras that are equipped with this feature. On the S50, S50c, and the S500, the button for activating the Anti-Shake mode is located on the top as well. The Anti-Shake mode button is represented by a hand with shaky lines around it.

> **Cross-Reference** *For more information on the Anti-Shake mode see Chapter 3.*

✦ **On/Off button.** Powers up the camera when you press and hold it for about three quarters of a second.

✦ **Shutter Release button.** You press this button to engage the auto focus and to actually make the picture.

✦ **One Touch Portrait button.** You press this button to switch the camera to Face-Priority AF and

apply In-Camera Red-Eye fix. When the camera is in Playback mode, this button doubles as the D-Lighting button. *D-Lighting* is a function within the camera that can fix the underexposure that can often happen to images that are backlit.

✦ **Anti-Shake Button.** By pressing this button, Best Shot Selector, VR, and high ISO are all activated. This mode allows low light photography (without a flash) with Image Stabilization with a high ISO capability.

The major exceptions to the top of the camera view are the S4 and S10 cameras. These cameras have a swiveling lens capability, and when they are closed, the lens of the camera points straight up to the top of the camera.

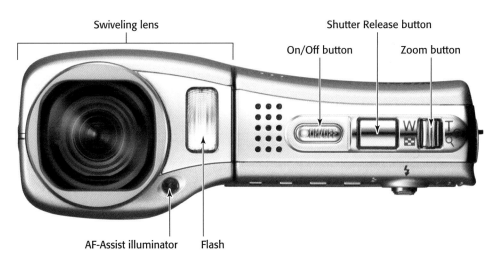

Swiveling lens

Shutter Release button

On/Off button

Zoom button

AF-Assist illuminator Flash

Image courtesy of Nikon, Inc.

1.6 Top view of the S10

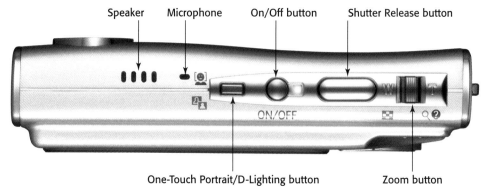

Speaker Microphone On/Off button Shutter Release button

One-Touch Portrait/D-Lighting button Zoom button

Image courtesy of Nikon, Inc.
1.7 Top view of the S9

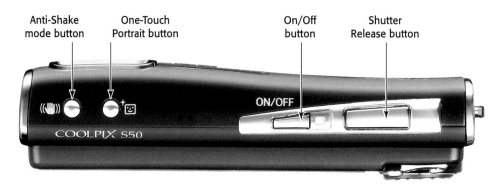

Anti-Shake mode button One-Touch Portrait button On/Off button Shutter Release button

Image courtesy of Nikon, Inc.
1.8 Top view of the S50

Front of the camera

The front of the camera is where the lens, the flash, and the AF-assist illuminator/self-timer lights are located. On cameras such as the S200 and S500, this is also where the built-in microphone is located.

The lens on the S200 and S500 is easily visible as it protrudes from the front of the camera. The rest of the cameras, with the exception of the S10, have an internally zooming lens. This means that even when

the camera is on, no lens sticks out from the front of the camera. The S7c and the S500 S Series cameras have a 3X zoom with the exception of the S4 and S10, which have an amazing 10X optical zoom.

Located above the lens is the flash, or in Nikon terminology, the Speedlight. Although several reasons to use flash exist, the main function of the flash is to provide ample illumination when the lighting is too dim to take a photograph.

Also on the front of the camera is the AF-assist illuminator/self-timer lamp. AF-assist lights up when there is not enough light for the camera to focus properly. This provides enough light to allow the camera to detect enough contrast to focus. The lamp also functions as a self-timer light. The self-timer light blinks, letting you know that the timer has been activated and the camera shutter will fire.

On the S200 and S500 models, there is a small microphone located on the front for recording sound when using the Movie mode, or for recording notes to a still image.

Back of the camera

The back of the S Series cameras is where most of the controls and option buttons reside. You can control everything from the zoom to exposure compensation from here. This is also where the LCD screen is located.

Start with the most obvious feature: the LCD screen. The S Series cameras have either a 2.5- or 3-inch LCD. The S7c, S50, and S50c all have a 3-inch LCD, while the remaining S Series cameras have a 2.5-inch LCD. The LCD panel is where you compose and view your images; view the menus to change

AF-Assist illuminator/ Self-timer lamp

Flash

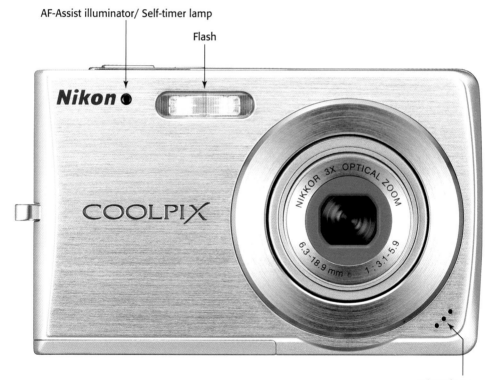

Microphone

Image courtesy of Nikon, Inc.
1.9 Front view of the S200

Flash

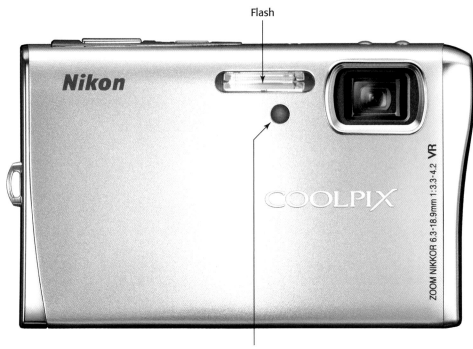

AF-Assist illuminator/Self-timer lamp

Image courtesy of Nikon, Inc.
1.10 The front of the S50c

your settings; and do any in-camera editing to your images, such as in-camera cropping and D-Lighting. The LCD screens on the COOLPIX cameras are bright, easy to see, durable, and scratch-resistant.

✦ **Multi-selector in Shooting mode.** Probably the most important and complex button is the multi-selector. This button is really a conglomeration of five buttons, each having more than one function. When you're in Shooting mode, whether you're in Auto or Scene mode, the primary function of the multi-selector is to enable you to change the most important features quickly. For ease of use, each direction on the button is marked with the icon of what it does.

Note *In the S Series cameras, with the exception of the S9 and S200, the multi-selector also is a rotary multi-selector dial. The outer ring of the button rotates to make it easier and faster for you to scroll through the menus and pictures.*

• **Flash button.** Represented by a small lightning bolt icon, when you press this button, the Flash mode options appear on the LCD panel. Use this button to change the Flash mode, choosing the one that is more suited to your needs.

• **Exposure compensation button.** Use the right button on the multi-selector to adjust the

exposure compensation to fine-tune the image to get it just right. It is represented by a plus and minus icon. Exposure compensation is used when you take a photograph. After you preview the image, if it looks too dark or too light you can adjust the exposure compensation and re-shoot the picture with the adjustments in place.

● **Focus mode button.** You use the Focus mode button, which looks like a flower, to enable the close-up function. This allows you to focus very close to the subject to get greater detail in your images.

● **Self-timer button.** The left button, which looks like a clock or a timer, is used to set the self-timer. The self-timer puts a ten-second delay on the shutter so you can set your camera up for shooting self-portraits.

● **OK button.** Use this button, located in the center of the multi-selector, to set the selection of the function being modified. Pressing the center button while the camera is in Shooting mode also puts the camera in Anti-shake mode, for cameras equipped with this feature.

✦ **Multi-selector in Playback mode.** Use the multi-selector to navigate through and review on the LCD the images that you've taken. The top and left buttons of the multi-selector display the previous images and the bottom and right buttons display the next images in the order you took them. You can also use the rotary multi-selector to scroll through the images. Scrolling the rotary multi-selector clockwise displays the images in the order you took them; scrolling it counter-clockwise displays the images in reverse order.

✦ **OK button.** When you're connected to a computer via USB cable, press the OK button to start downloading all pictures that have been marked for transfer.

✦ **Playback button.** Pressing this button allows you to view a full-frame playback of the images you have taken. Once in Playback mode, you can use the multi-selector or the rotary multi-selector to review the images. To return to the Shooting mode, press the Playback button again. When the camera is powered off, you can press and hold this button to turn the camera on in Playback mode.

✦ **The Mode button.** Press the Mode button when in Shooting or Playback mode to view the menus. You can switch between the Shooting mode menu and the Playback mode menu by pressing the Playback button.

✦ **The Menu button.** When you press this button, you see menus within specific shooting modes.

✦ **Delete button.** This button is marked with an icon that looks like a trash can. When you press the Delete button in Playback mode, the image on the LCD panel is permanently deleted. To save your images from accidental deletion, the camera asks whether you want to erase the image. Use the multi-selector up or down to select Yes or No, and then press the OK button.

✦ **Zoom button.** The newest of the S Series, the S50, S50c, S200, and the S500 cameras have the Zoom button on the back of the camera. The Zoom button is a two-way rocker switch that allows you to zoom the lens in or out. To the left on this button is the wide-angle setting, marked with a W, which allows you to fit a lot of the scene into the image; the right button, marked with a T for telephoto, allows you to zoom in close to capture faraway subjects or to focus on a specific detail of a subject. The Zoom button also has two other uses, depending on the mode the camera is in:

• **In Playback mode.** Under the button on the left-hand (W) side is a small checkerboard pattern. When you press it in Playback mode, the LCD plays back your images as small thumbnails. Under the right-hand (T) side of the button is a magnifying glass icon. When you press this side of the button, you're able to zoom into the image that is being played back for closer inspection.

• **In Menu mode.** Next to the magnifying glass icon is a question mark symbol. When your camera is in Menu mode, you can press this button on the T side to display a brief description of whatever menu item is currently selected.

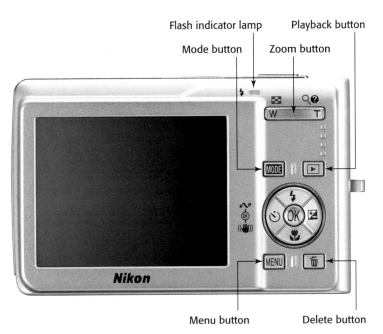

Flash indicator lamp Playback button
Mode button Zoom button

Menu button Delete button

Image courtesy of Nikon, Inc.
1.11 Back of the S200

Menu button

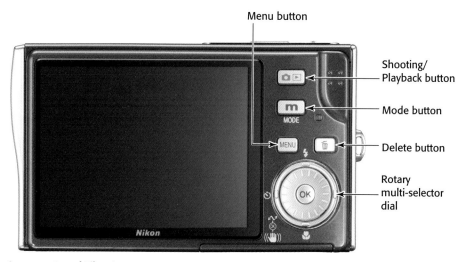

Shooting/
Playback button

Mode button

Delete button

Rotary
multi-selector
dial

Image courtesy of Nikon, Inc.
1.12 Back view of the S7c

Sides and bottom of the camera

One side of the camera has the USB port that you use to connect your camera to your computer to download your images; you can also use the USB cable to connect to a PictBridge compatible printer to print directly from the camera.

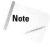

Note *Some COOLPIX cameras, such as the S7c and the S50c, come with a special connection that is not USB, but has a USB output. See your owner's manual for detailed information on the cable.*

The side of the camera also has an eyelet that you use to attach the strap that is supplied with the camera.

On the bottom of the camera are the battery door cover and the tripod socket. You open the battery door cover to insert the batteries as well as the memory card. You use the tripod socket to screw in the quick-release plate of a tripod or to connect the camera directly to a tripod head.

The P Series

Nikon calls the P Series the "Performance" series because there are more shooting controls and generally a higher megapixel count. These advanced shooting modes allow you control the camera settings rather than let the camera choose them for you. Of course, the P Series cameras also have the Auto settings and Scene modes that are available on the L and S Series cameras.

Due to the advanced settings and the need for more controls and buttons on the camera, the P Series cameras are slightly larger than models in the other COOLPIX camera series; however, these cameras are still compact enough to fit in your pocket, purse, or a small camera bag.

With the addition of the Programmed, Aperture Priority on the P3 and P4; and Programmed, Aperture Priority, Shutter Priority, and Manual modes on the P5000, the P Series cameras allow you set your camera the way you want, enabling you

greater creative control over your images. These are the same settings that are available on Nikon's much more expensive digital SLR (dSLR) cameras.

The P5000 even has a flash hot-shoe attachment so that you can use a larger flash unit, called a Speedlight, such as the SB-400, SB-600, or SB-800. These larger Speedlights have a much greater range than the built-in flash can offer. Using an SB-600 or an SB-800 also allows you to do some more advanced flash techniques such as *bouncing*. Bouncing the flash is a technique where

you tilt the flash head at an angle to create a more diffused and natural-looking light.

 Note *Hot-shoe is just a photography term for the place where you attach an external accessory flash, such as a Speedlight, to your camera.*

Basic camera layout

There are some minor differences between the camera models, but the layouts are closely related.

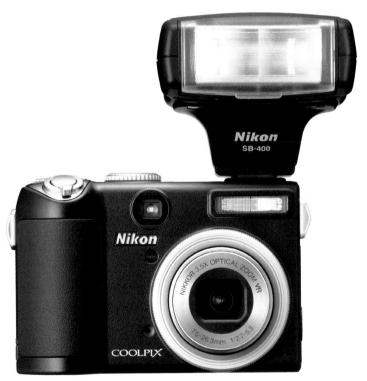

Image courtesy of Nikon, Inc.
1.13 P5000 with SB-400 Speedlight attached at the hot-shoe

Top of the camera: P3 and P4 models

The P3 and P4 cameras are nearly identical with the exception of the WiFi setting, so this section starts there, and then continues on with the P5000.

✦ **Mode dial.** The most prominent feature on top of the P3 and P4 cameras is the Mode dial. This is where you set your camera to the mode that you desire to work in. The Mode dial is also where you enter the menus in order to change the settings of your camera. The P3 also has the wireless setting menu on the Mode dial.

✦ **On/Off button and power lamp.** On the right side of the top of the camera are the On/Off button and the power lamp. Pressing and holding the On/Off button for about a half-second turns the camera on, thus lighting the power lamp.

✦ **Shutter Release button.** You use the Shutter Release button to initiate the camera's autofocus and then take the picture.

✦ **Vibration Reduction/Image Stabilization button.** On the left side of the P3 and P4 cameras is the Vibration Reduction/Image Stabilization (VR) button. You press this button to choose between VR off, VR normal, and VR active.

Top of the camera: P5000 model

The P5000 is currently the most advanced feature-wise of all the Nikon COOLPIX cameras. There are more controls and the camera allows for more flexibility when deciding

how to shoot in various situations. Take a look at the top of the camera.

✦ **Mode dial.** The P5000 Mode dial is a little different than the Mode dial on the P3 and P4. The P5000 Mode dial has a few more shooting modes. These modes include the Auto mode, P, S, A, and M modes, as well as an Anti-shake mode and a mode for shooting with a high ISO, VR, and Best Shot Selector. The modes also include the standard Scene mode and the Movie mode. Like the P3 and P4, the P5000 setup menu is also accessed through the Mode dial.

✦ **On/Off button and power lamp.** On the right side of the top of the P5000 are the On/Off button and the power lamp. Pressing the On/Off button for about half a second turns the camera on, lighting the power lamp.

✦ **Shutter Release button.** This is the button you press to focus and take the picture.

✦ **Zoom button.** Located right next to the Shutter Release button, use this rocker-style button to zoom from wide-angle to telephoto and back when in Shooting mode. In Playback mode, you use the Zoom button to zoom in and out of images being viewed on the LCD screen.

✦ **Command dial.** You use the Command dial to change the various settings when using the Manual mode or one of the semi-manual modes such as Aperture Priority or Shutter Priority mode.

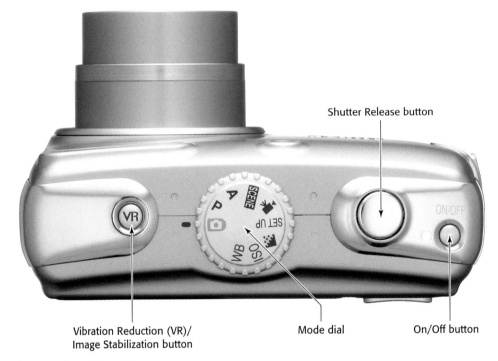

Shutter Release button

ON/OFF

Vibration Reduction (VR)/
Image Stabilization button

Mode dial

On/Off button

Image courtesy of Nikon, Inc.
1.14 Top view of the P4

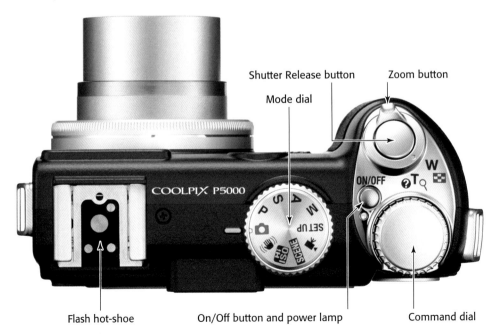

Shutter Release button

Zoom button

Mode dial

COOLPIX P5000

ON/OFF

W

T

Flash hot-shoe

On/Off button and power lamp

Command dial

Image courtesy of Nikon, Inc.
1.15 Top view of the P5000

✦ **Flash hot-shoe.** The P5000 features a flash hot-shoe. This is where an external Speedlight is attached to the P5000 camera body. Terminals underneath the removable plastic cover of the hot-shoe interact with a Nikon Speedlight, communicating electronically to tell that flash at what power to fire to achieve the correct exposure for the subject that you are photographing.

Front of the Camera

Located in the front of the P Series cameras are the lens, the built-in Speedlight, the AF-assist illuminator, and the microphone. The P5000 also has an optical viewfinder to facilitate shooting in all lighting conditions.

The lenses on the P Series cameras are high-quality Zoom-Nikkor lenses. The P Series cameras come equipped with 3.5X zoom. The lens has an aperture, or lens opening that varies between f/2.7 and f/5.3 at its widest, depending on how far the lens zooms in.

Located above the lens is the built-in Speedlight or flash. While there are all sorts of different reasons to use flash, the main function of the flash is to provide enough illumination to take a photograph when the lighting is too dim, or to fill in flash in a backlit situation.

Cross-Reference *For more on using the built-in flash see Chapter 3.*

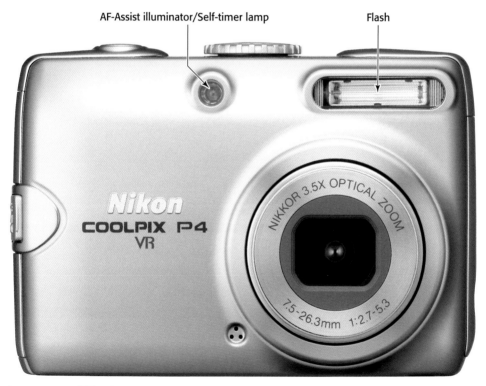

AF-Assist illuminator/Self-timer lamp Flash

Image courtesy of Nikon, Inc.
1.16 Front view of the P4

Also on the front of the camera is the AF-assist illuminator. This is a small LED lamp that lights up in dimly lit situations to allow your camera's autofocus to achieve the proper focus. This lamp also doubles as a self-timer lamp that blinks a countdown when you have your camera in the Self-timer mode so you can know when the camera is going to fire.

There is also a small microphone on the front of the P-series cameras. This is used for recording sound when the camera is in Movie mode. It can also be used to record notes attached to specific images when the camera is in Playback mode.

Additionally, the P5000 has the element optical viewfinder on the front of the camera. I discuss the optical viewfinder and its uses in the next section, which covers the back of the camera.

The back of the camera: P3 and P4 models

The back of the camera has the bulk of the buttons for accessing most of the features available on your P Series camera. This is where you enter the Playback and Shooting modes, dial in exposure compensation, change flash modes, set the self-timer, and control or access a multitude of other features.

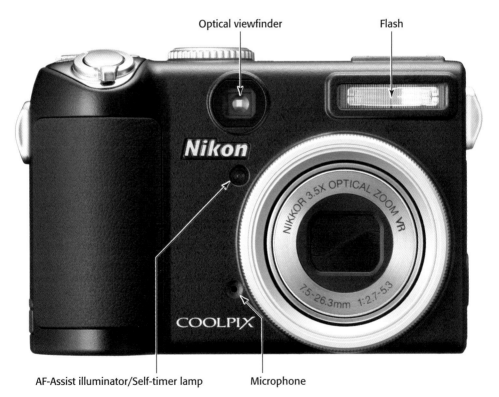

Optical viewfinder Flash

AF-Assist illuminator/Self-timer lamp Microphone

Image courtesy of Nikon, Inc.
1.17 Front view of the P5000

✦ **LCD screen.** The most obvious feature on the back of the camera is the LCD screen. The P Series cameras have a 2.5-inch LCD panel with an anti-reflective coating and adjustable brightness levels. The LCD is where you compose and view your images, view the menus to change your settings, and do any in-camera editing to your images, such as in-camera cropping and D-Lighting. The LCD screens on the COOLPIX cameras are bright, easy to see, durable, and scratch-resistant.

✦ **Zoom button.** The button at the top right of the camera is the Zoom button, which is a two-way rocker switch. The Zoom button has three functions, depending on the Mode your camera is in:

 • **In any Scene mode.** The Zoom button allows you to zoom the lens in or out. The left of this button is marked with a W for wide-angle, which allows you to fit a lot of the scene into the image; the right is marked with a T for telephoto, which allows you to zoom in close to capture faraway subjects or to focus on a specific detail of a subject.

 • **In Playback mode.** Under the button on the left-hand (W) side is a small checkerboard pattern. When you press this in Playback mode, the LCD plays back your images as small thumbnails. Under the right-hand (T) side of the button is a magnifying glass icon. When you press this side of the button, you're able to

zoom into the image that is displayed for closer inspection.

 • **In Menu mode.** Next to the magnifying glass icon is a question mark symbol. With your camera in Menu mode, you can press this button on the T side to display a brief description of whatever menu item is currently selected.

✦ **Menu button.** When you press this button, the LCD panel shows a menu enabling you to change various camera settings. The menus have different options depending on which mode you're in. If your camera is set to Auto mode, when you press the menu button, you will be in the Shooting menu. If you're set to the Scene mode, then you will see the Scene menu and so on.

✦ **Multi-selector in Shooting mode.** When you're in Shooting mode, whether you're in Auto, Scene, or one of the Exposure modes, the primary function of the multi-selector is to enable you to change the most important features quickly. For ease of use, each direction on the button is marked with the icon of what it does.

 • **Flash mode button.** A small lightning-bolt icon represents the Flash mode button. When you press this button, the Flash mode options appear on the LCD panel. This is used to change the Flash mode to choose one that is more suited to your needs.

- **Exposure compensation button.** You use the right button on the multi-selector to adjust the exposure compensation to fine-tune the image to get it just right. Exposure compensation is used when you take a photograph. After you preview the image, if it looks too dark or too light you can adjust the exposure compensation and re-shoot the picture with the adjustments in place.

- **Focus mode button.** You use the button on the bottom of the multi-selector to change the focus mode.

- **Self-timer button.** The left button allows you to set the self-timer. The self-timer puts a three- or ten-second delay on the shutter so you can set your camera up for shooting self-portraits or reduce the effect of camera shake caused from pressing the shutter release button while the camera is mounted on a tripod.

- **OK button.** You use the OK button in the center of the multi-selector to set the selection of the function being modified.

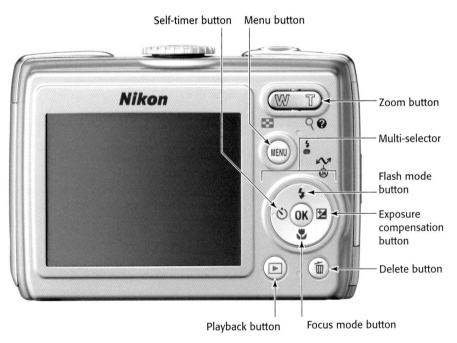

Self-timer button Menu button

Zoom button

Multi-selector

Flash mode button

Exposure compensation button

Delete button

Playback button Focus mode button

Image courtesy of Nikon, Inc.
1.18 Back view of the P4

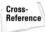

Cross-Reference *All of these features and more are discussed in greater detail in Chapter 2.*

✦ **Multi-selector in Playback mode.** Use the multi-selector to navigate through the images. The top button and the button on the left display the previous images, and the bottom and right buttons display the next images in the order you took them. The OK button enters you into the Quick Playback Zoom mode. This divides the current displayed image into nine sections, initially zooming in on the center section. You can then use the directional buttons on the multi-selector to quickly move to another section of the image. While in Quick Playback Zoom mode, you can also use the Zoom button to zoom in further or to zoom out.

Note *When you are connected to a computer by using a USB cable, press the OK button to start downloading all pictures that have been marked for transfer.*

The back of the P5000 Series

The back of the P5000 has more buttons and options on it than all of the other COOLPIX series cameras. The P5000 is designed to be more flexible than the typical compact camera, so there are buttons that allow you direct access to some of the options that you can only reach by going through menus on the other cameras. This is a very convenient feature that allows you to make adjustments on the fly without missing shots.

✦ **Optical viewfinder.** Directly above the LCD panel on the P5000 is the optical viewfinder. You can use the optical viewfinder when bright sunlight makes the LCD screen difficult to see or when you may want to turn the LCD monitor screen off to conserve battery power.

Caution *The image in the viewfinder may not appear the same as the final picture, especially when you're shooting close-up and shooting in 3:2 or 16:9 image mode, which have a different length and width from the standard image.*

✦ **Flash indicator lamp.** Located right next to the optical viewfinder is the Flash indicator lamp. The Flash indicator lamp lights up when the shutter is half-pressed to show you the status of the flash. When the light is on, the flash is ready to fire. If the light is blinking, the flash is charging; wait a few seconds until the light stops blinking and then take the photo. If the light is off, the flash is turned off or is not needed.

✦ **AF indicator lamp.** The AF indicator lamp lights when focus is achieved. If the camera is unable to focus, the AF lamp blinks rapidly.

✦ **Multi-selector in Shooting mode.** The multi-selector on the P5000 is on the right side of the camera. When you're in Shooting mode, whether you're in Auto, Scene, or one of the Exposure modes, the primary function of the multi-selector is to enable you to change the most important features quickly.

- **Flash button.** A small lightning-bolt icon represents this. When you press this button, the Flash mode options appear on the LCD panel. You use this to change the flash mode, selecting the one that best suits your needs.

- **Exposure compensation button.** You use the right button on the multi-selector to adjust the exposure compensation to fine-tune the image to get it just right.

- **Focus mode button.** You use the button on the bottom of the multi-selector to change the focus mode.

- **Self-timer button.** You use the left button to set the self-timer. The self-timer puts a three- or ten-second delay on the shutter so you can set your camera up for shooting self-portraits or reduce the effect of camera shake caused from pressing the shutter release button while the camera is mounted on a tripod.

- **OK button.** You use the OK button to set the selection of the function being modified.

✦ **Multi-selector in Playback mode.** When in Playback mode, you use the multi-selector to navigate through the images. The top button and the button on the left display the previous images, and the bottom button and right button display the next images in the order you took them. The OK button takes you into the Quick Playback Zoom mode. This divides the current displayed image into nine sections, initially zooming in on the center section. You can then use the directional button on the multi-selector to quickly move to another section of the image. While in Quick Playback Zoom mode you can also use the Zoom button to zoom in further or to zoom out.

Note *When you are connected to a computer via USB cable, you press the OK button to start downloading all pictures that have been marked for transfer.*

On the left side of the back of the camera is a series of five buttons. In descending order, they are as follows:

✦ **Function button.** This button is a shortcut. When in Scene mode, you can press this button and use the Command dial to scroll through the different modes without actually having to enter the Scene Mode menu screen; the Function button works in the same way it does when it's in Movie mode. When the camera is set to P, S, A, or M, you can customize the Function button to quickly adjust the ISO, Image Quality, Image Size, White Balance, or Vibration Reduction settings.

✦ **Monitor button.** Pressing this button in Shooting mode allows you to view or hide the displays on the LCD panel. When in P, S, A, or M, you can use this button to turn off the LCD panel altogether. When in Playback mode, pressing the monitor button enables you to view the shooting data and the histogram, which represents the graphic representation of the tonal distribution of the image being displayed.

✦ **Playback button.** Pressing this button allows you to view a full-frame playback of the images you have taken with your P5000. Once in Playback mode, you can use the multi-selector to view the images. To view pictures in the order they were taken, press the right or down buttons; to view the images in reverse order, press the left button. To return to the Shooting mode, press the Playback button again or tap the Shutter Release button.

✦ **Menu button.** When you press this button, the LCD panel shows a Settings menu. The menu may have different options depending on which mode you're in. If your camera is set to Auto mode, when you press the Menu button, you are in the Shooting menu. If you're set to the Scene mode, then you see the Scene menu.

✦ **Delete button.** Pressing this button while in Playback mode deletes the image currently displayed in the monitor. While in Shooting mode, pressing this button displays the last image taken and asks if you want to delete it.

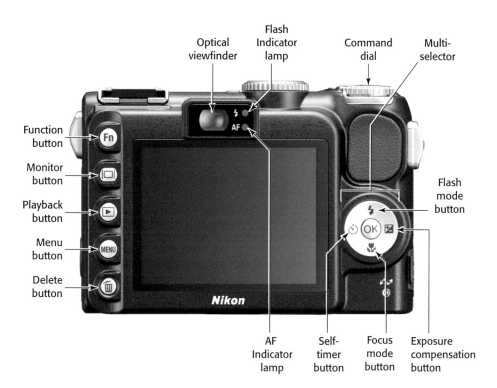

Image courtesy of Nikon, Inc.

1.19 Back view of the P5000

Sides and bottom of the camera

The bottom of the P Series cameras contains a tripod socket for attaching the camera to a tripod head or to a tripod quick release plate. Also on the bottom of the camera is the battery chamber door. Opening this door allows you access to the battery and the memory card. This is also where you would attach the optional external power supply.

On the left side of the camera with the lens facing you, you'll see the USB port, which has a cover to keep the dust and debris out. There is also a place to attach a strap.

The right side of the camera (when the lens is facing you) is where the built-in speaker resides. The P3 also has an LED that flashes when the camera is in Wireless Transfer mode. The P5000 also has an additional strap attachment here for attaching a neck strap.

Power Requirements

Although the S and P Series cameras come with rechargeable Nikon Lithium-ion (Li-on) batteries and a charger, the L Series cameras use standard AA sized batteries. There are a few different options available to you when it comes to powering your L Series camera.

Tip	*The LCD on the camera can use a lot of power; you most likely want to invest in a good set of rechargeable batteries.*

Non-rechargeable batteries

If you don't use your camera much or if you aren't ready to invest in a set of rechargeable batteries, there are a few different battery options for you to choose from.

✦ **Zinc-carbon.** These are the cheapest batteries you can buy. They are generally very low-priced store-brand batteries. I wouldn't recommend using these types of batteries unless you are in pinch and can't get anything else.

✦ **Alkaline-manganese.** These are your everyday, standard-type of battery; alkaline batteries are available nearly everywhere, from the local gas station to high-end camera shops. There can be differences in quality depending on the manufacturer. When you buy these types of batteries, I suggest purchasing those batteries that specify they are for use with digital cameras. They usually last longer than the cheaper brands.

✦ **Lithium.** Lithium batteries cost a little more than standard alkaline batteries, but they last a lot longer, are lighter, and have a longer life in cold weather conditions. You can find lithium batteries at mass-market retailers and some camera shops.

Rechargeable

Rechargeable batteries do require an initial investment, but you easily get your money back in what you save by not having to buy disposable batteries often. There are two types of rechargeable batteries to choose from for your COOLPIX cameras:

✦ **NiCad.** Nickel-cadmium batteries are the most common type of rechargeable batteries. Department stores usually sell them along with a charger for less than ten dollars. Also, you can usually find them at most camera stores. Although NiCad batteries are rechargeable, they don't last forever. Eventually

they hold less and less of a charge until they're finally depleted. If the battery is repeatedly charged when it has not been fully exhausted, the life of the NiCad is even shorter. For example, if you come home from shooting and your battery was only used to half of its capacity, you likely place it in the charger for your shoot tomorrow. After doing that several times, the battery remembers that it only charges to half power, which is called battery memory. Some manufacturers, however, claim that battery memory does not exist.

Choosing the Right Battery

When choosing a battery for your camera, you must decide how much you are going to use your camera and how often you are willing to change the batteries. Because most compact digital cameras have no other means of composing the image than using the LCD screen, they tend to use quite a bit of energy powering the display, not to mention using the zoom and flash. Throw in VR and WiFi and you have quite a power hog.

If you plan on only shooting a few snapshots here and there and don't mind buying new batteries once in a while, you can probably get away with just buying standard AA alkaline or lithium batteries.

If you carry your camera with you all the time and tend to take quite a few pictures — sometimes using flash and you take your time composing the image to get it just right — chances are you probably want to invest in a set of rechargeable batteries. In fact, you probably want to invest in at least two sets. This way you can have a set to use while the other set is charging.

Regardless of whether you use rechargeable on disposable batteries, it's a good idea to have at least one extra set of batteries on you. You don't ever want to miss out on that once-in-a-lifetime shot because your batteries died.

Another thing to consider when choosing a battery is how much power they can hold. This is expressed in Milliamp Hours or, more commonly, mAh. Simply put, batteries with higher mAh ratings last longer than ones with lower ratings.

Typical AA zinc-carbon batteries range from 400-900 mAh. Zinc-chloride batteries, which are almost the same as zinc-carbon batteries, are usually rated at 1000-1500 mAh. Ni-Cad batteries are commonly available in the 650-800 mAh range. Although this is not a high-power battery, because it can be recharged, it's generally a better buy than a standard battery of that power range. Ni-MH batteries usually range anywhere between 1400 and 2900 mAh. Obviously, the higher the mAh rating, the more expensive the battery will be. Personally, I use 2500 mAh batteries in my COOLPIX L5. On average, they cost just a little more than $20 for four batteries and a charger.

I recommend making the initial investment in a good set of high-mAh Ni-MH batteries. The time and money you save on batteries is well worth it in the long run.

✦ **Ni-MH.** Nickel metal hydride batteries are the most expensive type of batteries, but as the saying goes, "You get what you pay for." AA Ni-MH batteries have two to three times the capacity of AA NiCd batteries; therefore, they last longer on a single charge than NiCd batteries do, and the battery memory problem is not as significant. You can find Ni-MH batteries pretty easily in any store that sells any type of electronic equipment.

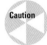 **Caution** *With Ni-MH batteries, you must fully charge the batteries before you install them into your COOLPIX camera. If one of the batteries in the set becomes discharged before the others, the discharged battery goes into polarity reversal, which means the positive and negative poles become reversed, causing permanent damage to the cells, rendering the battery useless and possibly damaging your camera.*

Choosing the Right Memory Card

A memory card is where your camera stores the data that makes up the images that you have taken with your camera. Although your Nikon COOLPIX camera has anywhere from 7 to 32 megabytes of internal memory (depending on which camera model you own), this little bit of memory is usually only enough for a few pictures. To get the most out of your camera, you're going to need to get a larger memory card.

Although there are many different types of memory cards, the Nikon COOLPIX series of cameras use what is called SD or MMC. SD stands for Secure Digital media and MMC stands for Multi Media Card. The only difference between these two types of cards is that SD cards have a write protect switch that you can use to prevent the accidental loss of data.

Memory cards come in many different memory amounts, ranging from 16 megabytes all the way up to 8 gigabytes. With the leaps and bounds being made every day in the memory business, you can easily find a high capacity memory card at an affordable price.

Choosing the right memory card depends on a few different things. First and foremost is how much resolution your camera has. A 3-megapixel camera image has a much smaller file size than the image from a camera with a 7-megapixel sensor. Therefore, the higher the resolution of your camera, the larger the memory card you need to have.

Another thing to consider is how many photos you take on a typical outing. If you only shoot a few images here and there, maybe you don't need as much memory, or if you immediately delete any unsatisfactory images, it may be possible to get away with using a smaller card.

Finally, consider how often you download your images to a computer. If you tend to go quite a while without downloading your images, you may be a candidate for a very high capacity card. This way you can store a lot of images without having to go through and delete any to make space for new images.

To give you a rough estimate of how many images you can store on various sizes of cards, see Table 1.1.

Table 1.1
Memory Card Image Storage*

Number of Megapixels	Memory Card Size						
	128 mb	256 mb	512 mb	1 gb	2 gb	4 gb	8 gb
3 mp	120	240	490	996	2000	4000	8000
5 mp	48	95	195	395	800	1600	3200
7 mp	35	72	149	297	600	1200	2400
10 mp	26	53	110	221	445	887	1723

* The actual numbers of images varies according to image data, resolution, and compression.

Navigating Your COOLPIX Camera

◆ ◆ ◆ ◆

In This Chapter

Main menus

Exposure modes

Pictmotion movies

◆ ◆ ◆ ◆

In this section I cover the menus and how to navigate through them to gain access to their particular settings and features. Navigating these menus for the first time can be very frustrating, so this chapter should help you understand where you are in the menus and what each does.

 Note *This book covers the full range of COOLPIX cameras rather than just one single camera, so ways to access identical menus may vary among the models. I've made every effort to try to point out the differences in the camera models.*

Main Menus

The main menus contain the different submenus where you make the bulk of the setting changes. For the most part, you don't need to change these settings often. This is why you access them through a menu rather than the touch of a single button, as you do for flash modes, exposure compensation, and the like.

Set up menu

You set up how your camera interfaces with you in the Set up menu. It includes such settings as Languages, the Time and Date, and the various LCD panel settings. For the most part, once you've set these to your personal preferences, you rarely need to access them, except to format the memory card. The steps to access the Set up menu in the three COOLPIX series are outlined in the following sections, by camera.

L Series

1. **Turn on the camera.** Make sure that the camera is set to the Auto shooting mode, not the Scene or Movie mode. When using the older S Series cameras, S1 to S6, press the Menu button instead of the Mode button.

2. **Press the Menu button.** This brings you to the Shooting menu. The first menu item listed under the Shooting menu is the Set up menu. Make sure that Set up is highlighted.

3. **Press the multi-selector to the right to enter the Set up menu.** There are three screens of set up options, if you scroll through them all using the multi-selector.

S Series

1. **Turn on the camera.**

2. **Press the Mode button.** This brings you to a menu that allows you to choose from the Shooting menu and other shooting modes. Use the multi-selector or rotary multi-selector (depending on the model) to highlight the Set up menu icon. The Set up menu icon looks like a wrench with an arrow next to it.

3. **Press the OK button in the center of the multi-selector to enter the Set up menu.**

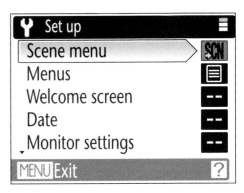

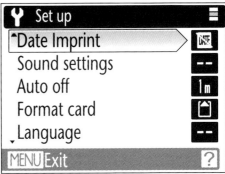

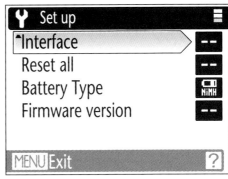

2.1 The Set up menu options from the L5

P Series

1. **Turn on the camera.**

2. **Rotate the Mode dial until it is in the Set up position.** The Set up menu appears and you see a list of setting options. Move between the settings by pressing the multi-selector up or down.

3. **Select a specific setting by pressing the multi-selector right, or pressing the OK button in the center of the multi-selector.** To go back to the previous menu, press the multi-selector left.

 Note *Not all of the settings are available with every COOLPIX camera. The menu options differ from model to model.*

Set up menu options

The following comprehensive list includes all the Set up menu options from all camera series. If you don't see an option in your Set up menu, then it is likely not available on your camera model. The Set up menu options are as follows:

✦ **Menus.** This setting allows you to select whether you want to see the menu options in text form or as icons. Highlight the option using the multi-selector up or down keys, then press the multi-selector right to set the selection.

✦ **Quick startup.** The S and P Series cameras have this setting. It allows them to turn on faster by disabling the Welcome Screen.

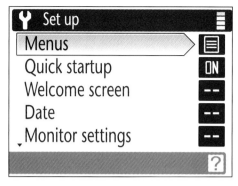

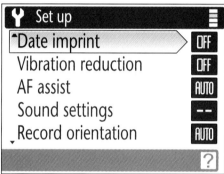

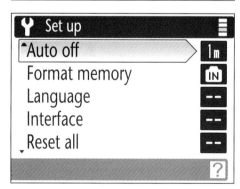

2.2 The Set up menu options from the S50c

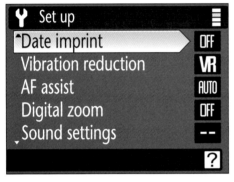

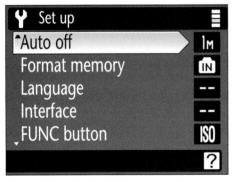

2.3 The Set up menu options from the P5000

✦ **Welcome screen.** The Welcome screen is an image that is displayed on the LCD when the camera is turned on. There are three settings: Nikon, Animation, and Select an image. The first two are stock Nikon images; the third allows you to set an image from your memory card as the opening image. The L Series cameras offer a fourth option, Disable Welcome, which allows you to turn off the Welcome screen — similar to turning on the Quick startup function with the P and S Series.

> **Note** When the Quick startup is set to "On," the Welcome screen setting is bypassed.

✦ **Date.** Selecting this setting allows you to adjust the time, date, and time-zone settings.

✦ **Monitor settings.** This menu selection brings you to a submenu that allows you to customize the LCD. There are two options:

 • **Photo Info.** Pressing right when Photo Info is highlighted brings you to another submenu that offers four options: Show Info, Auto Info, Hide Info, and Framing grid. Show Info shows all of the shooting information on the LCD panel at all times. Auto Info shows the shooting info for a few seconds before automatically hiding it from view. Hide Info hides all of the shooting info. Framing grid allows all shooting info to be displayed along with a grid on the LCD to help with composition.

• **Brightness.** This second option on the Monitor settings submenu allows you to adjust the brightness of the LCD. This menu setting is available on all COOLPIX cameras except the P5000.

✦ **Brightness.** This main Set up menu setting is only on the P5000; it enables you to adjust the brightness of the LCD panel. You may want to adjust the brightness higher when you're out in direct sunlight or dim the display in lower light to help conserve battery power. This menu setting is available under the Monitor settings on all other COOLPIX cameras.

✦ **Date imprint.** This setting allows you to have the date or the date and time that the photo was taken on the image. There is also a date counter setting that you can use. When you use the date counter, the number of days elapsed or the numbers of days remaining between dates set by the user imprint along with the time and date.

✦ **Vibration reduction.** Use this setting to turn the Vibration Reduction (VR) on or off. The Vibration reduction setting is not available on all cameras.

✦ **AF assist.** This setting is used to set the Auto Focus- (AF-) assist illuminator. The AF-assist illuminator shines an LED light on the subject when you're taking pictures in low light to help achieve proper focus. The two available settings are Auto, which allows the light to come on automatically when the camera sensor doesn't detect enough light; and Off, which completely disables the AF-assist illuminator.

✦ **Sound settings.** When this is selected, you are shown another submenu. There are three options, depending on your camera model.

• **Button sound.** This setting allows you to turn off the beeping sound that happens when an operation such as a menu selection is completed.

• **Shutter sound.** Some cameras allow you to choose different sounds to let you know that the shutter has been released (P and S Series), while other camera models only let you decide the volume of the shutter sound (L Series). The third option also differs between camera models. The L Series allows you to adjust the volume level of the start up sound, while the P and S Series allow you to adjust the volume globally for all of the camera sounds.

✦ **Auto off.** This setting allows you to set the camera to turn off after a specified time has passed while the camera has not been used. It is used to conserve battery power. The choices are 30 seconds, 1 minute, 5 minutes, and 30 minutes. Some cameras also have an additional Sleep mode setting that allows the camera to enter into standby mode when the camera detects no change in brightness from the subject. The Sleep mode overrides Auto off. The camera enters Sleep mode after 30 seconds when the camera is set to Auto off for 1 minute, or it enters Sleep mode after 1 minute when it's set to Auto off for 5 minutes or more.

✦ **Format card/memory.** This setting allows you to completely erase all of the data on the memory card or internal memory. Some models have a Quick Format option that only erases portions of the card that contain data. To erase the internal memory of the camera, first remove the SD memory card and then choose this setting. Formatting the memory card after you have downloaded all of your images to your computer helps to maintain maximum performance of your memory cards.

✦ **Language.** This setting shows you a list of languages. Select the language you would prefer the menus to be in and press the OK button.

✦ **Interface.** Use this setting to decide how your camera interfaces with the different devices you may want to connect it to, such as a television, a computer, or a printer. You may need to change this setting depending on the type of TV you have, the operating system on your computer, or the manufacturer and type of printer you are using. I strongly suggest checking the owner's manual for the camera and device before connecting the camera to anything. There are three options:

• **USB port.** The USB menu has two options: PTP (Picture Transfer Protocol) and Mass storage. *PTP* is a standard transfer platform that allows the easy transfer of pictures to a computer. The Mass storage setting allows a computer to see the camera as a hard drive with data on it. Most computers recognize that a camera has

been attached whether the USB is set to PTP or Mass storage. The exception is Windows 2000 Professional: When you're using this operating system, you want to be sure to set the USB interface to Mass storage.

When you connect the camera directly to a printer, set the USB interface to PTP.

• **Video mode interface.** There are two options in this submenu's submenu: NTSC and PAL. Without getting into too many specifics, these are types of standards for the resolution of televisions. All of North America, including Canada and Mexico, use the NTSC standard, while most of Europe and Asia use the PAL standard. Check your television owner's manual for the specific setting.

• **Auto transfer.** This setting allows you to decide whether the camera automatically marks your images for transfer or you can turn this function off and mark the images for transfer manually in the Playback menu.

✦ **FUNC button.** This menu option is available only on the P5000. It allows you to set the function button on the camera to quickly access a specific setting in order to change it quickly. The options are ISO sensitivity, Image quality, Image size, White balance, or Vibration reduction.

✦ **Reset all.** When this option is selected, all of the camera settings return to the default setting. Check your camera owner's manual for a list of the default settings.

✦ **Battery type.** This menu option is available only on cameras that use AA batteries. The choices are alkaline, Ni-Mh, and lithium. Setting this option to match the batteries ensures that your camera can accurately gauge the amount of charge remaining in the battery.

✦ **Wireless settings.** This menu option is available on cameras equipped with Wi-Fi. Selecting this redirects you to the Wireless settings menu.

✦ **Firmware version.** Selecting this option displays what version of *firmware* your camera functions with. Firmware is the software that is embedded in the camera that allows it to operate. Occasionally Nikon may change the firmware to fix a bug or to enhance the existing product. You can usually upgrade your firmware using a download from the Nikon Web site, www.nikonusa.com.

Shooting menu

The Shooting menu contains the settings that control the image quality, the different color options, and the options that pertain to taking the pictures, such as ISO sensitivity, shutter control, exposure compensation, and the auto focus area. The steps to access the Shooting menu in the three COOLPIX series are as follows:

L Series

1. **Turn on the camera.** Be sure that the camera is set to the Auto shooting mode.

2. **Press the menu button to enter the Shooting menu.**

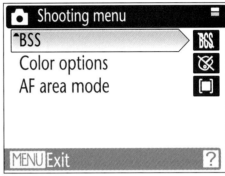

2.4 The Shooting menu options on the L5

S Series

1. **Turn on the camera.** Be sure that the camera is in the Auto shooting mode by pressing the menu button and selecting the Auto icon (green camera).

2. **Press the OK button.**

3. **With the camera in the Auto mode, press the menu button to enter the Shooting menu.**

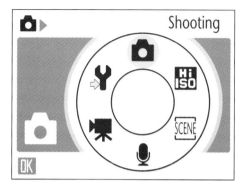

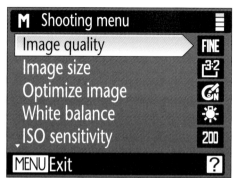

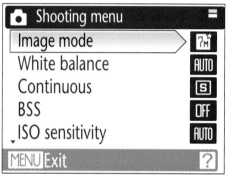

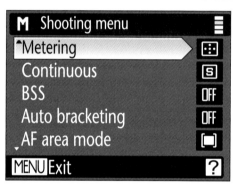

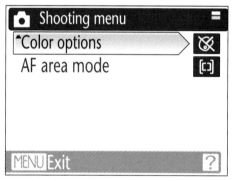

2.5 The Shooting menu options on the S50c

P Series

1. **Turn on the camera.**

2. **Turn the Mode dial to the P or A setting (P, S, A, or M with the P5000).**

3. **Press the Menu button to enter the Shooting menu.**

2.6 The Shooting menu options on the P5000

Once you're in the Shooting menu, you have a list of different settings. To move among the settings, press the multi-selector up or down; or if your camera has a rotary multi-selector, you can scroll the dial left or right.

To select a specific setting to change, press the multi-selector right, or press the OK button in the center of the multi-selector. To go back to the previous menu, press the multi-selector button left.

Note *Not all of the settings are available with every COOLPIX camera. The menu options may differ from model to model.*

The Shooting menu settings are as follows:

L Series

✦ **Set up.** Selecting this setting takes you to the Set up menu.

✦ **Image mode.** Choosing this menu setting allows you to set the resolution of the image your camera is recording.

✦ **White balance.** This setting brings up a submenu in which you can set the white balance to match the lighting. You can also set the white balance to Auto, and the camera chooses the white balance for you.

✦ **Metering.** This setting allows you to adjust the way the camera meters the light in the scene to determine the proper exposure. There are two options: Matrix and Center-weighted.

✦ **Continuous.** This setting is where you set how the camera shoots when you press the Shutter Release button. You can choose from Single shot, Continuous, and Multi-16.

✦ **BSS.** This setting is where you turn on and off the Best Shot Selector (BSS) mode, in which you shoot a series of images and the camera chooses the sharpest one and discards the rest.

✦ **Color Options.** This setting brings you to a submenu where you can fine-tune the color of your images to suit your taste, or can choose black and white, sepia, or cyanotype.

✦ **AF area mode.** In this sub-menu, you choose where the camera auto focuses. You can choose between Auto, where the camera chooses the AF point, and Center, where the camera focuses in the middle of the frame.

Cross-Reference *For detailed information on image resolution, white balance settings, metering modes, Continuous shooting options, color settings, and AF area modes, see Chapter 3.*

S Series

✦ **Image mode.** Choosing this setting allows you to set the resolution of the image your camera is recording.

✦ **White balance.** This setting brings up a submenu in which you can set the white balance to match the lighting. You can also set the white balance to Auto, and the camera chooses the white balance for you.

✦ **Continuous.** This setting is where you set how the camera shoots when you press the Shutter Release button. You can choose from Single shot, Continuous, and Multi-16.

✦ **BSS.** This setting is where you turn on and off the Best Shot Selector (BSS) mode, in which you shoot a series of images and the camera chooses the sharpest one and discards the rest.

✦ **ISO sensitivity.** In this setting, you choose how sensitive your camera is to capturing light.

✦ **Color options.** This setting brings you to a submenu where you can fine-tune the color of your images to suit your taste, or can choose black and white, sepia, or cyanotype.

✦ **AF area mode.** In this setting, you choose where the camera auto focuses. You can choose between Auto, where the camera chooses the AF point; Manual, where you choose the AF point by using the multi-selector; and Center, where the camera focuses in the middle of the frame.

> **Cross-Reference** *For detailed information on image resolution, white balance settings, metering modes, continuous shooting options, ISO, color settings and AF area modes, see Chapter 3.*

P Series

✦ **Image quality.** This setting controls the amount of compression of the image data. The compression controls how big the file size is as well as the overall quality of the image. You can select one of three settings:

• **Fine** offers the least compression and the highest overall quality.

• **Normal** offers more compression and normal quality.

• **Basic** offers the most compression with the smallest file size.

✦ **Image size.** This setting allows you to change the recorded image to a lower resolution.

✦ **Image Adjustment.** This setting is used to adjust the contrast of the image. There are four different settings for this option:

• **Auto.** Automatically adjusts the contrast depending on the lighting conditions.

• **Normal.** Performs a standard adjustment that is the same for all images.

• **More Contrast.** Gives the image more definition between the light and dark areas of the picture. Use this setting when there is not a lot of contrast in the scene.

• **Less contrast.** Decreases the difference between the light and dark areas of the picture. Use this setting in high-contrast situations such as a bright sunny day.

✦ **Image sharpening.** This setting increases the contrast between the actual pixels in the image to add more definition to the picture, making it look sharper. There are five settings for this option:

• **Auto.** Sharpens the image depending on the sharpness of the subject.

• **High.** Sharpens the image, very much increasing the edge detail.

• **Normal.** Sharpens the image a small amount.

• **Low.** Decreases the sharpness of the image.

- **Off.** Applies no image sharpening at all. This is the recommended setting if you will be working on your images with software.

✦ **Saturation control.** This setting controls how rich, or bright, the colors in your images are. There are two or five settings for this option depending on your P camera model:

- **Maximum.** This setting provides the richest and most vivid colors. This setting is useful when you're printing photos directly from the camera. (P3/P4)

- **Enhanced.** This setting provides rich colors just a little below the maximum setting. It is also a good choice when you're printing from the camera. (P3/P4/P5000)

- **Normal.** This setting provides a standard amount of saturation; it is not too bright, but the colors are given a little boost. (P3/P4)

- **Moderate.** This settings gives colors just a minute amount of boost. (P3/P4/P5000)

- **Minimum.** This setting provides the colors as the camera sees them, with no saturation adjustment. This is a good mode to select if you plan on retouching the photos on a computer, where you can add saturation with greater control. (P3/P4)

Note *The Image adjustment, Image sharpening, and Saturation adjustments are available in the Optimize Image ⇨ Custom submenu on the P5000.*

✦ **Optimize image.** This setting brings you to a submenu. The options are Custom and Black and White. Choosing Custom allows you to adjust Contrast, Sharpening, and Saturation. Choosing Black and White allows you to choose a standard setting or a Custom setting. The Black and White custom menu offers the options of Contrast adjustment, Image sharpening, and Monochrome filters. The monochrome filters approximate the types of filters traditionally used with black-and-white film. These filters increase contrast and create special effects. The options are:

- **Yellow.** Adds a low level of contrast. It causes the sky to appear slightly darker than normal and anything yellow to appear lighter.

- **Orange.** Adds a medium amount of contrast. The sky will appear darker, giving greater separation between the clouds. Orange objects appear light grey.

- **Red.** Adds a great amount of contrast, drastically darkening the sky while allowing the clouds to remain white. Red objects appear lighter than normal.

- **Green.** Darkens the sky, and lightens any green plant life. This color filter can be used for portraits as it softens skin tones.

✦ **White balance.** This setting brings up a submenu in which you can set the white balance to match the lighting. You can also set the white balance to Auto (default) , and the camera chooses the white balance for you.

✦ **ISO sensitivity.** In this setting, you choose how sensitive your camera is to capturing light.

✦ **Metering.** This setting allows you to adjust the way the camera meters the light in the scene to determine the proper exposure. There are four options: Matrix, Center-weighted, Spot, and Spot AF area.

✦ **Continuous.** This is the setting where you set how the camera shoots when you press the Shutter Release button. You can choose from Single shot, Continuous, and Multi-16.

✦ **BSS.** This is the setting where you turn on and off the Best Shot Selector (BSS) mode, in which you shoot a series of images (up to 10) and the camera chooses the sharpest one and discards the rest.

✦ **Auto bracketing.** This setting brings you to a submenu where you can choose to shoot three images as the camera adjusts the exposure automatically. You have the options of ±0.3, ±0.7, ±1.0 EV (Exposure Value).

✦ **AF area mode.** In this setting, you choose where the camera autofocuses. You can choose between Auto, where the camera chooses the AF point; Manual, where you choose the AF point using the multi-selector; and Center, where the camera focuses in the middle of the frame.

Cross-Reference *For detailed information on all of these settings, see Chapter 3. For more information on accessories, see Chapter 5.*

✦ **Auto-focus mode.** This setting chooses how the camera's auto-focus (AF) functions. In Single AF, the camera only focuses when the shutter button is half-pressed; when it is set to Full-time AF, the camera is constantly focusing.

✦ **Flash exp. comp.** This menu setting for the flash's exposure compensation is available only on the P5000. It allows you to fine-tune the output of the flash by ±2.0 EV. The flash exposure compensation affects both the built-in Speedlight and the optional hot-shoe Speedlight.

✦ **Flash control.** This setting is available only on the P5000. Use it to choose whether the built-in flash fires when there is no optional flash. The Auto setting allows the flash to fire; the Off setting turns off the built-in flash completely.

✦ **Fixed aperture.** When this feature is turned on, the camera attempts to keep the aperture as close as possible to the aperture setting you chose in Manual or Aperture Priority exposure modes.

✦ **Noise reduction.** This setting turns the noise reduction feature on or off.

✦ **Converter.** This setting is available only on the P5000, and the options are for use with the optional lens converters.

Playback menu

You can make minor changes to your images, make copies, create Print sets, and mark your images for transfer in the Playback menu.

To enter the Playback menu, follow these steps:

1. **Turn the camera on.**

2. **Press the Playback button on the back of the camera.**

3. **Press the Menu button to enter the Playback menu.**

Once in the Playback menu, you have a list of settings to choose from. To move among the settings, press the multi-selector up or down, or if your camera has a rotary multi-selector, you can also scroll the dial left or right.

To select a specific setting to change, press the multi-selector right, or press the OK button in the center of the multi-selector. To go back to the previous menu, press the multi-selector left.

The following comprehensive list includes all the Playback menu options from all camera series. If you don't see an option in your Playback menu, then it is likely not available on your camera model. The Playback menu options are as follows:

✦ **D-Lighting.** This setting attempts to bring back some of the detail that can be lost in dark shadows. When you select the D-Lighting setting, the last picture you viewed during playback is displayed with a before and after icon. A confirmation menu appears. Using the multi-selector, highlight OK to perform D-Lighting or Cancel to cancel the operation. Your original image is preserved and another image is created with the D-Lighting applied.

2.7 The Playback menu options on the L5

2.8 The Playback menu options on the S50c

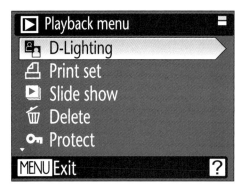

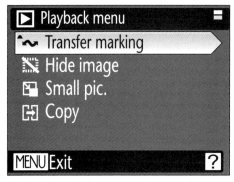

2.9 The Playback menu options on the P5000

> **Note** On some cameras, such as the L5 and the S50c, an external button accesses the D-Lighting function.

✦ **Print set.** Use this setting to select pictures for printing directly from the camera. To create a Print set, follow these steps:

1. **Select Print set from the Playback menu.** Press the multi-selector right or press the OK button.

2. **Use the multi-selector to highlight Print Selected.** Press the multi-selector right or press the OK button.

3. **Press the multi-selector left or right to highlight the image thumbnails you want to add.**

4. **Press the multi-selector up to add an image to the print set.** Push the multi-selector up additional times to print more than one copy. You can print up to nine multiples per image. Press the multi-selector down to reduce the number of copies and to remove the image from the print set.

✦ **Slide show.** This setting plays a slide show of the images currently stored on the camera. There are three options in the submenu:

• **Start.** Pressing the OK button or the right button starts the slide show playback.

• **Frame intvl.** Pressing the OK button or the right button brings up the time interval options. You can have each image display for 2, 3, 5, or 10 seconds.

• **Loop.** Selecting this option allows the slide show to continuously repeat.

✦ **Delete.** Choosing this setting allows you to erase selected images, or to erase all of the images at once. To erase selected images, follow these steps:

1. **Select the Delete option from the Playback menu.** Press the multi-selector right or press the OK button.

2. **Use the multi-selector to highlight Erase selected images.** Press it right or press the OK button.

3. **Press the multi-selector left or right to highlight the images you want to mark for deletion.** Press up and down to select and deselect the images you want to delete. Images that are selected to be erased have a checkmark icon in the corner.

4. **Once you've made your selection, press the OK button.** The camera asks you to confirm the deletion. Choose Yes to erase the images and No to keep them.

✦ **Protect.** This setting allows you to lock certain pictures to prevent them from being erased accidentally. To protect selected images, follow these steps:

1. **Select the Protect option from the Playback menu.** Press the multi-selector right or press the OK button.

2. **Press the multi-selector left or right to highlight the images you want to mark for locking.** Press up and down on the multi-selector to select and deselect the images you want to protect. Images that are selected for protection have a checkmark icon in the corner.

3. **Press the OK button.**

✦ **Transfer marking.** The setting marks the images you want to transfer to your computer using the automatic transfer button on your camera or in Nikon Picture Project. There are three options in the submenu as follows:

• **All on.** Selecting this option marks all of the images on the camera for transfer.

• **All off.** Selecting this option removes the transfer marking. No images will be transferred from the camera to the computer.

• **Select images.** Selecting this option allows you to pick and choose which images will be automatically transferred. To select images for transfer, follow these steps:

1. **Choose the Select images option from the Transfer marking submenu.** Press the multi-selector right or press the OK button.

2. **Press the multi-selector left or right to highlight the images you want to mark for transfer.** Press up and down to select or deselect the images you want to transfer. Images that are selected for transfer have a checkmark icon in the corner.

3. **Press the OK button.**

✦ **Hide image.** This setting allows you to select images to be hidden. These images won't appear with the others in Playback mode. Hidden images can only be seen in the Hide image menu. To hide images, follow these steps:

1. **Choose the Hide image option from the Playback menu.** Press the multi-selector right or press the OK button.

2. **Press the multi-selector left or right to highlight the images you want to hide.**
Press the multi-selector up and down to select or deselect the images you want to be hidden. Images that are selected to be hidden have a checkmark icon in the corner.

3. **Press the OK button.**

✦ **Small pic.** This setting makes a small copy of the last image viewed in Playback mode. Selecting this mode brings up a submenu with three different size options: 640 × 480, 320 × 240, or 160 × 120. This feature is for creating smaller copies of your pictures suitable for sending in e-mail. Once you've selected the size, press the OK button; you are then asked to confirm.

✦ **Copy.** This setting copies images from the camera's internal memory to the memory card or vice versa.

Exposure Modes

As defined in photographic terms, *exposure* is the amount of light that falls on the digital sensor of your camera. The amount of light that hits the sensor is determined by two variables: aperture, or f-stop (these two terms are interchangeable), and shutter speed.

The *aperture*, or *f-stop*, is the opening in a lens that allows a certain amount of light in. The *shutter speed* controls how long the sensor is exposed to the amount of light that the aperture allows in. When the aperture allows in a certain amount of light, and the shutter speed lets the light hit the sensor for the right amount of time, you get a perfect exposure.

Exposure modes work in conjunction with the camera's built-in light meter to determine the right aperture and shutter speed to achieve the perfect exposure. Sometimes in photography, variables occur when you may want to choose a certain exposure setting to achieve a particular effect. For this reason, different exposure modes exist. The L and S Series have a fully automatic setting that doesn't allow for much flexibility, but the P Series cameras have fully automatic exposure modes as well as semi-automatic modes that let you determine at least one part of the exposure equation.

Automatic

All of the Nikon COOLPIX series cameras have the Automatic exposure mode. For the L and S Series cameras, this is the only exposure mode with the exception of the Scene modes, which I discuss in the next section.

In the Auto exposure mode, the camera first uses a meter to measure the lighting of the scene you are photographing. Then it uses programmed algorithms to determine the proper shutter speed and aperture and applies them. The only flexibility that you have with this mode is the exposure compensation feature, which you use to adjust the exposure.

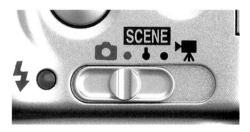

2.10 An L12 set to Auto exposure mode

 Cross-Reference *For more on exposure compensation, see Chapter 3.*

To access the Auto Exposure mode for the L Series, you simply turn on the camera and make sure the switch on the back of the camera is set to the green camera icon (all the way to the left).

To access this mode with an S Series camera, turn on the camera, press the Menu button, and then use the multi-selector to highlight the green camera icon. Press the OK button.

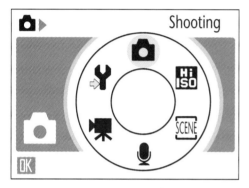

2.11 An S50c set to Automatic exposure mode

With a P Series camera, just turn on the camera and rotate the Mode dial until it is on the green camera icon.

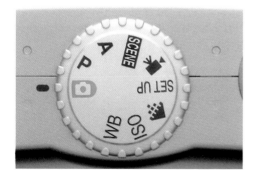

2.12 A P4 with the Mode dial set to Automatic exposure mode

Scene modes

Sometimes the Automatic exposure mode doesn't suit your needs, especially when you're shooting under difficult situations or when you have special circumstances. For example, suppose you want to take pictures of a fireworks display and have the camera set to Autoexposure mode. The exposure is going to be dark. The first problem the camera has is that it can't find anything to focus on. The second is its meter tells the camera that the scene is dark and the camera wants to fire the flash. This is not conducive to capturing great fireworks images because you don't want to illuminate the light from the fireworks (not to mention that the flash doesn't have the range to light that far anyway).

To make things easier, Nikon has preprogrammed Scene modes built into all of the COOLPIX series cameras. These Scene modes take into account different lighting situations and modify the way the camera meters the light, as well as control the focus points, the flash settings, and the aperture and shutter speed settings.

These Scene modes take difficult lighting situations and make it easier to get great photos. In addition, once you learn how the different Scene modes operate, you may be able to figure out uses for them other than what's intended. This can give you a little more flexibility opposed to simply setting the camera to Auto exposure mode and hoping that your photos turn out.

Here's how to enter the Scene mode menu for the L, S, and P Series cameras:

L Series

1. **Turn on the camera.**
2. **Set the Mode switch to Scene.**
3. **Press the menu button.**
4. **Use the multi-selector to choose the desired Scene mode.**
5. **Press the OK button.**

S Series

1. **Turn on the camera.**
2. **Press the Mode button to enter the main menu.**
3. **Use the multi-selector to select the Scene mode and press the OK button.**
4. **Press the menu button.**
5. **Use the multi-selector to choose the desired Scene mode.**
6. **Press the OK button.**

P Series

1. **Turn on the camera.**
2. **Rotate the Mode dial to the Scene position.**
3. **Press the menu button.**
4. **Use the multi-selector to choose the desired Scene mode.**
5. **Press the OK button.**

Scene modes

In this section you go over all of the different scene modes and the uses for them. You also learn a little bit about what camera settings are based on and how they affect the image.

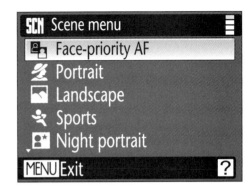
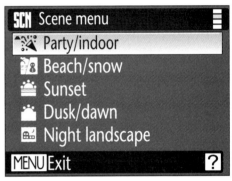
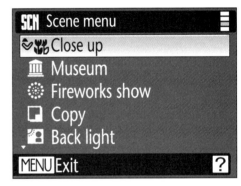
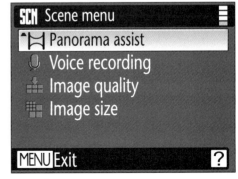

2.13 The P5000 Scene menu

✦ **Face-priority AF.** When this mode is activated Nikon's special face detection program is put in effect. This program automatically detects a person's facial features and locks the focus onto the face. Even if the subject moves, the camera can recognize this and change the focus area to remain focused on the subject.

Note *The face recognition feature may not function well in certain situations, such as when the subject is too close or too far and if something is obscuring the face such as sunglasses or hats.*

✦ **Portrait.** This mode is for taking photos of people. The camera uses a wide aperture and adjusts the color for natural skin tones. The AF point is set to the center. When in this mode, the camera automatically sets the flash to red-eye reduction, the close-up focus is turned off, exposure compensation is set to 0, and the AF-assist illuminator is set to Auto.

✦ **Landscape.** This mode is for taking photos of far off vistas. The camera chooses a smaller aperture to ensure maximum depth of field and sharp focus. The color saturation is enhanced, as is the contrast. When set to Landscape mode, the camera automatically focuses at infinity, the flash is turned off, and the exposure compensation is set to 0. The AF-assist illuminator is turned off and does not light up even in low-light situations.

✦ **Sports.** This mode is for taking pictures in which there is some sort of action taking place. The camera automatically sets a higher shutter speed to help freeze the action.

The camera autofocuses continuously and the autofocus (AF) point is in the center of the frame. The camera continues to shoot pictures as long as the shutter button is held down for up to eight images. The flash is turned off. The AF-assist illuminator is turned off and will not light up even in low-light situations.

✦ **Night portrait.** This mode for taking pictures of people in low-light situations where you want to be sure the background gets enough exposure so that it is visible in the image. The camera uses a wide aperture and a slow shutter speed to capture the background, while the flash is set to Slow Sync Red-Eye Reduction to properly expose the person in the picture. The AF is set to automatic. Noise Reduction is turned on. A tripod is recommended when using this setting.

✦ **Party/indoor.** This mode is similar to the Night Portrait mode. It is used to take pictures in low-light situations and to adequately capture the background light. The camera uses a wide aperture and a slow shutter speed to capture the background, while the flash is set to Slow Sync Red-Eye Reduction. The AF point is set to the center. If available, turn the VR on to reduce the effect of camera shake.

✦ **Beach/snow.** Light reflecting from snow or sand can fool the camera's light meter into thinking the scene is brighter than it actually is, so setting it to this mode means the camera overexposes the image slightly to ensure that the snow or sand appears bright. The flash is set to Auto. The camera's AF point is set to the center of the frame.

✦ **Sunset.** This mode captures the intense shades of colors seen during the sunset or sunrise. The camera boosts color saturation to enhance this effect. The flash is turned off, and the camera focuses at the center of the frame. A tripod is recommended when using this setting.

✦ **Dusk/dawn.** This mode is similar to the Sunset mode. It is intended for *after* the sun sets or *before* it rises. The color saturation is boosted more to accent the colors that are less visible when the sun has already set (or has yet to rise) and there is little light available. In this mode the camera is focused at infinity and the flash is turned off. A tripod is strongly recommended when using this mode.

✦ **Night landscape.** This mode uses very long shutter speeds and only available light to produce images. The flash is turned off, the camera is focused at infinity, and the AF-assist illuminator is turned off. A tripod is strongly recommended when using this mode.

✦ **Close up.** This mode allows you to focus on an object at a very close range to capture small details. The camera uses a wide aperture to provide a shallow depth of field to blur out the background details. The AF is set automatically to the close-up position. The camera is set to focus continuously until you press the shutter button halfway to lock the focus. The flash is set to Auto, although I recommend not using the flash when in Close up mode, given the lens usually casts a shadow on the subject.

✦ **Museum.** Light from flashes can have detrimental effects on paintings, artwork, and historic documents so most museums do not allow flash photography. This mode turns off the flash and AF-assist illuminator. The BSS (Best Shot Selector) is turned on. The AF area mode is set to Auto.

Cross-Reference | *You can find more information on the Best Shot Selector mode in Chapter 3.*

✦ **Fireworks show.** This mode uses long shutter speeds to capture images of bursts of fireworks blooming in midair. The AF is set to infinity and the flash and AF-assist illuminator are turned off. This Scene mode can also be used to capture light trails from lit moving subjects. The use of a tripod is almost always necessary when using this Scene mode.

✦ **Copy.** This mode is for taking pictures of documents or pages from books. The camera is set to Black and White mode. The camera AF area mode is set to Auto, although you may need to switch it to Close up mode for more detailed work. The flash is turned off.

Scene assist modes

Along with the Scene modes, some cameras offer Scene assist modes. These modes help with composition by adding guidelines on the LCD during the image preview. If your camera has Scene assist modes available, they appear in a submenu when you select the Scene mode. The Scene modes with the Scene assist options are Portrait/Night portrait, Landscape, Sports, and Night portrait. The Portrait/Night portrait assist settings are as follows:

✦ **Portrait/Night portrait assist.** The camera settings in Portrait assist are the same as the Standard/Night portrait mode with the exception of the focus points.

• **Portrait left.** Place your subject within the guides on the left side of the frame. This places your subject off-center and you can use it for a more interesting composition.

• **Portrait right.** Place your subject within the guides on the right side of the frame. You can also use this to add interest to your composition.

• **Portrait close-up.** Place your subject within the guides on the top half of the frame in the center.

• **Portrait couple.** Place a couple side by side within the guides.

• **Portrait figure.** When using this assist setting, turn your camera to the side and compose the subject within the guides. You use this setting to get more than a head-and-shoulders portrait.

The Landscape Scene assist menu settings are as follows:

✦ **Landscape.** The landscape assist mode has settings that are useful for landscapes, city skylines, buildings, and portraits with a view of the background.

✦ **Scenic view.** Use the wavy guideline to help you compose landscape photos with far-off skylines.

✦ **Architecture.** This setting is helpful when you're photographing buildings. A grid outline is displayed in the LCD panel to help you with the composition and to assist you with keeping horizontal and vertical lines straight in the frame.

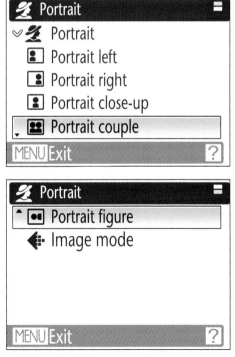

2.14 The Portrait Scene assist menu

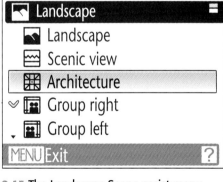

2.15 The Landscape Scene assist menu

✦ **Group right.** Use this setting to help you take group portraits in which the people are on the right and there is space on the left for the background to show.

✦ **Group left.** This setting is similar to Group right, but has the group framing guidelines on the opposite side.

The Sports Scene assist menu settings are as follows:

✦ **Sports assist.** The Sports assist mode does not display framing guides.

✦ **Sport spectator.** This setting is for shooting sports from a distance. The AF focuses farther out to reduce the chance of accidentally focusing on a close object.

✦ **Sport composite.** When this Scene assist mode is in use, the camera turns on the Multi-16 shooting mode.

Cross-Reference *For more information on the Multi-16 shooting mode, see Chapter 3.*

2.16 The Sports Scene assist menu

Movie mode

All the Nikon COOLPIX cameras are equipped with a Movie mode that allows you to shoot video with sound. Although the resolution of the movies that you take with your COOLPIX camera won't compare with video shot with digital camcorder, the COOLPIX cameras shoot video that has enough resolution to look good on any standard television.

COOLPIX cameras aren't designed for producing extravagant videos, but with a little time and effort, and a little playing around with some video editing software such as iMovie, you can piece together something worthwhile.

Before you start shooting movies, you need to decide at what resolution you want to shoot. The resolution you choose depends on your viewing needs; for viewing on a TV screen, you need to shoot the video at a resolution of 640 × 480 pixels; for Web viewing or e-mail, 320 × 240 pixels is sufficient. An even smaller resolution of 160 × 120 pixels is also available, though this is a low resolution and the picture quality is not very good.

One other thing to consider is the *frame rate* at which the video is recorded. The frame rate is the amount of images the camera records per second (video is nothing but a series of still shots shown consecutively). At the highest setting, the camera record 30 frames per second (fps). The reason frame rate is important is because when a camera records at a less than 24 fps, the video can look jerky. Some of the older COOLPIX cameras record at 15 fps, which is considered the minimum acceptable rate for a decent quality video.

Movie options

There are several different options to choose from in the movie mode, and they differ from camera to camera. For specific options, see the owner's manual for your camera.

The main options pertain to resolution size, but certain cameras, such as the P5000 and the S50, include options that allow you to do time-lapse photography and stop-motion recordings.

Time-lapse photography is a process in which separate still photos are taken at a set interval. These separate still photos are then combined into a movie that shows the event happening in a sped-up time frame. In the time-lapse setting, you set the interval and the camera automatically takes the picture at the specified time.

The stop-motion option is similar to the time-lapse option, although in stop-motion the photos aren't taken at a specific interval. Stop-motion photography is used in animation to make still objects appear to move, similar to cartoons. In the stop-motion setting, the picture is taken when you press the Shutter Release button. After you take the photo, you then move the object slightly, and then take another photograph. You repeat this process. To assist you, the camera displays the last frame taken on the LCD overlaid with the live preview.

> **Note** *Time-lapse and stop-motion movies are limited to 1800 frames or 60 seconds of play-back time.*

> **Note** *The Movie modes available differ from camera to camera. Check your owner's manual for available options on your particular camera model.*

The Movie mode menu settings are as follows:

✦ **TV movie 640*.** You can record movies at a resolution of 640 × 480 pixels at 30 fps.

✦ **TV movie 640.** You can record movies at a resolution of 640 × 480 pixels at 15 fps.

✦ **Pictmotion 640.** You can records movies at a resolution of 640 × 480 pixels at 10 fps. This mode is for use when creating Pictmotion movies in your camera.

✦ **Pictmotion 320.** You can record movies at a resolution of 320 × 240 pixels at 15 fps.

> **Cross-Reference** *For more information on Pictmotion movies, see the Pictmotion section in this chapter.*

✦ **Small size 320*.** You can record movies at a resolution of 320 × 240 pixels at 30 fps.

✦ **Small size 320.** You can record movies at a resolution of 320 × 240 pixels at 15 fps.

✦ **Smaller size 160.** You can record movies at a resolution of 160 × 120 pixels at 15 fps.

✦ **Time-lapse movie.** You can record movies at a resolution of 640 × 480 pixels. The movie plays at 30 fps.

✦ **Stop-motion movie.** You can record movies at a resolution of 640 × 480 pixels. The playback rate can be selected to play at 5, 10, or 15 fps.

> **Note** *The P5000 also allows you to record movies in Sepia or Black and White at a resolution of 320 × 240 pixels at 15 fps.*

2.17 The P5000 Movie mode menu

Auto focus in the Movie mode

When using the Movie mode to film, the camera has two AF modes: Single AF and Full-time AF.

In the Single AF mode, the camera focuses when the shutter is half-pressed, and then locks the focus in this position while filming.

Use this setting when the subject you are filming is going to be the same distance from the camera the entire time.

When in the Full-time AF mode, the camera continuously focuses while you are filming. This mode is handy when filming moving subjects such as pets or children. The downside to this mode is that sometimes, especially when you're filming quiet scenes, the microphone can pick up the camera's AF. If the noise presents a problem, switch to the Single AF mode.

L Series

To access the Movie menu in an L Series camera, follow these steps:

1. **Turn the camera on.**

2. **Slide the Mode selector switch to the Movie position.**

3. **Press the Menu button.** This brings you to the Movie mode menu.

4. **Use the multi-selector to highlight Movie options or Autofocus mode.** Press the multi-selector right or press the OK button.

5. **Use the multi-selector to choose the Movie mode or AF mode you want to use and press the OK button.**

S Series

To access the Movie menu in an S Series camera, follow these steps:

1. **Turn the camera on.**

2. **Press the Mode button.**

3. **Use the multi-selector button to select Movie mode and press the OK button.**

4. **Press the Menu button.**

5. **Use the multi-selector to high-light Movie options or Auto-focus mode.** Press the multi-selector right or press the OK button.

6. **Use the multi-selector to choose the Movie mode or AF mode you want to use and press the OK button.**

P Series

To access the Movie menu in a P Series camera, follow these steps:

1. **Turn the camera on.**

2. **Turn the Mode dial to movie.**

3. **Press the Menu button.**

4. **Use the multi-selector to high-light Movie options or Auto-focus mode.** Press the multi-selector right or press the OK button.

5. **Use the multi-selector to choose the Movie mode or AF mode you want to use and press the OK button.**

Pictmotion Movies

The COOLPIX S Series cameras starting with the S5 up to the S50c have a feature called *Pictmotion*. This is a program that is built-in to the camera. The program creates a slide show of selected pictures, combining the pictures with fades and music to create a 60-second presentation. You can also choose to film a video clip that you can set to music with the Pictmotion feature.

2.18 The Pictmotion option

To use Pictmotion, follow these steps:

1. **Turn on the camera.**

2. **Enter Playback mode by press-ing the Play button.**

3. **Press the Mode button to view the menu.**

4. **Use the multi-selector to choose the Pictmotion option and press the OK button.**

5. **When the Pictmotion screen is displayed on the LCD panel, press the menu button.** This brings you to the Pictmotion options menu.

6. **Use the multi-selector to select the menu options you want to change.** You can change the back-ground music, effects, playback order, playback duration, and auto select images.

7. **Once you've changed the setting to your personal preferences, press the OK button.**

8. **Press the OK button again to enter the Picture selection menu.**

9. **Use the multi-selector to choose the selection options.** Choose to view all items or choose to view images from a specific date.

10. **Press the OK button.** The LCD panel displays thumbnails of the images.

11. **Press the multi-selector left and right to scroll through the images.** Press the multi-selector up to select the pictures you want to include in the Pictmotion movie; press the multi-selector down to deselect an image.

12. **Once you've selected all of the images, press the OK button.** The camera then creates and displays the movie on the LCD.

13. **After the movie plays, choose Yes or No to save the movie.** You also have the option to return to the menu to make changes if you should desire to do so.

Getting the Most Out of Your Nikon COOLPIX Camera

As with any type of equipment, you need to know what the features do in order to take full advantage of them. While some COOLPIX cameras have more features than others, all of them have many different options for you to choose from.

In this chapter, I explain the different modes, features, and settings so you understand how they work and what they do, and are familiar with some instances where you might want to use them.

Image Capture Modes

Every Nikon COOLPIX camera offers a variety of different setting you can use to capture your images, whether you're taking one picture at a time, shooting a continuous series of images, or even recording short video sequences. The image capture mode settings are located in the Shooting menu.

Single

In the Single Shot mode, one shot is taken when the Shutter Release button is fully pressed. Even if you hold the Shutter Release button down after the shot is taken, the camera does not fire again.

This setting is suitable for casual snapshots, portraits, still lifes, and photos of other subjects that aren't moving around too quickly.

Continuous

In the Continuous Shooting mode, the camera continues to shoot pictures as long as you hold the Shutter Release button down. How fast the camera shutter fires depends on the camera you are using. Some cameras can shoot 1.6 frames per second and some only .5 frames per second. Check your owner's manual for more details on the framing rate of your specific camera.

This setting is useful when you're shooting sports or other fast moving subjects. It can also come in handy to capture the fleeting expressions of children and pets. You can also use this mode to do *sequence shots*. Sequence shots consist of three or more images showing the progression of an action, such as a skateboarder doing a trick.

Multi-shot 16

Multi-shot 16 mode, referred to in menus as Multi-16, is similar to the Continuous Shooting mode, although it is a little faster. The camera fires off 16 shots in approximately two seconds. The drawback to this mode is that the camera places the 16 shots into one full-sized image.

This mode is strictly for taking sequence shots.

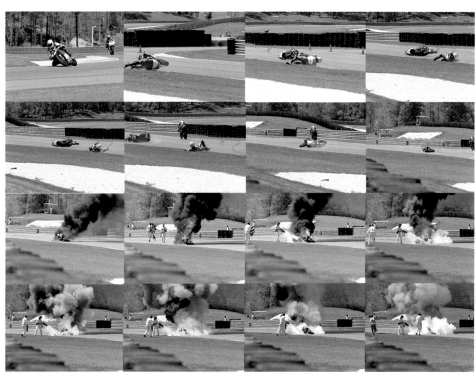

3.1 An image shot in the Multi-shot 16 mode

Color options

When you shoot in the Auto mode, most COOLPIX cameras allow you select different color options. These options enhance the image or add special effects that simulate traditional darkroom photography.

When you use these color options, you can see the effects directly in the LCD panel.

Standard

The Standard color option records the image just as the camera sees it, adding no effect at all. This is an acceptable mode to use if you are going to do adjustments to your images using some type of photo editing software.

Vivid

The Vivid color option boosts the saturation of the colors to make them brighter and more eye-catching. This is a good mode to use when you're shooting landscapes or other things with bright colors. I recommend staying away from this setting when you're shooting portraits, as it tends to produce inaccurate skin tones.

You may want to use this option when printing directly from the camera.

Sepia

The Sepia color option, which gives an image a reddish-brown look, duplicates a photographic toning process done in traditional darkrooms using silver-based black and white prints. Antique photographs were typically treated with this type of toning.

3.2 An image shot in the Sepia color option

Note | *In traditional photography, toning a photographic image requires replacing the silver in the emulsion of the photo paper with a different silver compound, thus changing the color, or tone, of the photograph.*

So, when you use this color option, it gives your image an antiqued look. The images have a reddish-brown look to them.

You may want to use this for an image when trying to convey a feeling of antiquity or nostalgia. This mode works well with portraits, as well as still lifes and photographs of architecture.

Black and White

The Black and White option simulates the traditional black and white film prints done in a darkroom. The camera records the image in black, white, and shades of gray.

This option is suitable for use when the color of the subject is not important. You can use it for artistic purposes or, as with the sepia mode, to give your image on antique or vintage look.

3.3 An image shot in the Black and White color option

Cyanotype (Cool)

The cyanotype is another old photographic printing process; in fact it's one of the oldest. When they're exposed to the light, the chemicals that make up the cyanotype turn a deep blue color. This method was used to create the first blueprints and was later adapted to photography.

The images taken when in this setting are in shades of cyan – blue. Given cyan and blue are considered cool colors, this option is also referred to as Cool. You can use the Cyanotype option to make interesting, artistic images.

P, S, A, and M modes

The P Series cameras have some advanced shooting modes that allow you to exercise more creative control over how the final image looks. These are the same types of shooting modes found in the more expensive digital single lens reflex (dSLR) cameras.

✦ **Programmed Auto (P).** This mode operates, for all intents and purposes, like the fully Auto mode. The main difference is that if you are not satisfied with the camera's automatic setting, you can adjust it to suit your needs.

✦ **Aperture Priority Auto (A).** This is a semi-automatic mode. In this mode, you decide which aperture to use and the camera sets the shutter speed for the best exposure. The *aperture*, also known as an f-stop, is the opening in the lens that lets in a specific amount of light. Situations where you may want to set the aperture include when you're shooting a portrait and want a large aperture (small f-stop number) to blur out the

3.4 An image shot in the Cyanotype mode

background, and when you're shooting a landscape and want a small aperture (high f-stop number) to ensure the entire scene is in focus.

✦ **Shutter Priority Auto (S).** Currently only available on the P5000, this is another semi-automatic mode. In this mode, you choose the shutter speed and the camera controls the aperture for the proper exposure. You want to use S mode when shooting action scenes where you want to freeze the motion.

✦ **Manual (M).** This mode is currently only available on the P5000. In this mode, you set the aperture and the shutter speed. The LCD panel shows a graphic meter to let you know when you achieve the proper exposure.

Caution *When you're using M mode, improper settings will cause your images to be overexposed (too bright) or underexposed (too dark).*

Flash Modes

All COOLPIX cameras come equipped with a small flash built-in right on the front of the camera. There are many different times when you may want to use the flash, not just indoors and at night, and Nikon provides you with more options than just straight-ahead full-on flash. You can quickly access the Flash menu by pressing the multi-selector up.

Auto

When you're in the Auto mode, the flash fires when the camera senses that there

may not be enough light to get a proper exposure for your subject. Unfortunately, when you use this mode, the camera exposes just for the subject, and the flash can be very bright and the lighting harsh.

Use this mode when taking snapshots.

Auto with Red-Eye Reduction

When using the Auto with Red-Eye Reduction mode, the camera fires a pre-flash before the actual exposure to reduce *red-eye*, as well as applies in-camera red-eye fix to remove red-eye before the image is recorded to the memory card or internal memory. Red-eye is caused by light from the flash reflecting off of the retina (back of the eye) of the subject.

In this mode the camera fire a series of low-powered flashes before the shutter opens. These pre-flashes help to constrict the pupils of the subject therefore reducing the amount of light being reflected from the retina and reducing the red-eye effect.

3.5 A snapshot without Red-Eye Reduction

3.6 A snapshot with Red-Eye Reduction

You want to use this mode when taking snapshots of people in a dimly lit area.

Flash Cancel

When you set the camera to the Flash Cancel flash mode, the flash does not fire at all, even when the lighting is dim. Use this mode when you're taking portraits with *available light* or when you don't want the flash to fire. Available light is just what it sounds like: whatever light you have in the scene to light your subject. One way to do this is to use the light filtering in from a window to light your subject. The result is usually a very soft and dramatic portrait.

You may want to use this mode in conjunction with Vibration Reduction (VR) and/or a higher ISO setting when the lighting is dim.

3.7 A portrait taken with available light

Anytime Flash

The Anytime Flash mode is also known as *fill flash.* The flash fires to fill in shadows caused by bright lights or direct sunlight, or to better illuminate subjects who are *backlit* (lit from behind).

Use this mode when you want to use the flash not as your main source of lighting, but as a secondary light source to fill in the shadows. The result is an image with less contrast between the shadows and the highlights.

I recommend using this mode if you're shooting backlit photographs outdoors when the sun is very bright.

Slow Sync

The Slow Sync mode is similar to the flash's Auto mode except when you select it, Slow Sync allows the camera to fire at slower shutter speeds to capture the ambient light (existing light), which is much dimmer than the flash.

3.8 A portrait without fill flash

3.9 A portrait with fill flash

This mode helps to add depth to your night-time images by allowing the background to come through in your photographs. When you use straight Auto flash at night, the subject can appear to be lost in a black hole, given you can't see the background.

Using the Slow Sync mode allows the camera to use a slower shutter speed that gives the background light enough time to be sufficiently exposed.

3.10 An image taken in Slow Sync mode

Rear Curtain Sync

The Rear Curtain Sync mode, which is only available on the P5000, is similar to the Slow Sync mode as it allows the camera to use a slower shutter speed, but also causes the flash to fire at the end of the exposure rather than the beginning. When you photograph moving subjects, if the flash fires at the beginning of the exposure, the ambient light being recorded causes a blur in front of the subject that can look unnatural. Using Rear Curtain Sync causes the motion blur to lead up to or follow the subject.

Use this mode to create special lighting effects to show the motion of a subject.

3.11 An image shot with Rear Curtain Sync mode

Manual Settings

Manual settings are settings that you can change when you shoot in the Auto mode (L, S and P Series) or in one of the advanced Manual modes (P Series). Some of camera settings, such as white balance, metering, and AF, are overridden when you use the Scene modes. Other camera settings, such as the Image Mode and Date Imprint, are retained in all shooting modes.

Image Mode

You use the Image Mode setting to set the size and the quality of the JPG file data that the camera records when it takes a photo. The Image Mode menu is located in the Shooting menu.

This setting allows you to choose a lower resolution than your sensor is able to record. This means that although you may have a 7-megapixel sensor, you can choose an option to record the image as a 3- or 5-megapixel image, which results in an image with a smaller file size. You may want to do this if, for example, you need to conserve space on your memory card or if you know you aren't going to be printing the images to a very large size.

This mode also allows you to choose a setting for pictures that will only be viewed on a computer screen (the PC option) and another setting for images that will only be viewed on a TV screen (the TV option).

At the highest megapixel setting, you also have the choice of the normal or high setting. When you plan on making big enlargements of your pictures (larger than 8 × 10 inches), you may want to use the high setting. For most applications, the normal setting will suffice.

The P5000 has two separate settings that give you a little more control over the image resolution and file size. Instead of using Image Mode menu, you can use two separate menus: Image Quality and Image Size.

✦ **Image Quality menu.** This allows you to set the amount of JPG compression: Fine, Normal, or Basic. The compression amount determines how large or small the file size is, with fine being the largest file and basic being the smallest.

✦ **Image Size menu.** This allows you to adjust the resolution to 10, 5, 3, 2, or 1 megapixels. It also allows you to set it to PC or TV.

Additionally, the P5000 also has settings that allow you to approximate different ratios. The 3:2 setting approximates the proportions of a picture taken with 35mm film; the 16:9 ratio has the same proportions as a wide-screen TV.

White Balance

The reason that white balance is important is to ensure that your images have a natural look. You can change the white balance in the Shooting menu. There are seven different White Balance settings, as explained in Table 3.1.

Table 3.1
White Balance Settings

Icon	Setting Name	Best Uses
AUTO	Auto	This setting is best for most circumstances. The camera takes a reading of the ambient light and makes an automatic adjustment. This setting works very well for most subjects.
PRE	White balance preset	This setting allows you to choose a neutral object to measure for the white balance. It's best to choose an object that is either white or light grey. This setting is best used under difficult lighting situations such as when there are two different light sources lighting the scene (mixed lighting).
	Daylight	This setting is best outdoors in direct sunlight.
	Incandescent	This setting is best when the lighting comes from a standard light bulb.
	Fluorescent	This setting is best when the lighting comes from a standard fluorescent lamp.
	Cloudy	This setting is best with overcast skies.
	Flash	This setting is best when you're using the built-in Speedlight or with a hot-shoe Speedlight and the P5000.

Choosing the Right Resolution

Choosing which resolution to set your camera to all depends on how you intend to output your images. If you only intend to post your pictures to the Internet or to e-mail them to friends or family, you can shoot your images at a lower resolution.

If you plan on printing your images, then you want to record your images at a higher resolution. The larger you plan on printing your images, the higher you need to set the resolution. The table below shows the approximate maximum print size for the specified resolution.

Other than the resolution setting in megapixels, you have the compression setting. There is considerable controversy regarding whether compressing a JPG to a smaller size reduces the actual resolution. This controversy stems from the fact that when a JPG file is closed, it compresses to smaller size, discarding some of the image information to save space. When the compression setting is set to Basic or Normal, more information is discarded, supposedly, which results in less image detail. Some photographers say that using the Fine or high setting is the only way to go, while others profess that the Normal setting is perfectly good for print use.

I don't want to choose sides in this controversy. The advice I offer is this: Set up a shot and take one picture at each of the settings, make a print of each, and decide for yourself whether you can see an appreciable difference or not.

Resolution (Megapixels)	Pixel Count (Image Size)	Maximum Print Size (Inches)
1	1280 x 960	4 x 5
3	2048 x 1536	6 x 9
4	2272 x 1704	9.5 x 7
5	2592 x 1944	8.5 x 11
6	3008 x 2000	9 x 12
7	3072 x 2304	10 x 13
10	3648 x 2736	16 x 20

When you deal with different lighting sources, the light can have an effect on the coloring of the subject. For example, a standard light bulb casts a very yellow light; if you don't adjust the white balance to compensate, the subject can look overly yellow. When you shoot under fluorescent lighting, the subject often has a sickly greenish cast, so you need to adjust your white balance to compensate for that.

To adjust for the color cast of the light source, the camera introduces a color cast of the complete opposite *color temperature*. Light, whether it is sunlight, light from a light bulb, fluorescent light, or light from a flash, all has its own specific color, which is called color temperature. It is measured using the Kelvin scale.

For example, to combat the green color of a fluorescent lamp, the camera introduces a slight magenta cast to neutralize the green if set to the proper white balance setting.

The term *color temperature* may sound strange to you. "How can a color have a temperature," you might think. Well, once you know about the Kelvin scale, things make a little more sense. *Kelvin* is a temperature scale, normally used in the fields of physics and astronomy, where absolute zero denotes the absence of all heat energy. The concept is based on a mythical object called a *black body radiator.* Theoretically, as this black body radiator is heated, it starts to glow. When the black body radiator reaches a certain temperature, it glows a specific color. It is akin to heating a bar of iron with a torch. As the iron gets hotter, it turns red, then yellow, and then eventually white before it reaches its melting point — although the theoretical black body does not have a melting point.

Kelvin and color temperature is a tricky concept because in the Kelvin scale, colors are the opposite of what we generally consider "warm" and "cool." On the Kelvin scale, red is the lowest temperature, and color temperatures becomes warmer, increasing through orange, yellow, and white to blue, which is the highest temperature. Typically, humans think of reds, oranges, and yellows as warmer colors — think sun — and white and bluish colors as colder ones — think snow. Color temperature is the opposite. Luckily for you, the camera has this all figured out already, as demonstrated by the series of images in 3.12 through 3.17.

3.12 Tungsten, 2800K

3.13 Fluorescent, 3800K

3.14 Auto, 4300K

3.15 Flash, 5500K

3.16 Daylight, 5500K

3.17 Cloudy, 6500K

Tip *If you keep your digital camera set to the automatic setting, you can reduce the amount of images you take with incorrect color temperatures. The settings for most of your images, in many lighting situations, will be accurate. You may discover that your camera's ability to evaluate the correct white balance is more accurate than setting white balance settings manually.*

Metering

The metering system that Nikon COOLPIX cameras use is Nikon's proprietary system, Matrix metering. With Matrix metering, the camera takes an evaluative reading of the light falling on the entire scene and then runs the data through some sophisticated algorithms to determine the proper exposure for the scene. All COOLPIX cameras are set to Matrix metering by default. This metering works extremely well for almost all subjects. If you decide you want to try another metering mode and your camera offers others as an option, you can change the metering options in the Shooting menu.

Note *The S Series cameras do not have the option of changing the metering mode.*

The L and P Series cameras offer a second option: Center-weighted metering. When the camera's metering mode is set to Center-weighted, the meter takes a light reading of the whole scene, but bases the exposure settings mostly from the light falling on the center of the scene. This metering mode is useful when you're photographing a dark subject against a bright background, or a light subject against a dark background. It works especially well for portraits where you want to expose the background properly while also exposing correctly for the subject.

The P Series cameras offer an additional option: Spot metering. When in this metering mode, the camera bases the exposure off of a single small area. There are two different options within Spot metering. The camera can meter either from the center of the frame, or you can choose to set the spot meter to be linked with the AF area. This metering mode is useful when you're photographing a dark subject against a bright background, or a light subject against a dark background. And it works well when you're shooting a subject that is backlit; for example, a portrait of someone with a sunset or sunrise behind him or her.

 If the camera AF mode is set to Center while the spot-metering mode is in effect, the metering defaults to Matrix.

Exposure compensation

Sometimes when there is an excessively large bright or dark area in a scene, the camera meter can be fooled and, therefore, underexpose or overexpose the image. This is where exposure compensation comes in. You use exposure compensation to fine-tune the exposure to get it exactly the way you want it. You can quickly adjust exposure compensation by pressing the multi-selector button to the right.

Adding exposure compensation (+) gives you colors that are a little paler and show more detail in the shadow areas of the image. On the downside, upping exposure compensation can cause the highlights to *blow out*. Blown-out highlights are places in the images that are completely white where there should be detail. Blown-out highlights are distracting and undesirable.

Decreasing exposure compensation (-) gives the image richer, more saturated colors. The downsides are grayish whites and highlights, and *blocked-up* shadows. Blocked-up shadows are places in the image that are completely black and show no detail. This is usually undesirable, but is not necessarily a problem in all images, especially in dark or low-key images (dark subject on a dark background) where the shadow detail is not needed.

The exposure compensation is adjustable in 1/3 intervals, from -3 EV to +3 EV.

Best Shot Selector

You use the Best Shot Selector (BSS) mode when there might be camera shake, such as when the shutter speed is slow. When the BSS is on, the camera is automatically set to Continuous Shooting mode and takes up to ten shots while the Shutter Release button is pressed. The camera then compares the series of pictures and saves the sharpest image. The rest of the images are immediately deleted.

 When the camera is in the BSS mode, the flash automatically turns off, and focus exposure and white balance are determined by the first picture in the sequence. This mode is not recommended for moving subjects.

Date Imprint

When the Date Imprint option is turned on, the date and time the photo was taken is imprinted on the bottom-right corner of the image. The date imprint function can be turned on in the Set-up menu.

 The Date Imprint feature is not available when you use the Sports, Museum, and Panorama scene modes. This feature is also unavailable when in Anti-shake and Movie mode, and also when in Continuous, BSS, and Auto bracketing mode.

In-Camera Crop

You can use the In-Camera Crop feature to crop out unwanted portions of your images. The cropped portion is saved as a copy so you don't lose the original image. To use this feature, do the following:

1. **Switch the camera to Playback mode.**

2. **Use the Zoom button and multi-selector controls to display the portion of the image you want to keep.**

3. **Press the Shutter button to crop the image.**

4. **Use the multi-selector button to confirm the process by choosing Yes or No.** Your cropped image is now saved to the memory card, as well as your original image.

This feature is meant to be used when you're printing photos directly from the camera. I strongly recommend cropping your images on the computer, using photo-editing software whenever possible.

Advanced Features

There are several more advanced features that some of the COOLPIX cameras offer. While these advanced features may not be available on all cameras, if your camera has one or more of these features, read on to learn how and when to use the feature.

D-Lighting

D-Lighting is an in-camera fix for underexposed images or images with high contrast that have excessively dark areas in them. It is available in all current COOLPIX cameras. When you use this feature, the camera automatically adjusts the exposure to bring out more detail in the dark areas of the image, resulting in a well-balanced photo.

When D-Lighting is applied to an image, the camera automatically saves an adjusted copy while retaining a copy of the original.

Vibration Reduction

Nikon's Vibration Reduction/Image Stabilization (VR) System counteracts small movements from shaky hands, shooting from a moving vehicle, and many other situations that can cause the image to blur. Slow shutter speeds are also a major cause of blur, especially when you're shooting at a long focal length where the camera shake can become more pronounced.

Vibration Reduction works by shifting the lens elements to compensate for camera movements. The VR function can be turned on or off in the Setup menu, with the exception of the L5, which has a dedicated external button in which you can choose VR On, Off, or Active with the push of a button. Most COOLPIX cameras offer VR, with the exception of the L3, L4, L6, L10, and L11 models.

The L5 has two VR settings, Normal and Active.

Normal

With the VR set to Normal mode, the camera senses the small movements associated with camera shake and adjusts for it. It ignores larger sweeping movements, such as those associated with focusing and recomposing the shot or panning. Use this setting for normal to low-light shooting situations.

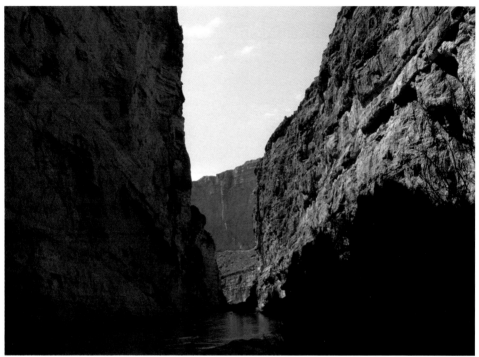

3.18 An image with normal exposure

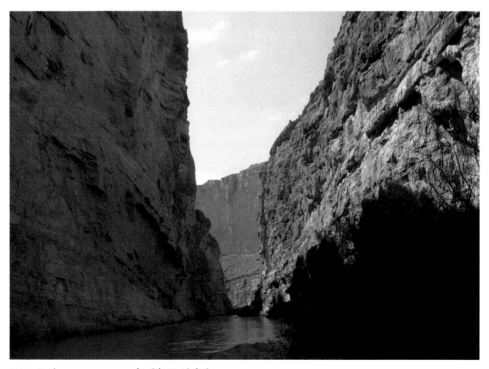

3.19 An image processed with D-Lighting

Active

When the VR is set to Active, even larger movements are compensated for. Use Active VR when you're shooting from a moving car or when you or the camera is in an extremely unstable position.

Anti-Shake

This feature is available on the S7c, S50, S50c, S200, S500, and P5000 models.

Pressing the Anti-Shake button activates the Anti-Shake mode. This button is found in different locations depending on which camera you are using. To locate this button, look for the icon that looks like a hand.

The Anti-Shake mode combines three different features — Vibration Reduction, Best Shot Selector, and High Sensitivity — to ensure that the image you capture is in sharp focus, and counteracts the blur than can be caused by camera shake.

It is important to note that when the camera is in Anti-Shake mode, the flash is disabled. The Anti-Shake mode is for capturing your images in natural light and works well for taking portraits in a dark environment, or when you're photographing subjects that are far distances from the camera.

High Sensitivity

The High Sensitivity mode is available on the newer S-Series cameras; S7c, S50, S50c, S200, S500, and P5000.

Pressing the Mode button when in Shooting mode activates the High Sensitivity mode. Use the multi-selector to choose Hi-ISO and then press the OK button. Repeat this process to cancel the High Sensitivity mode.

This mode is similar to the Anti-Shake mode. When the camera is set to High Sensitivity (Hi-ISO) mode, the camera automatically raises the ISO up to a maximum setting of ISO 1600 to ensure a faster shutter speed, which reduces the blur from camera shake.

The differences between the Hi-ISO mode and the Anti-Shake mode are that when the camera is in Hi-ISO mode, the flash is able to be fire and the Best Shot Selector is not activated.

One thing to watch for is that if there is not enough light on the subject, even at ISO 1600 the shutter speed may be too slow, and this results in a blurry image.

 Caution *When using the Anti-Shake and High Sensitivity modes, images may be affected by excessive noise.*

Auto-Bracketing

Bracketing is a photographic technique in which you vary the exposure of your subject over three or more frames. Doing this can ensure you get the proper exposure in difficult lighting situations where your camera's meter can be fooled. The Auto-Bracketing function is available only on the P5000.

The Auto-Bracketing setting enables the camera to take three shots in sequence: One shot is the correct exposure, one shot is underexposed, and one shot is overexposed. The underexposure and overexposure can be set to ±0.3, ±0.7, or ±1.0 EV.

The Auto-Bracketing feature is available in the Shooting menu.

 Note *Auto-Bracketing is not available when shooting in the Manual mode.*

3.20 A bracketed image, -1EV

3.22 A bracketed image, +1EV

3.21 A bracketed image, as shot

Wi-Fi

With the COOLPIX cameras that are Wi-Fi-enabled (S6, S7c, S50c, and P3), you are able to wirelessly transfer your images straight from your camera to your Wi-Fi-enabled computer or e-mail directly from the camera (S7c and S50c) in a Wi-Fi-enabled environment.

This feature also allows you to print wirelessly from your camera (S6, S7c and P3 only) if you use the Wireless Printer Adaptor PD-10. This optional accessory is available from Nikon.

To enter the wireless menu on the P4, sim-
ply rotate the mode dial until you are in the
wireless mode position.

For the S6, the Wireless menu is available by
following these steps:

1. **Turn the camera on.**

2. **Select Shooting mode.**

3. **Press the Mode button.**

4. **Use the multi-selector to high-
 light the wireless icon (this
 appears as an antenna).**

5. **Press the OK button.**

To enter the wireless menu on the S7c:

1. **Turn the camera on.**

2. **Press the Playback button.**

3. **Press the Mode button to enter
 the Playback menu.**

4. **Use the multi-selector to high-
 light the wireless icon (this
 appears as an antenna).**

5. **Press the OK button.**

To enter the wireless menu on the S50c:

1. **Turn the camera on.**

2. **Press the mode button.**

3. **Use the multi-selector to choose
 set up menu.**

4. **Press the OK button.**

5. **Use the multi-selector to scroll
 down to Wireless settings.**

6. **Press the OK button again.**

Creating Great Photos with Your Nikon COOLPIX Camera

Photography and Composition Basics

There are literally volumes written about photography and all its intricacies; however, at this point you are probably still grappling with the basics, so start there and work your way up. This chapter is designed to do just that — get you started with the basics so you have a solid foundation to make good choices in your photography as you discover the world through your lens.

Exposure

An exposure is made of four elements all related to light, and each depends on the others to create a good exposure. If the one element changes, then others must increase or decrease proportionally. The four elements are as follows:

+ **Available light.** All exposures start with light. Sometimes you can adjust the light and other times you have to work with light as it is.

+ **ISO sensitivity.** What you set your ISO to influences how sensitive your camera is to light.

+ **Aperture/f-stop.** How intensely the light reaches the sensor of your camera is controlled by the aperture, or f-stop. Each camera has an adjustable opening on the lens. As you change the aperture (the opening), you allow more or less light to reach the sensor.

+ **Shutter speed.** The shutter speed determines the length of time that light can reach the sensor.

4.1 The camera's meter exposed for the background allowing the colors of the sunset to shine through and causing the Joshua tree to become a silhouette.

ISO

ISO, which stands for International Organization for Standardization, is how your camera determines how sensitive it will be to light. The higher the ISO number, the less light that's needed to take a photograph. For example, you might choose an ISO of 100 on a bright, sunny day when you are photographing outside because you have plenty of light. However, on a cloudy, dark day you'd want to consider something at ISO 400 or higher to make sure your camera captures all the available light.

It is helpful to know that each ISO setting is twice as sensitive to light as the previous setting. So, at ISO 200, your camera is twice as sensitive to light as it was at ISO 100, needing only half the light at ISO 200 that was needed at ISO 100.

Tip *If you shoot with a very high ISO setting, you may get what is called noise. Use the Zoom button to zoom into the image and look for flecks of color in shadows or darker areas that don't match the other pixels. If you want to avoid noise, try to lower the ISO you are using.*

Aperture

The size of the opening in the lens determines the amount of light that strikes the image sensor. Aperture is expressed as f-stop numbers, such as f/2.8, f/5.6, and f/8. Here are a few important things to know about aperture:

✦ **Smaller f-numbers equal wider apertures.** A small f-stop of f/2.8, for example, opens the lens to let in more light. If you have a wide opening (aperture), the time the shutter speed needs to stay open to let light into the camera decreases.

✦ **Larger f-numbers equal narrower apertures.** A large f-stop of f/11, for example, closes the lens opening so that less light reaches the sensor. With a narrower opening (aperture), the time the shutter needs to stay open to let light into the camera increases.

Deciding what aperture to use depends on what kind of photo you are going to take. If you are using a high ISO, and you don't want blur from hand-holding the camera, choose a wide aperture (smaller f-number). That means you have a faster shutter speed.

Tip *Don't forget to consider depth of field when deciding on an aperture for your photo. Depth of field is discussed later in the chapter.*

Shutter Speed

How long the light entering from the lens is allowed to exposure the image sensor is

4.2 This image illustrates noise, which occurs when you take an image at a high ISO setting.

shutter speed. Obviously, if the shutter is open longer, there is more light reaching the sensor. The shutter speed affects whether or not you get a crisp image when there is lower light, or you are handholding the camera and your ability to capture motion.

Shutter speeds are indicated in fractions of a second. Common shutter speeds (from slow to fast) are 1 second, 1/2, 1/4, 1/8, 1/15, 1/30, 1/60, 1/125, 1/500, 1/1000, and so on. Increasing or decreasing shutter speed by one setting doubles or halves the exposure, respectively. It may seem like math (okay, technically it does involve math), but it is pretty easy, really. For example, if you took a picture with a 1/2 second shutter speed and it was too dark, logically you'd want to keep the shutter open longer, so you want the shutter speed to be 1 second.

Tip *Avoid hand-holding your COOLPIX camera if you are shooting in low light conditions and have to use a slow shutter speed, such as in Night portrait mode. Find a solid surface to set the camera on or use a tripod.*

Depth of Field

Depth of field is the distance range in a photograph in which all included portions of an image are at least acceptably sharp. It is heavily affected by aperture, but how far you and your camera are from the subject can also have an affect.

You can use depth of field practically or creatively; it is up to you.

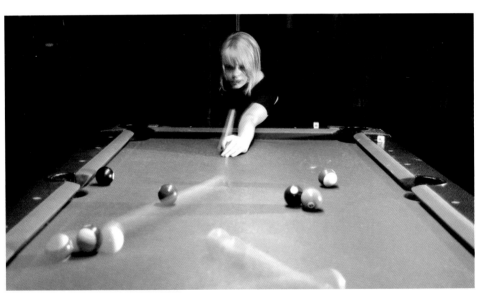

4.3 Here I used a slow shutter speed was used to show the motion of the billiard balls.

✦ **Shallow depth of field.** Shallow depth of field in a photo results in an image where the subject is in sharp focus, but the background has a soft blur. You likely have seen it used in portraits time and time again. Using a wide aperture such as f/2.8 results in a subject that is sharp and a non-distracting background. It is a great way to get rid of ugly elements in the background of an image.

✦ **Deep depth of field.** A photo that is reasonably sharp from the foreground through the background has deep depth of field. Use of a narrow aperture such as f/11 is ideal to keep photographs of landscapes or groups in focus throughout.

Tip
To understand how depth of field works, remember that to enlarge your depth of field you want a large f-number; to shrink your depth of field you want a small f-number.

The farther you are from a subject, such as a mountain, the greater the depth of field will be in your photograph. If you stood in the same place to take a photo of a tree a block away and your dog, the photo of the tree should be relatively sharp in the background and foreground whereas your dog should be in focus, but that tree a block away will be just a blur of color.

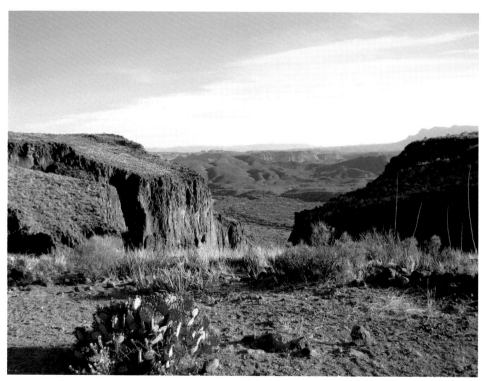

4.4 A small aperture was used to ensure that everything in the scene was in focus, from the cactus up front to the distant mountains of Mexico in the background.

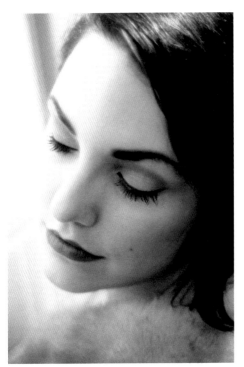

4.5 A wide aperture was used to blur some distracting shapes in the background of this portrait.

Composition Rules

Photography, as with any other art, has general rules of composition. Although they're called rules, they're really nothing more than guidelines. Some photographers—notably Ansel Adams, who was quoted as saying "The so-called rules of photographic composition are, in my opinion, invalid, irrelevant, and immaterial"—claim to have eschewed the rules of composition. Ironically, when you look at many of Adam's photographs, they follow those rules perfectly.

Another famous photographer, Edward Weston, said that "Consulting the rules of composition before taking a photograph is like consulting the laws of gravity before going for a walk." Again, as with Adams, when you look at Weston's photographs, they often follow these very same rules.

This isn't to say you need to follow every one of the rules of composition each time you take a photograph. As I said, these are really just general guidelines that, when followed, can make your images more powerful and interesting.

When you first start out in photography, you should pay attention to guidelines such as simplicity, the Rule of Thirds, and leading lines. As your expertise grows, you become so accustomed to following them that they become second nature. You no longer need to "consult" the rules of composition; you just inherently follow them.

Keep it simple

Simplicity. This is arguably the most important rule when creating a good image. You want the subject of your photograph to be immediately recognizable. When you have too many competing elements in your image, it can be hard for the viewer to decide what to focus on.

Changing your perspective to the subject can sometimes be all you need to do to remove a distracting element from your image. Walk around and try to shoot from different angles.

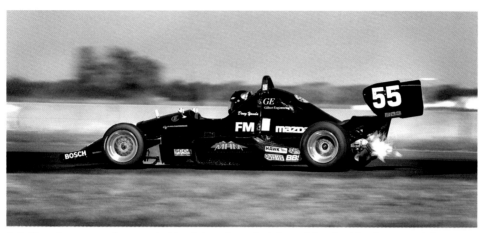

4.6 There's no guessing needed to determine what the subject in this photograph is.

4.7 Shooting this little bird from down low removed the distracting elements of the racetrack behind him.

The Rule of Thirds

Most of the time you are probably tempted to take the main subject of your photograph and stick it smack-dab in the middle of the frame. This makes sense and most of the time it works pretty well for snapshots. To create more interesting and dynamic images, however, it often works better to put the main subject of the image a little off-center.

The Rule of Thirds is a compositional guide-line that has been in use for many hundreds of years; most famous artists down through the centuries have been using this rule.

With the Rule of Thirds, you divide the image into nine equal parts using two equally spaced horizontal and vertical lines, kind of like a tic-tac-toe pattern. You want to place the main subject of the image where one of these lines intersects, as illustrated in figure 4.8. The subject doesn't necessarily

4.8 The main subject of this photograph, Henrietta, appears in one of the intersecting lines according to the Rule of Thirds.

have to be right on the intersection of the line; merely being close to it is enough to take advantage of the Rule of Thirds.

Another way to use the Rule of Thirds is to place the subject in the center of the frame, but at the bottom or top third of the frame, as illustrated in figure 4.9. This part of the rule is especially useful when photographing landscapes. You can place the horizon at or near the top or bottom line, but you almost never want to place it in the middle. Notice in figure 4.10, the mountain range covers the entire bottom third of the frame.

When you use the Rule of Thirds, keep in mind the movement of the subject. If the subject is moving, you want to be sure to keep most of the frame in front of the subject so it doesn't look like it's going to fly right off of the picture. You want to keep the illusion that the subject has someplace to go.

The Rule of Thirds is a very simple guideline, but it can work wonders in making your images more interesting and visually appealing. To make this easier, many cameras have guides in the viewfinder. Once you get used to this, you can start composing to the Rule of Thirds without even realizing it.

Leading lines and s-curves

Another good way to add drama to an image is to use a *leading line* to draw the viewer's eye through the picture. A leading line is an element in a composition that leads the eye toward the subject. It can be a lot of different things: a road, a sidewalk, railroad tracks, and building columns are just a few examples.

4.9 In this image, the subject is in the center of the frame, but is at the bottom third.

In general, you want your leading line to go in a specific direction. Most commonly a leading line leads the eye from one corner of the picture to another. A good rule of thumb to follow is to have your line go from the bottom left corner, leading towards the top right corner.

You can also use leading lines to go from the bottom of the image to the top and vice-versa. Depending on the subject matter, this can work equally as well. For the most part, leading lines heading in this direction lead to a *vanishing point*. A vanishing point is the point at which parallel lines converge and seem to disappear. Figure 4.13 shows a leading line ending in a vanishing point.

4.10 This image shows the Rule of Thirds in a landscape, with the subject covering the entire bottom third of the frame.

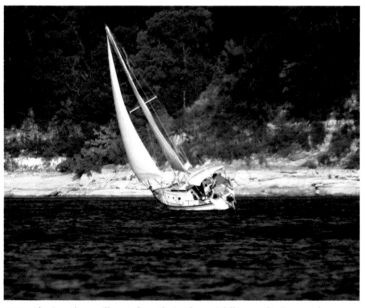

4.11 Placing the sailboat directly in the middle results in an okay snapshot.

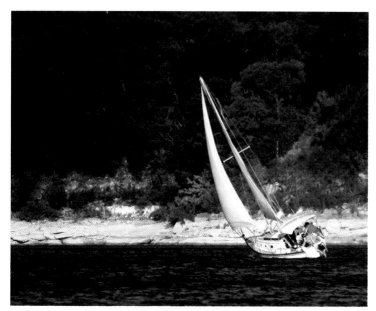

4.12 Recomposing the shot so the sailboat appears in the lower right third of the frame results in a much more dramatic image.

4.13 In this image, the leading line ends in a vanishing point.

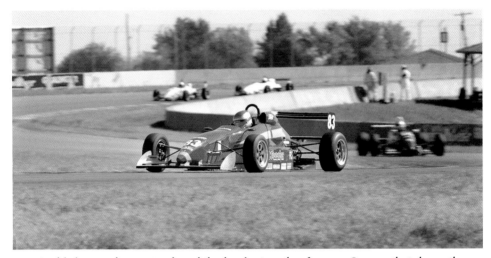

4.14 In this image, the racetrack and the barrier together form an S-curve that draws the eye through the whole image.

Another nice way to create a leading line is to use an *S-curve*. An S-curve is exactly what it sounds like; it resembles the letter S. An S-curve can go from left to right or vice versa. The S-curve will draw the viewer's eye up from the bottom of the image through the middle, on to the corner, and back to the other side again.

Helpful Composition Hints

Along with these rules of composition — simplicity, the Rule of Thirds, and leading lines — you can refer to all sorts of other helpful guidelines. Here are just a few:

✦ **Frame the subject.** Use elements of the foreground to make a frame around the subject to keep the viewer's eye from wandering.

✦ **Avoid having the subject look directly out of the frame.** Having the subject look out of the photograph can be distracting to the viewer.

✦ **Avoid mergers.** A *merger* is when an element from the background appears to be a part of the subject. Like the snapshot of Granny at the park that looks like she has a tree growing out of the top of her head.

✦ **Try not to cut through the joint of a limb.** When composing or cropping your picture, it's best not to end the frame on a joint. This will make your subject look like an amputee.

✦ **Avoid having bright spots or unnecessary details near the edge.** Having anything bright or detailed near the edge of the frame will draw the viewer's eye away from the subject and out of the image.

✦ **Avoid placing the horizon or strong horizontal or vertical lines in the center of the composition.** This cuts the image in half and makes it hard for the viewer to decide which half of the image is important.

✦ **Separate the subject from the background.** Make sure the background doesn't have colors or textures that are similar to the subject's. If necessary, try shooting from different angles or use a shallow depth of field to achieve separation.

✦ **Fill the frame.** Try to make the subject the most dominant part of the image. Avoid having lots of empty space around the subject.

✦ **Use odd numbers.** When photographing multiple subjects, odd numbers seem to work best.

These are just a few of the probably hundreds of guidelines out there. And remember, these are not hard and fast rules, just simple pointers that can help you on your way to creating interesting and amazing images.

Accessories and Additional Equipment

CHAPTER **5**

There are many accessories that can be purchased for your COOLPIX camera. These range from gadgets that help to hold your camera steady to sturdy cases to protect your camera in inclement weather. This chapter introduces you to many of them.

Tripods

One of the most important accessories you can have for your camera, whether you're a professional or just a hobbyist, is a tripod. The tripod allows you to get sharper images by eliminating the shake caused by handholding the camera in low-light situations. A tripod can also allow you to use a lower ISO, thereby reducing the camera noise and resulting in an image with better resolution.

There are literally hundreds of different types of tripods available, ranging in size from less than 6 inches to one that extends all the way up to 6 feet or more. In general, the heavier the

tripod is, the better it is at keeping the camera steady, but for the smaller-sized cameras in the COOLPIX line, a super heavy-duty tripod is probably not necessary.

There are many different features available on tripods, but the standard features include the following:

✦ **Height.** This is an important feature. You want the tripod to be the right height for the specific application you will be using it for. If you are out shooting landscapes most of the time and you are 6 feet tall, but your tripod is only 4 feet tall, you will have to hunch over to look into the viewfinder to compose your image. This may not be the optimal size tripod for you.

✦ **Head.** Tripods have several different types of heads. The most common type of head is the *pan/tilt head*. This type of head allows you to rotate, or *pan*, with a moving subject and also allows you to tilt the camera for angled or vertical shots. The other common type of head on a tripod is the *ball head*. The ball head is the most versatile. It can tilt and rotate quickly in any position.

✦ **Plate.** The plate attaches the camera to the tripod. Most cameras have a threaded socket on the bottom. Tripods have a type of bolt that screws into these sockets, and this bolt is on the plate. Most decent tripods have what is called a *quick-release plate.* You can remove a quick-release plate from the tripod and attach it to the camera, and then reattach it to the tripod with a locking mechanism.

If you're going to be taking the camera on and off of the tripod frequently, this is the most time-efficient type of plate to use. The other type of plate, which is on most budget-type tripods, is the standard type of plate. This plate is attached directly to the head of the tripod. It still has the screw bolt that attaches the camera to the plate, but it is much more time-consuming to use when you plan to take the camera on and off a lot as you must screw the camera to the plate every time you want to remove it from the tripod.

When to use a tripod

There are many situations when it would be ideal to use a tripod, and the most obvious is when it's dark. However, using a tripod even when there is ample light can help keep your image sharp. These are just a few ideas of when you may want to use one:

✦ **When the light is low.** Your camera needs a longer shutter speed to get the proper exposure. The problem is, when the shutter speed gets longer, you need steadier hands to get sharp exposures. Attaching your camera to a tripod eliminates any camera shake.

✦ **When the camera is zoomed in.** When you are using a long focal-length (zoomed in), the shaking of your hands is more exaggerated and can cause your images to be blurry, even in moderate light.

✦ **When shooting landscapes.** Landscape shots, especially when you're using the Landscape scene mode, require a smaller aperture

to get maximum depth of field to ensure that the whole scene is in focus. When the camera is using a smaller aperture, the shutter speed can be long enough to suffer from camera shake, even when the day is bright.

✦ **When shooting close-up.** When the camera is very close to a subject, camera shake can also be magnified. When you're shooting close-ups or macro shots, it may also be preferable to use a smaller aperture to increase depth of field, thus lengthening the shutter speed.

Which tripod is right for you?

Considering there are so many different types of tripods, choosing one can be a daunting experience. There are many different features and functions available in a tripod; here are some things to think about when you're looking into purchasing one:

✦ **Price.** Tripods can range in price from as little as $5 to as much as $500 or more. Obviously the more a tripod costs, the more features and stability it's going to have. Look closely at your needs when deciding what price level to focus on.

✦ **Features.** There are dozens of different features available in any given tripod. Some tripods have a quick-release plate, some have a ball head, some are small, and some are large. Again, you need to decide what your specific needs are.

✦ **Weight.** This can be a very important factor when deciding which tripod to purchase. If you are going to use the tripod mostly in your home, then a heavy tripod may not be a problem. On the other hand, if you plan on hiking, a 7-pound tripod can be an encumbrance after awhile. Some manufacturers make tripods that are made out of carbon fiber. While these tripods are very stable, they are also extremely lightweight. On the down side, carbon fiber tripods are also very expensive.

Tripod alternatives

Sometimes you just don't have room to pack a tripod, or you don't want to carry the weight. Some alternatives exist. The most common is a photographer's beanbag. You can sit the beanbag on almost any stable surface and set your camera on top of that. It may not be the most versatile for composing your images, but it will definitely get the job done and is lightweight and very portable. You can purchase them through most camera stores and online.

Another thing to consider is clamps. You can attach any type of clamp that has a ¼-inch stud to screw your camera's tripod socket to a stable object, and you're in business. You can find these clamps at many hardware stores.

Some companies also make special miniature tripods that you can use as a regular, independent tripod, or you can attach it to other objects. One such device is the Gorillapod. You can attach this ingenious little device to nearly any stable object.

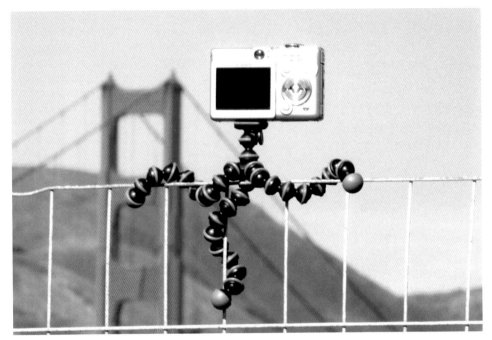

Photo courtesy of Joby.com
5.1 You can attach the Gorillapod to almost anything.

There are many places on the Web where you can find tripods; here are a few to get you started:

✦ http://precision-camera.com

✦ www.minitripods.com

✦ http://bhphotovideo.com

Camera Bags and Cases

Another important thing to consider is buying a bag or carrying case for your camera. These can provide protection not only from the elements but also from impact. Camera bags and cases exist for any kind of use you can imagine, from simple cases to prevent scratches to elaborate camera bags that can hold everything you may need for a week's vacation. Some of the bags and cases available are listed here:

✦ **Pelican cases.** These are some of the best cases you can get. The Pelican Micro Case series, shown in figure 5.2, are watertight, crush-proof, and dustproof. They are unconditionally guaranteed forever. Starting out at less than $20, these cases are amazing. If you are hard on your cameras or do a lot of outdoor activities, you can't go wrong with these.

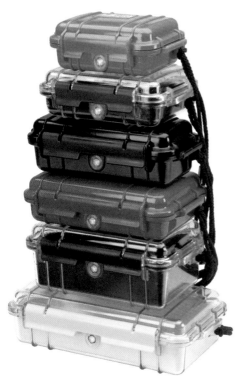

Photo courtesy of Pelican

5.2 Pelican Micro Cases come in several colors and are super sturdy.

+ **Shoulder bags.** These are the standard camera bags you can find at any camera shop. They come in a multitude of sizes, to fit almost any amount of equipment you can carry. Reputable makers include Tamrac, Domke, and Lowepro. Look them up on the Web to peruse the various styles and sizes.

+ **Backpacks.** You wear certain camera cases on your back just like a standard backpack. These also come in different sizes and styles, and some even offer laptop-carrying capabilities. The type of camera backpack I use when traveling is a Naneu Pro Alpha. It's designed to look like a military pack, so thieves don't know you're carrying camera equipment. When traveling, I usually pack it up with two dSLR camera bodies, two COOLPIX cameras, a wide-angle zoom, a long telephoto, three or four prime lenses, two Speedlights, a reflector disk, a 12-inch Apple PowerBook, and all of the plugs, batteries, and other accessories that go along with my gear. And, with all that equipment packed away, space is still left over for a lunch. Lowepro and Tamrac also make some very excellent backpacks.

Many companies also make small bags that you can loop your belt through for easy access if you don't like carrying your camera in your pocket. As you can see, there are an amazing amount of different types of cases and bags.

Some camera bag manufacturers' Web sites you can look at include these:

+ http://naneupro.com
+ http://tamrac.com
+ http://lowepro.com

Lens Adaptors

Sometimes the zoom lens that is built-in to your camera might not be quite wide enough for you, or you may want some more reach from the telephoto setting. This is where lens adaptors come in. These adaptors fit over the existing lens of your COOLPIX camera and give you the additional range you need.

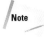 **Note** *As of this writing, the only COOLPIX camera that has lens adaptors available is the P5000.*

Telephoto

The Nikon TC-E3ED telephoto lens adaptor extends the range of the standard lens by three times. The P5000 has a focal length range of 36-126mm; adding the TC-E3ED extends the apparent focal length of the lens to an impressive 108-378mm.

You may want to use the telephoto when shooting subjects that are far away, such as sporting events or wildlife. Be sure to remember that as your focal length gets longer, the camera shake from handholding the camera becomes more pronounced.

You need a faster shutter speed to compensate for camera shake. To use a faster shutter speed, you may need to adjust the ISO higher as well as make sure the Vibration Reduction (VR) is turned on.

Wide-angle

The Nikon WC-E67 wide-angle lens adaptor widens the apparent focal length of the existing lens. When attached to the P5000, it changes the focal length range by 0.67 times, thus giving you an effective focal length of 24-84mm.

Using a wide-angle adaptor is preferable when shooting landscapes as well as architectural subjects and group portraits.

Photo courtesy of Nikon, Inc.
5.3 This P5000 has a TC-E3ED telephoto lens attached.

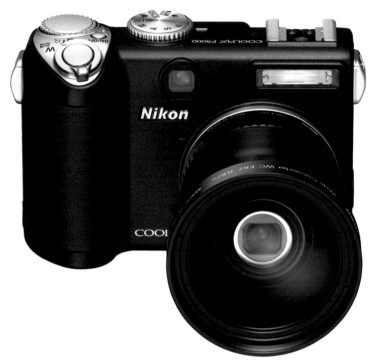

Photo courtesy of Nikon, Inc.
5.4 This P5000 has a WC-E67 wide-angle lens attached.

Underwater Housings

For those of you interested in underwater photography, there are many affordable options for the Nikon COOLPIX series of cameras.

The only Nikon-made underwater housing available at this time is the Nikon FJ-CP1 for the S5 camera. This housing is rated to 9 feet.

A company called Ikelite manufactures top-of-the-line underwater housings as shown in figure 5.5. The housings start out at around $300. You can use these housings at depths of up to 200 feet. All of the camera functions are accessible, and the manufac-turer also offers an optional external strobe for better flash coverage underwater. You can find out more about these housings at http://ikelite.com.

Next in line are the Fantasea housings. Starting out at $200, these housings are rated to 130 feet and also allow full func-tionality of all camera functions. You can find out more about these housings at http://fantasea.com.

These are just a few of the companies that manufacture underwater housings. You can find a wealth of knowledge on the subject with a quick search on the Web.

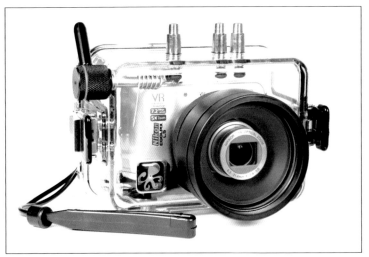

Photo courtesy of Ikelite

5.5 Ikelite offers underwater housings to keep your camera safe and dry, like the L5 shown here.

External Lighting Equipment

One of the things that you may find when you use a compact digital camera is that although you may have the on-camera flash to use when there is low light, it is not always the most flattering for your subjects. The direct flash can be too harsh and may not give your subjects the best look, especially when it comes to portraits. The way to overcome this is to use external lighting that you can place specifically to get the lighting the way you like it.

Although most professional photographers opt for studio strobes (large external flashes), most compact digital cameras have no way to sync with these; the exception is the P5000 with its hot-shoe flash capability. The most affordable option is to use what are called *hot lights* or *continuous lights.* Hot light is photographer slang for lights that use

tungsten, halogen, or quartz lamps. Hot lights are inexpensive and easy to come by.

The great advantage to using continuous lighting is the "what you see is what you get" effect. When you have your lights positioned on your subject, you can be sure that what you see in your viewfinder is exactly how the image will be recorded to your camera's sensor.

The most inexpensive option you can use is the clamp light. These are the typical lights you can find in any hardware store for less than $10. These lights use standard light bulbs, have a reflector to direct the light, and have a built-in clamp so you can clamp the light to a stand or whatever you have handy.

The next option is the halogen work lamp. These are also readily available at any hardware store. The advantage to using this type of light is that they generally have a higher

light output than standard lights. The downside is that they are very hot and the larger lights can be a bit unwieldy. You may also have to come up with some creative ways to get the lights in the position you want them in. Some halogen work lamps come complete with a tripod stand. If you can afford it, I'd recommend buying these; they're easier to set up and less of an aggravation in the long run. The single lamps that are usually designed to sit on a table or some other support are easily available for less than $20; the double lamp with two 500-watt lights and a 6-foot tripod stand are usually available for less than $40.

If you're really serious about doing portrait photography with your COOLPIX camera, you may want to invest in a photographic hot light kit. These kits are widely available from any photography or video store. They usually come with lights, light stands, and sometimes with light modifiers such as umbrellas or softboxes for diffusing the light for a softer look. The kits can be relatively cheap, with two lights, two stands, and two umbrellas for around $100, or much more elaborate setups for up to $2,000. I've searched all over the Internet for these kits and have found the best deals to be on eBay.

Cross-Reference For more information on portrait and studio lighting, see Chapter 6.

Techniques for Great Photos

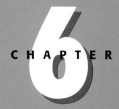
Now that you've got the hang of using your COOLPIX camera, it's time to put your skills to use in the real world. This chapter details many different kinds of photography and offers you insight on how to approach the subjects, as well as tips and suggestions from real experiences. Try the formulas and insight you gather here with your own COOLPIX photography for great results.

Abstract Photography

Abstract photography deals with a theoretical subject rather than an absolute subject. For the most part, when you photograph something, you're concerned with what the subject is. When photographing a portrait, you aim to represent the face; when shooting a landscape, you try to show what's in the environment, be it trees, mountains, or some other facet.

In abstract photography, the subject is less important than the actual composition. When attempting abstract photography, you want to try to reveal the essence of what you're photographing.

There are no hard and fast rules to photography, and this is most true in abstract photography. You may be attempting to show the texture or color of something, and what the actual object is isn't necessarily important. Your photograph should give the viewer a different perspective of the subject than a normal photograph would.

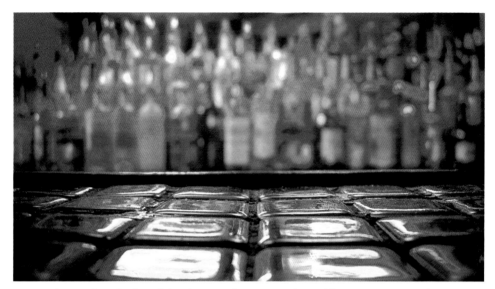

6.1 Bug's eye view, Casino el Camino, Austin, Texas. Taken with a P5000 zoomed to 7.5mm, ISO 64, 6 sec. at f/2.7, Aperture Priority mode, AF set to Close-up.

Inspiration

You can use almost anything to create an abstract photograph. It can be a close-up of the texture of tree bark or the skin of an orange. Look for objects with bright colors or interesting textures.

Many structures have interesting lines and shapes. Cars can have interesting lines. Keep an eye out for patterns. Patterns can appear anywhere, on the side of a building, or even in a pool of water next to a fence, as shown in figure 6.3.

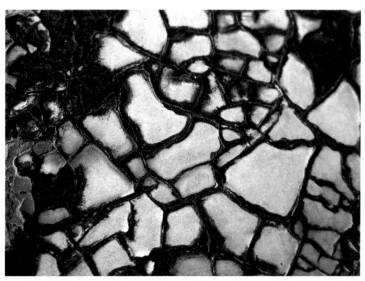

6.2. Study in rust and paint. Taken with an L5 zoomed to 6.3mm, ISO 79, 1/60 at f/2.9, Auto mode, AF, set to Close-up.

Abstract photography practice

6.3 Puddle of Blue. Taken with an L5 zoomed to 31.4mm, ISO 100, 1/250 sec. at f/5, Auto mode.

Table 6.1
Taking Abstract Pictures

Setup	**Practice Picture:** For figure 6.3, I was photographing a sports car race in the rain when there was a break in the action. I was looking around and noticed the reflection of the chain link fence in the puddle and thought it was interesting how the raindrops distorted the lines.
	On Your Own: Keep your eyes and mind open. Even the most mundane subject can have interesting textures and lines.
Lighting	**Practice Picture:** To ensure I wouldn't get a reflection in the puddle, I turned the flash off and relied on natural light only
	On Your Own: It doesn't always take complex lighting to make an interesting photograph; sometimes just changing the white balance can add the needed effect.
Zoom Settings	**Practice Picture:** I had the lens zoomed in as far as possible to capture the detail in the puddle.
	On Your Own: Depending on how close you can get to your subject, you may want to zoom in. If you're using the close-up setting, you need to use a wide-angle setting.

Continued

Table 6.1 *(continued)*

Camera Settings

Practice Picture: My camera was set to Auto mode and the White Balance was set to incandescent in order to give the image a blue tone.

On Your Own: Making an abstract photo can be a very different process for each image; try to experiment with different settings until you get a result that you like.

Abstract photography tips

✦ **Keep your eyes open.** Always be on the lookout for interesting patterns, repeating lines, or strange textures.

✦ **Don't be afraid to experiment.** Sometimes something as minor as changing the White Balance setting can change the whole image. Sometimes the "wrong" setting may be the right one for the image.

6.4 Barbed wire. Taken with an L5 zoomed to 6.4mm, ISO 100, 1/250 sec. at f/2.7, Close-up scene mode.

Action and Sports Photography

Action and Sports photography is usually just what it sounds like, although it doesn't necessarily mean your subject is engaging in some type of sport. It can be any activity that involves fast movement, such as your child riding his bike down the street or running across the beach. Shooting any type of action can be tricky, even for seasoned pros. You need to be sure to shoot at a fast enough shutter speed to freeze the movement of your subject.

You can employ a number of different techniques to further decrease motion blur on

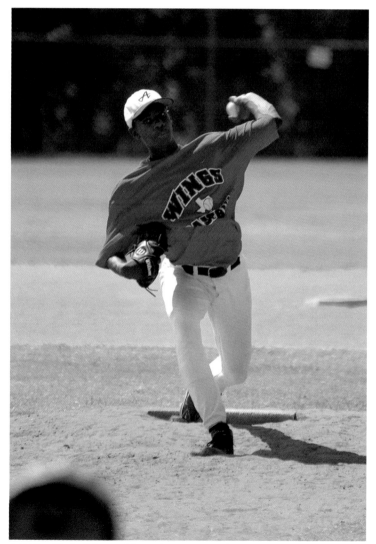

6.5 The Pitch. Taken with an S50c zoomed to 18.9mm, ISO 100, 1/250 sec. at f/4.2, Sports scene mode.

your subject. The most commonly used technique is *panning*. Panning is following the moving subject with your camera lens. With this method, it is as if the subject is not moving at all because your camera is moving with it at the same speed. When panning is done correctly, the subject should be in sharp focus while the motion blurs the background. This effect is great for showing the illusion of motion in a still photograph. While panning, you can sometimes use a slower shutter speed to exaggerate the effect of the background blur. Panning can be a very difficult technique to master and requires a lot of practice. It can be made a little easier if you use a *monopod*. A monopod is similar to a tripod, except it only has one leg. Monopods keep the camera steady while allowing more freedom of movement than a tripod.

Using flash for action and sports photography is not always necessary or advisable. Sometimes you are so far away from the action, your flash won't be effective, or you are in a situation where flash is not allowed. In these cases, just make sure you have a fast enough shutter speed to freeze the motion. You can either use a wider aperture or crank up your ISO setting to be sure you get the proper shutter speed.

Inspiration

When looking for action scenes to shoot, I tend to gravitate toward the more exciting and edgy events. On your own, just keep your eyes open; just about everywhere you look, you can see some kind of action taking place.

6.6 A BMW gets up on two wheels at the SCCA Solo Nationals, Topeka, Kansas. Taken with a P5000 zoomed to 26.3mm, ISO 100, 1/250 sec. at f/4.2, Shutter Priority mode.

Go to the local parks and schoolyards. Almost every weekend, a soccer tournament takes place at the school across the street from my studio. I often go there just to practice getting action shots. Check your local newspapers for sporting events. Often the local skateboard shops and bike shops have contests. I try to take pictures of people having fun doing what they love to do.

Action and sports photography practice

6.7 Slasher Steve: One-footed tire grab, 9th Street, Austin, Texas. Taken with a P5000 zoomed to 7.5mm, ISO 100, 1/125 sec. at f/4, Shutter Priority mode.

Table 6.2
Taking Action and Sports Pictures

Setup	**Practice Picture:** For figure 6.7, I was photographing some local BMX riders showing off their skills at the dirt jumps.
	On Your Own: When photographing a sporting event, if at all possible, try to keep the sun at your back so that your subject is lit from the front.
Zoom Settings	**Practice Picture:** I used a P5000 zoomed to 7.5mm. I was able to get fairly close to the action so I could use a wider focal length.
	On Your Own: Depending on how close you can get to your subject, you may want to zoom in to a telephoto setting.
Camera Settings	**Practice Picture:** I set my P5000 to Shutter Priority mode to ensure that I had a fast enough shutter speed to freeze the action in midair. Another reason I chose Shutter Priority mode is because when you're shooting sports, the aperture setting and depth of field are secondary to getting a fast shutter speed.
	On Your Own: When photographing action, setting your shutter speed is the key to capturing the image properly. Whether you want to stop motion by using a fast shutter speed or blur the background using a slower shutter speed and panning with your subject, you want to be able to control the shutter speed in Shutter Priority mode.
Exposure	**Practice Picture:** 1/125 at f/4, ISO 100.
	On Your Own: Try to use the fastest shutter speed you can to stop motion. If the light is dim, you may need to bump up your ISO to achieve a fast shutter speed.
Accessories	When you're zoomed out to a long focal length, a monopod or tripod can help steady the camera, resulting in sharper images.

Action and sports photography tips

✦ **Scope out the area to find where the action is.** Getting a great action shot is being at the right place at the right time. Before you break out your camera and start shooting, take some time to look around to see what's going on.

✦ **Stay out of the way.** Be sure you're not getting in anybody's way. It can be dangerous for you and the person doing the activity. Also, when shooting a sporting event, don't touch the ball! While shooting a baseball tournament, a foul ball rolled to my foot and I instinctively knocked it away. It cost the team a run. The coach was not happy with me. Luckily, they were up 14 to 1, so it wasn't a big deal, but I'll never touch another ball again!

✦ **Practice makes perfect.** Action photography is not easy. Be prepared to shoot a lot of images. After you get comfortable with the type of event you're shooting, you learn to anticipate where the action will be and you'll start getting better shots.

Architectural Photography

Buildings and structures surround us, and many architects pour their hearts and souls into designing buildings that are interesting to the casual observer. This is probably why architecture photography is so popular.

Despite the fact that buildings are such familiar, everyday sights, photographing them can be technically challenging and difficult — especially when you're taking pictures of large or extremely tall buildings. A number of different problems can come up, the main one being *perspective distortion*. Perspective distortion is when the closest part of the subject appears irregularly large and the farthest part of the subject appears abnormally small. Think about standing at the bottom of a skyscraper and looking straight up to the top.

Professional architectural photographers have special cameras and lenses that allow them to correct for the distortion. Unfortunately, you can't make these types of adjustments in a compact camera. You have to either fix the image using software or work with the perspective distortion to make a dynamic and interesting image.

6.8 The Blanton Museum of Art in Austin, Texas. Taken with an S50c zoomed to 6.3mm, ISO 100, 1/125 sec. at f/8, Auto exposure mode.

Copyright and Permission

In most places, you don't need to permission to photograph a building as long as it's a place to which the public has free access. If you are on private property, you should definitely request permission to photograph before you start. If you are inside a building, it is generally a good idea to ask permission before photographing, also.

Due to recent tightening of security policies, a lot of photographers have been approached by security and/or police, so it's a good idea to check the local laws in your city or the city to which you will be going to know what rights you have as a photographer.

For the most part, copyright laws allow photography of any building on "permanent public display." Although the architect of the structure may own the copyright of the design, it usually does not carry over to photographs of the building. There are exceptions to this, so again, you may want to check local laws, especially if you plan on selling your images.

Inspiration

Since buildings and architecture are all around us, there are limitless possibilities to shoot. Try looking for buildings with architectural features that you may enjoy, such as art deco, gothic, or modern.

6.9 Fayette County Courthouse, La Grange, Texas. Taken with an L5 zoomed to 6.3mm, ISO 79, 1/250 sec. at f/7.1, Auto exposure mode, flash off.

Architectural photography practice

6.10 Texas State Capitol, Austin, Texas. Taken with an L5 zoomed to 6.3mm, ISO 79, 1/950 sec. at f/4.9, Landscape assist Architecture mode.

Table 6.3
Taking Architectural Pictures

Setup	**Practice Picture:** For figure 6.10, I photographed the Texas State Capitol building.
	On Your Own: When photographing a building, make sure the sun is shining on the side of the building you are photographing, so your main subject isn't in shadow.
Zoom Settings	**Practice Picture:** I used a L5 zoomed to 6.3mm. I wanted to use the wide-angle zoom setting to fit as much of the building in the image as I could.
	On Your Own: Given buildings are usually fairly large, a wide-angle zoom setting is your best bet to get a good shot of the majority or all of the structure.

Continued

Table 6.3 *(continued)*

Camera Settings	**Practice Picture:** I set my L5 to the Landscape assist architecture scene mode, and then I used the guidelines to help me compose the image for a dramatic look.
	On Your Own: When photographing buildings or architecture, you can use a Scene assist mode or try the Auto exposure mode.
Exposure	**Practice Picture:** 1/950 at f/4.9, ISO 79.
	On Your Own: Try to use a smaller aperture to increase your depth of field so that everything in the photo appears sharp.
Accessories	A tripod can come in handy when photographing buildings, especially when the light is low.

Architectural photography tips

✦ **Shoot from a distance.** When taking pictures of tall buildings and skyscrapers try not to take your photograph too close to the base of the building. The perspective distortion can make the structure look abnormal.

✦ **Avoid backlighting.** If the building you are photographing is backlit you will lose detail in the structure and the background will appear too bright. Try to take your picture when the sun is shining on the part of the building you wish to photograph.

Candid Photography

Candid photography is more or less like taking a snapshot. This type of photograph is meant to be spontaneous; nothing is set up and the subject usually acts as he or she normally would in everyday life.

The candid photo usually centers on people interacting with their surroundings. This could be someone chatting with a friend, or playing with his or her pet, although capturing someone deep in thought or in a moment of personal introspection can also be a candid image.

Candid photography is meant to be spontaneous, but it is not meant to be intrusive. It isn't like the photos the paparazzi take, which intrude in the subject's personal space or are taken when a person isn't expecting it. When you take candid photos, the subject can be aware that you are there, but continue to act naturally, and not pose for the camera.

Candid photography has many uses both in everyday life and in professional photography. Many wedding photographers take candid photos at weddings. These images range from the bride getting ready to people

6.11 Denny Mack at Secret Hideout Studio, Austin, Texas. Taken with an L5 zoomed to 6.3mm, ISO 274, 0.4 sec. at f/2.9, Night portrait scene mode.

at the reception having a good time and interacting with the other guests. Many photojournalists also employ candid photography in their work, documenting a range of moments from civic events to periods of social unrest. Candid photography attempts to show events and subjects as they truly are.

Inspiration

While most of you may not be photographing weddings professionally or sent out on assignments, there are many opportunities for you to get candid photographs. Family get-togethers, birthday parties, or just a night out amongst friends are all great opportunities to catch some great candid shots.

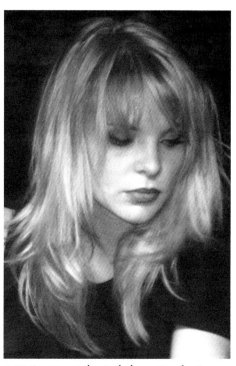

6.12 Lauren at the Jackalope, Austin, Texas. Taken with a P5000 zoomed to 26.3mm, ISO 400, 0.5 sec. at f/5.3, Aperture Priority mode.

Candid photography practice

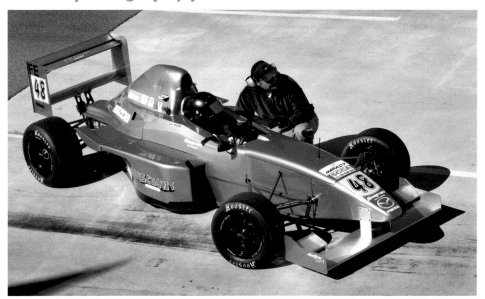

6.13 Formula car driver, MSR Houston, Houston, Texas. Taken with an L5 zoomed to 18.6mm, ISO 79, 1/370 sec. at f/7.1, Auto exposure mode.

Table 6.4
Taking Candid Pictures

Setup	**Practice Picture:** For figure 6.13, I was photographing a sports car race in Houston, Texas. I saw the driver conferring with his crew chief and I thought it would make a great candid photo.
	On Your Own: Opportunities for taking candid photos can present themselves at any time, so be ready with your camera.
Zoom Settings	**Practice Picture:** I used a L5 zoomed to 18.6mm. I used the telephoto zoom setting to zoom in close to the scene because I was up in the stands quite a ways away.
	On Your Own: Depending on how close to the subject you can get, you'll want to use a wide-angle or zoom setting. For close-up subjects, use a wider setting; for further subjects or to be less intrusive, zoom in on the subject.

Table 6.4 *(continued)*

Camera Settings	**Practice Picture:** I set my L5 to the Auto exposure mode.
	On Your Own: The Auto exposure mode enables you to snap photographs without worrying about changing settings.
Exposure	**Practice Picture:** ISO 79 1/370 sec at f/7.1
	On Your Own: When in Auto mode the camera does all of the settings for you, but if you're shooting in A, S, or M mode, be sure to have a fast enough shutter speed to capture the action or set your aperture to get the depth of field you're after.

Candid photography tips

✦ **Be unobtrusive.** Try not to stick your camera in everyone's face and tell people to "say cheese." These can end up looking like casual portraits and lose the spontaneity that you're after.

✦ **Don't be sneaky.** You don't want to intrude, but worse than that is acting sneaky. This can make people uncomfortable.

✦ **Use available light.** Whenever possible, try to avoid using the flash; it not only attracts attention to you, but available light looks more natural for candid photos.

Child Photography

One of the best things about owning a compact digital camera is you're able to carry it with you at all times. This is especially good when you have children or relatives with children. Let's face it: Kids grow up fast and having a photographic chronicle of them growing up is great.

One of the greatest challenges when photographing children is that they seem to never stop moving and you have to be on your toes to catch those fleeting moments when they are at their best. Child photography is one part candid photography, one part portrait photography, and one part luck!

One of the first things you want to think about is the setting. This is very important, as you want the child to be comfortable, and you want to have a nice background that doesn't compete with the subject for attention. Often the child's bedroom can be the perfect place. The child is in his or her own environment, and there are likely to be toys he can play with and that you can use as props. Another great place is outside,

6.14 Caden enjoying dinner. Taken with a P5000 zoomed to 10.4mm, ISO 400, 1/30 sec. at f/4, Shutter Priority mode.

either in the child's own backyard or, even better, at a park where there is playground equipment to play on.

One of the most important things to remember when photographing children is that they are amazingly perceptive to moods and emotions. They can easily tell when you are getting frustrated, so if things aren't exactly working out the way you planned and you're getting a bit irritable, it may be a good time to take a break. The best way to get great pictures is to make sure everyone involved is having fun!

Another thing to remember is that not every photograph of a child has to be taken in their finest clothes, posed for the camera. Kids are active and dynamic and sometimes messy, so use your COOLPIX to capture them they way they *really* are.

Inspiration

Having children or grandchildren of your own is inspiration enough to want to take a million photographs of them. However, if you don't have children of your own, maybe you have a family member or close friend with children who would not mind being your practice subjects.

Just enjoy watching the kids be kids and try to capture a little of their personality. Or, for older children, let them have fun posing for the camera.

6.15 Seamus playing with the D200. Taken with an S50c zoomed to 6.3mm, ISO 100, 1/30 sec at f/3.3, Auto mode, flash on.

Child photography practice

6.16 Portrait of Mia. Taken with an S50c zoomed to 18.9mm, ISO 100, 1/100 sec. at f 4.2, Auto mode, flash off.

Table 6.5
Taking Children's Pictures

Setup	**Practice Picture:** For figure 6.16 the sun was very bright so I placed Mia under a shady tree to get a softer light quality.
	On Your Own: When photographing children it's best to have soft light to enhance the smooth skin tones.
Zoom Settings	**Practice Picture:** I zoomed my S50c in to 18.9mm.
	On Your Own: Using a longer focal length when taking portraits helps to flatten the subject's features.
Camera Settings	**Practice Picture:** Auto exposure mode.
	On Your Own: Using the Auto mode or the Portrait scene mode usually makes for good pictures. Aperture priority mode also works well.
Exposure	**Practice Picture:** ISO 100, 1/100 sec at f 4.2.
	On Your Own: If you're using Aperture Priority or Manual settings try to use a wide aperture to soften the background a bit.

Child photography tips

✦ **Have patience.** Sometimes it may take quite a bit of photographing to get the image that you're after. Don't get discouraged if it doesn't turn out right away.

✦ **Keep some props handy.** A favorite toy or stuffed animal can add a personal touch to the photograph as well as keep the child occupied.

✦ **Bring along some sweets.** Sometimes a little bit of a treat can dry up tears or just keep kids from getting bored.

Concert Photography

Doing concert photography can be both frustrating and rewarding. Sometimes to get "the" shot, you have to get in and fight a crowd, blow your eardrums out in the process, and get drinks spilled all over your camera. Of course, if you're the type of person who likes to get into the fray, this is great fun.

Tip
I strongly suggest that you invest in good earplugs if you plan to do much of this type of photography.

Some photographers are staunchly against using flash at concerts, preferring to shoot with the available light. I, for one, like to use some flash at times, as I find that the stage lights can oversaturate the performer, resulting in loss of detail. Another downside to shooting with available light is you need to use high ISO settings to get a shutter speed fast enough to stop action. Typically you need to shoot anywhere from ISO 800 to 1600, which results in noisy images and the loss of image detail.

Note
Some venues or performers do not allow flash photography at all. In this situation, just try to use the lowest ISO you can while still maintaining a fast enough shutter speed.

6.17 Kevin DuBrow of Quiet Riot, Austin, Texas. Taken with an L5 zoomed to 8.5mm, ISO 640 1/160 at f/4.5, Auto exposure mode, flash off.

Inspiration

A good way to get your feet wet with concert photography is to find out when your favorite band or performer is playing and bring your camera. Smaller clubs are usually better places to take good close-up photos.

The key is to take pictures of what you like. Most local bands, performers, and regional touring acts don't mind having their photos taken. Offer to e-mail them some images to use on their Web site. This is beneficial for both them and you, as lots of people will see your photos.

6.18 Billy Duffy of the Cult, Del Mar Racetrack, California. Taken with a P5000 zoomed to 26.3mm. ISO 1600, f/5.3, 1/200 sec. Shutter Priority mode, flash off.

Concert photography practice

6.19 Ramona Crypt of the Flametrick Subs at Beerland, Austin, Texas. Taken with a P5000 zoomed to 7.5mm, ISO 100, 1 sec. at f/2.7, Aperture Priority mode, flash mode set to Slow Sync.

Table 6.6
Taking Concert Pictures

Setup	**Practice Picture:** For figure 6.19, I was in front of the stage; although it grants you greater access to the band, it can be somewhat dangerous because sometimes the crowds can get pretty rowdy, depending on the concert and venue. **On Your Own:** Try to find a spot that gets you a good perspective. Sometimes finding a place that is higher than the stage can be good, or you can even hold the camera above your head. This can help to eliminate the crowd from your pictures and focus on the performers.
Lighting	**Practice Picture:** For this image I wanted to capture some of the ambient light to get an unearthly glow, but unfortunately the stage lights weren't bright enough to allow a high shutter speed to reduce camera blur. I used an SB-600 in the hot-shoe to provide the main exposure for the subject to freeze the action. **On Your Own:** Experiment with using long exposures in conjunction with flash to get some interesting results. For cameras without manual settings, the Night portrait mode can produce similar results.
Camera Settings	**Practice Picture:** I set my camera to Aperture Priority mode. Make sure you're getting as much light to the sensor as possible. When using a flash in low-light situations, the quick flash duration compensates for a slow shutter speed. I had the flash set to Slow Sync to capture the available light. **On Your Own:** Try to use the Aperture Priority or the Night portrait mode in low-light situations.
Exposure	**Practice Picture:** ISO 100, 1 sec. at f/2.7. **On Your Own:** Slower shutter speeds let in more ambient light, resulting in a more colorful and interesting image.
Accessories	You can use an accessory flash such as the SB-400, SB-600, or SB-800 on the P5000. Using an external flash helps save your cameras batteries as well as supplies more light output than the built-in flash.

Concert photography tips

✦ **Experiment.** Don't be afraid to try different settings and long exposures. Slow Sync flash enables you to capture much of the ambient light while freezing the subject with the short bright flash.

✦ **Call the venue before you go.** Be sure to call the venue to ensure that you are able to bring your camera in.

✦ **Bring earplugs.** Protect your hearing. After spending countless of hours in clubs without hearing protection, my hearing is less than perfect. You don't want to lose your hearing. Trust me.

✦ **Take your Speedlight off of your camera.** If you're using a P5000 and one of the Nikon accessory flashes, invest in an off-camera through-the-lens (TTL) hot-shoe sync cord such as the Nikon SC-29 TTL cord. When you're down in the crowd, your Speedlight is very vulnerable. The shoe-mount is not the sturdiest part of the flash. Not only is using the Speedlight off camera safer, but also you have more control of the light direction by holding it in your hand. This reinforces my suggestion to experiment — move the Speedlight around; hold it high; hold it low; or bounce it. This is digital, and it doesn't cost a thing to experiment!

Flower and Plant Photography

One of the great things about photographing plants and flowers, as opposed to other living things, is that you have almost unlimited control with them. You can place them wherever you want, trim off any excess foliage, sit them under a hot lighting setup, and you never hear them complain.

Some other great things about photographing plants and flowers are the almost unlimited variety of colors and textures you can find them in. From reds and blues to purples and yellows, the color combinations are almost infinite. Plants and flowers are literally everywhere so there is no shortage of subjects. Even in the dead of winter, you can find plants to take photos of. They don't have to be in bloom to have an interesting texture or tone. Sometimes the best images of trees are taken after they have shed all of their foliage.

Flower and plant photography also offers a great way to show off your macro skills. Flowers especially seem to look great when photographed close-up.

You don't have to limit flower and plant photography to the outdoors. You can easily go to the local florist and pick up a bouquet of flowers, set them up, and take photos of them. After you're done, you can give them to someone special for an added bonus!

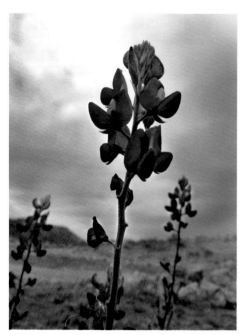

Inspiration

Just take a walk around and look at the interesting colors of the local flora. Pay close attention to the way the light interacts with different plants. A lot of the time, it can be undesirable to have a backlit subject, but the light coming through a transparent flower petal can add a different quality of beauty to an already beautiful flower.

It can also be fun to make your own floral arrangements, experimenting with different color combinations and compositions. Taking a trip and talking to a florist can give you some ideas of which plants and flowers work best together.

6.20 A bluebonnet, the state flower of Texas. Taken with an L5 zoomed to 6.3mm, ISO 79, 1/720 sec. at f/4.9, Auto exposure mode, Close-up focus setting.

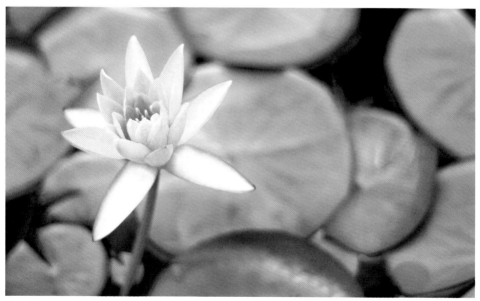

6.21 Lotus flower. Taken with a P5000 zoomed to 7.5mm, ISO 100, 1/1000 at f/2.7 Aperture priority mode, Close-up focus setting.

Flower and plant photography practice

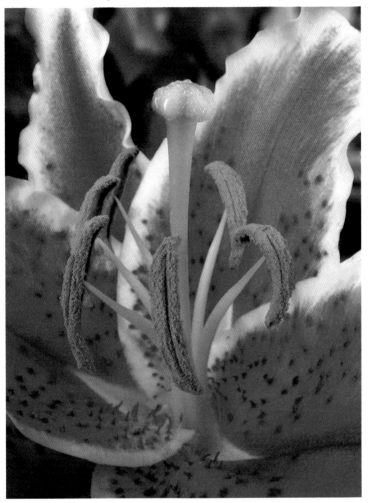

6.22 Lily. Taken with a P5000 zoomed to 7.5mm, ISO 200, 8 sec. at f/7.6, Auto exposure mode, Close-up focus setting.

Table 6.7
Taking Flower and Plant Pictures

Setup	**Practice Picture:** For figure 6.22, a friend was given a bouquet of flowers, which included these very colorful lilies. I photographed them as they sat in a vase on the coffee table while visiting one afternoon.
	On Your Own: You don't necessarily need an elaborate set-up to take nice pictures of flowers or plants. You can find great subjects at a local greenhouse or in your own backyard.
Lighting	**Practice Picture:** For this image, I wanted to be sure to capture the intense colors of the lily, but using the flash was casting unwanted shadows so I opted to use the available light.
	On Your Own: Sometimes using the flash, especially at close range, can cause undesirable effects. You may need to use available light or find an external light source such as a lamp.
Camera Settings	**Practice Picture:** I set my camera to Aperture Priority mode. I wanted to use a smaller aperture to ensure I could get most of the flower in sharp focus. I set the white balance to tungsten to match the lighting in the room.
	On Your Own: Try to use the Aperture Priority mode or the Close-up scene mode. You may need to turn the flash off at close ranges.
Exposure	**Practice Picture:** ISO 200, 8 sec. at f/7.6.
	On Your Own: I wanted to use a small aperture, and there wasn't much light to work with so I had to settle for an extremely long shutter speed. Luckily, flowers don't move much, so I set up the camera on a tripod to ensure a sharp image.
Accessories	Using additional lights that you can move around can help you add light where it is needed. A tripod can also be an invaluable tool for doing this type of photography.

Flower and plant photography tips

✦ **Shoot from different angles.**
Shooting straight down on a flower seems like the obvious thing to do, but sometimes shooting from the side or even from below can add a compelling perspective to the image.

✦ **Try different backgrounds.**
Photographing a flower with a dark background can give you an image with a completely different feel than photographing that same flower with a light background.

Landscape and Panorama Photography

With landscape photography, the intent is to represent a specific scene from a certain viewpoint. For the most part, animals and people aren't included in the composition so the focus is solely on the view.

Landscape photography can incorporate any type of environment—desert scenes, mountains, lakes, forests, or any other natural terrain. You can take landscape photos just about anywhere, and one nice thing about them is that you can return to the same spot, even as soon as a couple of hours later, and the scene will look different according to the position of the sun and the quality of the light. You can also return to the same scene months later and find a completely different scene due to the change in weather.

There are three distinct styles of landscape photography:

✦ **Representational.** This is a straight landscape, the "what you see is what you get" approach. This is not to say that this is a simple snapshot; it requires great attention to details such as composition, lighting, and weather.

✦ **Impressionistic.** With this type of landscape photo, the image looks less real due to filters or special photographic techniques such as long exposures. These techniques can give the image a mysterious or otherworldly quality.

✦ **Abstract.** With this type of landscape photo, the image may or may not even resemble the actual subject. The compositional elements of shape and form are more important than an actual representation of the scene.

One of the most important parts of capturing a good landscape image is knowing about *quality of light.* Simply defined, quality of light is the way the light interacts with the subject. There are many different terms to define the various qualities of light, such

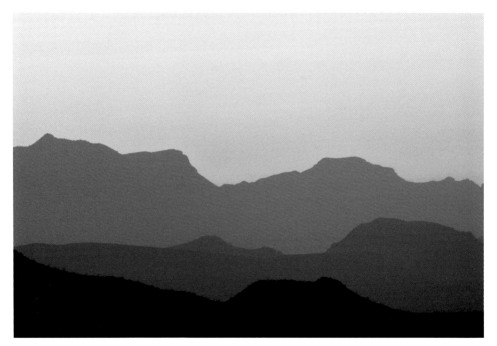

6.23 This an example of an abstract landscape image. Sunrise in the west Texas desert, Terlingua, Texas. Taken with an L5 zoomed to 31.4mm, ISO 250, 1/25 sec. at f/7.6, Sunrise/Sunset scene mode.

as soft or diffused light, hard light, and so on, but for the purposes of landscape photography, the most important part is knowing how the light interacts with the landscape at a certain time of day.

For the most part, the best time to photograph a landscape is just after the sun rises and right before the sun sets. The sunlight at those times of day is refracted by the atmosphere and bounces off of low lying clouds, resulting in a sunlight color that is different, and more pleasing, to the eye than it is at high noon.

This isn't to say you can't take a good landscape photo at high noon; you absolutely can. Sometimes, especially when you're on vacation, you don't have a choice about when to take the photo, so by all means take one. If there is a particularly beautiful location that you have easy access to, spend some time and check out how the light reacts with the terrain.

Inspiration

There are many breathtaking vistas everywhere you look. Even in the middle of a large city, you can go to a park or the top of a tall building and find a suitable subject for a landscape. Remember that a landscape doesn't have to be a spectacular scene with awesome natural forces like mountains; it can be a pond, or a small waterfall, or even a cityscape. A vista as plain as a simple wheat field can make a great landscape photo.

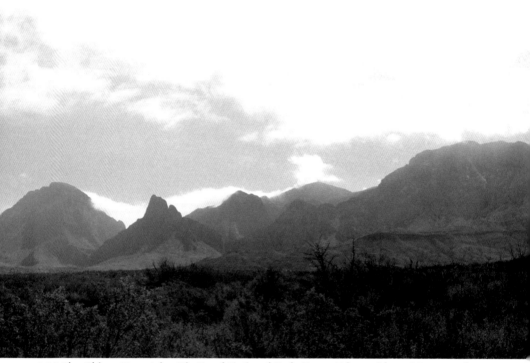

6.24 The Chisos Mountains Big Bend National Park, Texas. Taken with an L5 zoomed to 6.3mm, ISO 79, 1/1200 sec. at f/4.9, Panorama assist scene mode. Combined in image-editing software.

Using the Panorama scene mode on your COOLPIX camera can also help you create tremendous images. This mode allows you to take multiple pictures and helps you line up the separate images so you can combine them later using software. This allows you to fit vast stretches of scenery into one image.

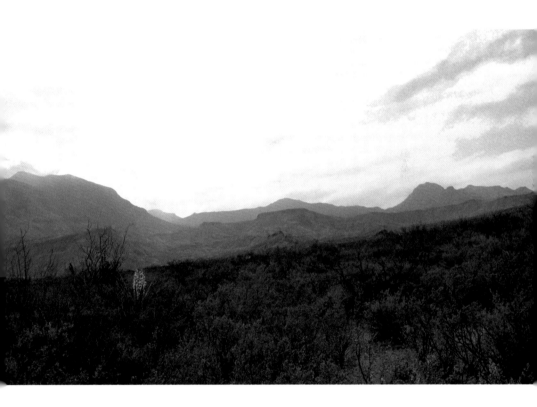

Landscape and panorama photography practice

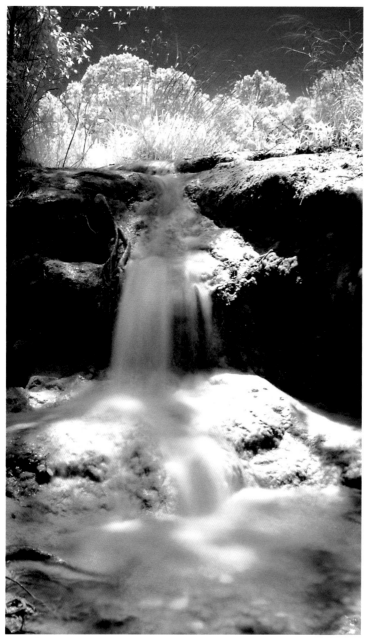

6.25 This an example of an impressionistic landscape. Bull Creek waterfall in Infrared, Austin, Texas. Taken with a P5000 zoomed to 8.5mm, ISO 100, 8 sec. at f/2.9, Manual exposure mode.

Table 6.8
Taking Landscape and Panorama Pictures

Setup	**Practice Picture:** For figure 6.25, I was headed to one of my favorite swimming spots when I came across this little waterfall. As soon as I saw it, I knew that I wanted to do a long exposure shot to give the flowing water a silky effect, so I set up my tripod and took a few different shots.
	On Your Own: Having your camera with you at all times can be fortuitous. If I hadn't had my camera with me I would've missed out on getting this shot.
Lighting	**Practice Picture:** For this image, I wanted to be sure to capture the water flowing with a long exposure; unfortunately even at the lowest ISO setting, I couldn't get a long-enough exposure. In my camera bag, I had an infrared filter, which blocks out most of the visible light, allowing only infrared light to pass through. You usually screw this filter onto the front of a standard lens with an SLR camera. I held the filter in the front of the P5000 lens by hand. The filter allowed me to get the long exposure that I needed while also capturing the ethereal effect of the infrared light.
	On Your Own: Using unorthodox techniques can sometimes give you fascinating results.
Camera Settings	**Practice Picture:** I set my camera to Manual exposure mode. I wanted to be sure to use a long shutter speed to capture the motion of the water. I also set the color option of the camera to Black and White.
	On Your Own: Figure out what kind of effect you are looking for and set your camera accordingly. Sometimes you may need to use a scene mode to fool your camera into giving you the exposure that you want. Setting the camera to the Night landscape scene mode would have also given me an exposure close to what I needed to achieve the effect I was after with the infrared filter.
Exposure	**Practice Picture:** ISO 100, 8 sec. at f/2.9.
	On Your Own: Normally for landscapes, using a smaller aperture is preferable to ensure that the whole scene is in focus. For this image using a smaller aperture wasn't possible because the P5000 has a maximum shutter speed of 8 seconds. Using a smaller aperture would have resulted in an underexposed image.
Accessories	Using a tripod can help you get sharper pictures, especially when you're using a small aperture and long shutter speed.

Landscape and panorama photography tips

✦ **Bring a tripod.** Often when you're photographing landscapes, especially early in the morning or at sunset, the exposure time may be quite long. A tripod can help keep your landscapes in sharp focus.

✦ **Scout out locations.** Keep your eyes open; even when you're driving around, you may see something interesting.

✦ **Experiment with filters.** Even though you may not be able to attach the filter directly to your COOLPIX lens, if you have a tripod, or someone to help you, you can place filters in front of your lens when taking the shots. Try colored filters or an infrared filter for interesting effects.

Light Trail and Fireworks Photography

One of the most fun and exciting types of photography is pictures of light trails. You can capture some amazing and surreal images, such as fireworks. Fireworks photography is, in theory, pretty simple, especially when you're using the Fireworks scene setting. The hardest part is getting the timing right. You have to have a sharp eye to know when the fireworks have been launched, so you can be sure to have the camera shutter open before the firework explodes with a burst of color.

6.26 Club de Ville, Austin, Texas. Taken with an L5 zoomed to 23.5mm, ISO 79, 4 sec. at f/7.7 / Fireworks scene mode.

Light trail photography, while different than fireworks photography, shares the same type of camera settings. You need a very slow shutter speed and a pretty small aperture. For those of you without manual settings on your camera, you can use the Fireworks setting for doing light trail photography as well.

Inspiration

A tripod is the one thing that is almost essential when you're doing any photography using long shutter speeds. If you try to handhold your camera with an 8 second exposure, your image will be nothing but a blurry mess. Of course, sometimes a hand-held blur is exactly what you're looking for.

When doing fireworks photography, the first thing you want to do is figure out where the fireworks are going to "bloom." Set your camera on the tripod and aim it in the right direction. For the most part, you're going to need a wide-angle lens setting to be sure to get everything in the frame; unless you are very far away you shouldn't need to zoom in.

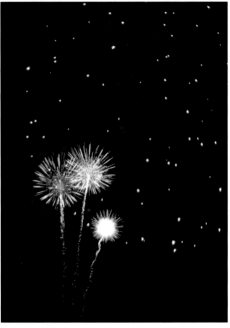

© *Jena Weber / www.flickr.com/photos/jenaleigh/*
6.27 Fireworks over Asheville, North Carolina. Taken with an L5 zoomed to 6.3mm, ISO 79, 4 sec. at f/7.7, Fireworks scene mode.

Light trail and fireworks photography practice

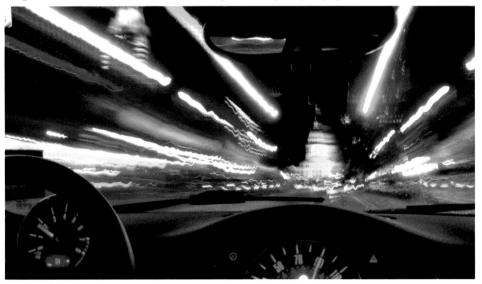

6.28 Racing, Austin, Texas. Taken with an L5 zoomed to 6.3mm, ISO 79, 4 sec. at 4.9 / Fireworks scene mode.

Table 6.9
Taking Light Trail and Fireworks Pictures

Setup	**Practice Picture:** A tripod was secured in the back seat to ensure that the interior of the car was fairly sharp while the lights raced by creating light trails. I learned this technique from my friend Ben McLeod (www.flickr.com/photos/benmcleod); he's a master at this.
	On Your Own: There are many different ways to do this; using a tripod, a monopod or even handholding the camera can yield interesting results.
Zoom Settings	**Practice Picture:** My L5 was zoomed to 6.3 mm.
	On Your Own: You want to use the widest zoom setting in order to capture as much of the scene as possible.
Camera Settings	**Practice Picture:** Fireworks scene mode.
	On Your Own: The Fireworks scene mode works perfectly for this type of photo.
Exposure	**Practice Picture:** ISO 79, 4 sec. at f/4.9.
	On Your Own: If you're using a camera with P, S, A, or M mode, be sure to select a long enough shutter speed to allow the light to streak.
Accessories	A tripod is definitely a good accessory to have.

Light trail and fireworks photography tips

✦ **Be patient.** Sometimes you will have to take many photos before you get one you like. It can be a trial-and-error process.

✦ **Look for multi-colored lights.** Bright lights of different colors can add more interest to your images.

✦ **Get there early.** To get a good spot for the fireworks, show up a little early to stake out a spot.

Macro Photography

Macros and close-ups are easily some of my favorite types of photography. Sometimes you can take the most mundane object and give it a completely different perspective just by moving in close. Ordinary objects can become alien landscapes. Insects take on a new personality when you can see the strange details of their faces.

Technically, macro photography can be difficult, because the closer you get to an object, the less depth of field you get, and it can be difficult to maintain focus. When your lens is less than an inch from the face of a bug, just breathing in is sometimes enough to lose focus on the area that you want to capture. For this reason, you usually want to use the Close-up scene mode, or if you're using Manual settings, the smallest aperture your camera can handle and still maintain focus. I say "usually" because a shallow depth of field can also be very useful in bringing attention to a specific detail.

 When shooting extremely close-up, the lens may obscure the light from the flash, resulting in a dark area on the bottom of the images.

6.29 Crawfish. Taken with an L5 zoomed to 6.3mm, ISO 400, 0.3 sec. at f/2.9. Close-up scene mode, flash turned off.

One of the best things about macro photography is that you aren't limited to shooting in one type of location. You can do this type of photography indoors or out. Even on a rainy day, you can find something in your house to photograph. It can be a houseplant, a trinket, a coin, or even your dog's nose (if the dog sits still for you!).

Inspiration

My favorite subjects for macro photography are insects. I go to parks and wander around, keeping my eyes open for strange bugs. Parks are also a great place to take macro pictures of flowers. Although these are the most common subjects, by no means are they the only subjects you can take pictures of. Lots of normal, everyday objects can become interesting when viewed up-close.

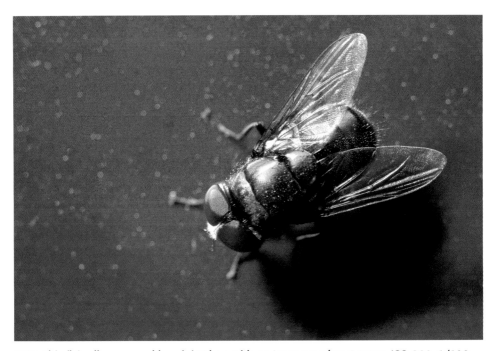

6.30 This fly's all green and buzzin'. Taken with an L5 zoomed to 6.3mm, ISO 200, 1/100 sec. at f/4.2, Close-up scene mode, flash turned off.

Macro photography practice

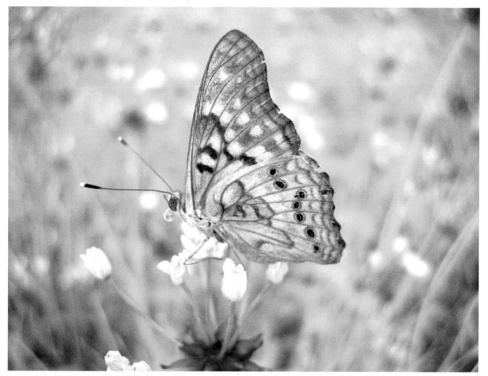

6.31 Butterfly at McKinney Falls State Park, Austin, Texas. Taken with a P5000 zoomed to 7.5mm, ISO 100, 1/200 sec. at f/2.7.

Table 6.10
Taking Macro Pictures

Setup	**Practice Picture:** Figure 6.31 shows a butterfly I found perched on a flower while hiking through McKinney Falls State Park.
	On Your Own: Look for subjects with bright colors and interesting texture, whether they are insects, flowers, or everyday objects.
Zoom Settings	**Practice Picture:** I was at the widest angle setting because the camera was in the close-up focus setting.
	On Your Own: When the camera is in Close-up mode, you must set it to a wide-angle setting to take macro pictures.

Continued

Table 6.10 *(continued)*

Camera Settings	**Practice Picture:** The camera was set to Aperture Priority mode. Most macro subjects aren't going to move at great speeds, so a fast shutter speed is not really needed. Controlling the depth of field and what is in focus is most important. **On Your Own:** Use the Close-up scene mode or, if possible, set the camera to Aperture Priority mode to have more control over the depth of field.
Exposure	**Practice Picture:** ISO 100, 1/200 sec. at f/2.7. **On Your Own:** Decide what's important in the image and focus on it. If your camera has manual settings, use a relatively wide aperture to throw the background out of focus, but use a small enough aperture to maintain enough focus on the subject.
Accessories	If your subject is stationary, a tripod can be an invaluable tool.

Macro photography tips

✦ **Use the self-timer.** When using a tripod, use the self-timer to make sure the camera isn't shaking from pressing the shutter release button.

✦ **Use a low ISO.** Because macro and close-up photography focuses on details, use a low ISO to get the best resolution.

Night Photography

Taking photographs at night brings a whole different set of challenges that are not present when you take pictures during the day. The exposures become significantly longer, making it difficult to handhold your camera and get sharp images. Your first instinct may be to use the flash to add light to the scene, but as soon as you do this, the image loses its "night-time" charm. It ends up looking like a photograph taken with a flash in the dark. In other words, it looks like a snapshot.

When taking photos at night, you want to strive to capture the glowing lights and the delicate interplay between light and dark. The best way to achieve this is to use a tripod. This allows you to capture the image with the long exposures that are necessary, but also enables you to keep your subjects in sharp focus.

Inspiration

When I look for scenes to photograph at night, I try to think of subjects that have a lot of color that can be accented by the long exposures. City skylines, downtown areas, and other places with lots of neon are very good subject matter for this type of photography.

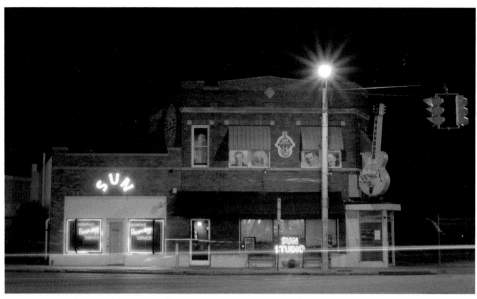

6.32 Sun Studio at night, Memphis, Tennessee. Taken with a P5000 zoomed to 7.5mm, ISO 200, 8 sec. at f/5.3.

Night photography practice

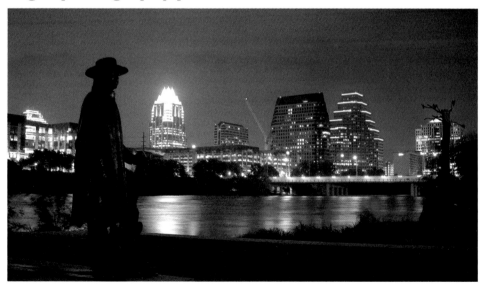

6.33 Statue of Stevie Ray Vaughan, Austin, Texas. Taken with a P5000 zoomed to 7.5mm, ISO 64, 8 sec. at f/2.7.

Table 6.11
Taking Night Pictures

Setup	**Practice Picture:** Figure 6.33 is a statue of the late Stevie Ray Vaughan located next to Town Lake in Austin, Texas.
	On Your Own: Look for subjects with bright colors and good contrast when taking photos at night.
Zoom Settings	**Practice Picture:** I used the widest-angle setting to capture as much of the scene as possible. I also had the camera image mode set to the 16:9 ratio setting to give the image an even wider feel.
	On Your Own: When shooting large subjects, keep your camera set to a wide angle. If you want to focus on a particular aspect of a scene, you may need to zoom in.
Camera Settings	**Practice Picture:** I set the camera to Aperture Priority mode. I wanted to have a wide enough aperture to capture plenty of light.
	On Your Own: Use one of the night scene modes or if possible, set to Aperture Priority or Manual exposure mode to have more control over the exposure.
Exposure	**Practice Picture:** ISO 64, 8 sec. at f/2.7. For this image, I set the ISO low because I wanted to have a long shutter speed to get a glassy look to the water, and to be sure that the colors would be super-saturated.
	On Your Own: You can use a higher ISO to cut down on exposure times, or you can take advantage of the longer exposure times required when using a low ISO.
Accessories	A tripod was absolutely necessary to achieve the effect in this image.

Night photography tips

✦ **Bring a tripod.** Without a tripod the long exposure times will cause your photos to be blurry.

✦ **Use the self-timer.** Often, when the camera is on the tripod, pressing the shutter release button causes the camera to shake enough to cause your image to blur. Using the self-timer gives the camera and tripod enough time to steady so your images come out sharp.

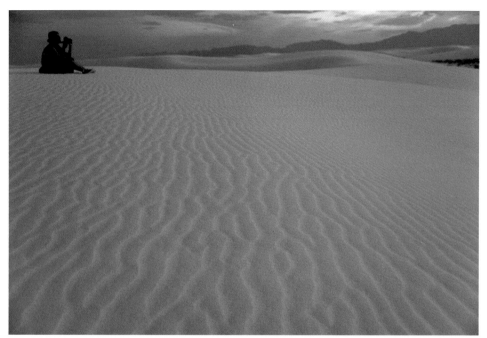

6.34 Jena at White Sands National Monument, White Sands, New Mexico. Taken with a P5000 zoomed to 7.5mm, ISO 200, .3 sec at f/2.7, Aperture Priority mode, flash off, with tripod.

Pet Photography

Photographing pets is something every pet owner likes to do. I've got enough pictures of my dog to fill a 300GB hard drive.

The most difficult aspect about pet photography is getting the animal to sit still.

Whether you're doing an animal portrait or just taking some snapshots of your pet playing, patience is a good trait to have.

If your pet is fairly calm and well trained, using a studio-type setting is entirely possible. For example, my cat, Charlie Murphy, is a pretty relaxed character that doesn't mind sitting for me on occasion.

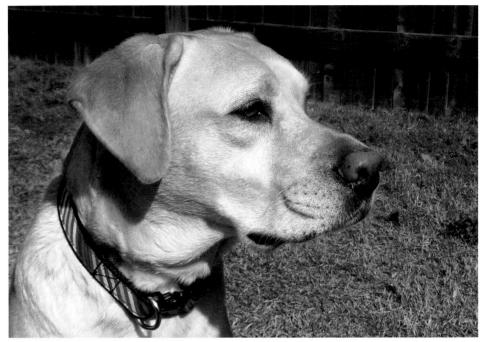

6.35 Oregon (Yellow Lab). Taken with an L5 zoomed to 9.5mm (58mm equiv.) ISO 79, 1/700 sec. at f/5.6, Auto exposure mode, flash set to fill.

Inspiration

Animals and pets are an inspiration in and of themselves. If you don't have a pet yourself, go visit a friend or relative who has one. Go to the park and find people playing with their dog. Lots of people have pets, so it shouldn't be hard to find one.

6.36 Bogie the horse. Taken with an L5 zoomed to 12.5mm, ISO 79, 1/50 sec. at f/3.6, Auto exposure mode, flash off.

Pet photography practice

6.37 Henrietta (Boston Terrier). Taken with an S50c zoomed to 8.5mm, ISO 400, 1/30 sec at f/3.5, Auto exposure mode, flash off.

Table 6.12
Taking Pet Pictures

Setup	**Practice Picture:** In figure 6.37, I was trying for a portrait-type shot that captured Henrietta's regal attitude.
	On Your Own: Not all pet portraits need to be traditional and posed. Every animal has its own personality; strive to bring it out in your image.
Lighting	**Practice Picture:** I placed Henrietta on a chair next to the French doors in my studio for nice diffused window light.
	On Your Own: Try using natural light when photographing animals. Using a flash can cause the animal's eyes to glow eerily, especially when the animal directly faces you.
Zoom Settings	**Practice Picture:** The zoom was set at 8.5mm.
	On Your Own: Use whatever zoom you need to fit your subject in the frame. Remember that wider angles can cause the features to distort a bit. This is not always bad when you're doing a pet portrait.
Camera Settings	**Practice Picture:** The camera was set to Auto exposure mode with the flash turned off.
	On Your Own: Because animals, especially dogs, are inquisitive, you might find it easier to use the Auto exposure mode so you don't have to worry about adjusting the settings or deciding which scene mode to use. You'll probably be chasing the dog around, trying to get a good shot.
Exposure	**Practice Picture:** 1/30 sec. at f/3.5, ISO 400.
	On Your Own: If you're using the Manual or Aperture Priority settings, use a wide aperture to throw the background out of focus.

Pet photography tips

✦ **Be patient.** Animals aren't always the best subjects; they can be unpredictable and uncooperative. Have patience and shoot plenty of pictures. You never know what you're going to get.

✦ **Bring some treats.** Sometimes animals can be coaxed to do things with a little bribe.

✦ **Get low.** Because we're used to looking down at most animals, we tend to shoot down at them. Get down low and shoot from the animal's perspective.

✦ **Use red-eye reduction.** If you are going to use the flash, using red-eye reduction is a must, although sometimes it doesn't completely remove the glare.

Portrait Photography

Portrait photography can be one of the easiest or one of the most challenging types of photography. Almost anyone with a camera can do it, yet it can be a complicated endeavor. Sometimes simply pointing a camera at someone and snapping a picture can create an interesting portrait; other times elaborate lighting set ups may be needed to create a mood or to add drama to your subject.

A *portrait*, simply stated, is the likeness of a person's face, whether it is a drawing, a painting, or a photograph. A good portrait should go further than that. It should go beyond simply showing your subject's likeness and delve a bit deeper, hopefully revealing some of your subject's character or emotion also.

You have lots of things to think about when you set out to do a portrait. The first thing to ponder (after you've found your subject, of course) is the setting. The setting is the background and surroundings, the place where you'll be shooting the photograph. You need to decide what kind of mood you want to evoke. For example, if you're looking to create a somber mood with a serious model, you may want to try a dark background. For something more festive, you need a background with a bright color or multiple colors.

There are many different ways to evoke a certain mood or ambience in a portrait image. Lighting and background are the principal ways to achieve an effect, but there are other ways. Shooting the image in black and white can give your portrait an evocative feel. You can shoot your image so that the colors are more vivid, giving your photo a live, vibrant feeling, or you can tone the colors down for a more ethereal look.

Indoor

When shooting portraits indoors, more often than not there isn't enough light to make a correct exposure without using flash or some sort of other additional lighting. Although the built-in flash on the Nikon COOLPIX cameras sometimes works very well, especially outdoors, I find that when I try to use it for an indoor portrait, the person ends up looking like a "deer caught in headlights." This type of lighting is very unnatural looking and doesn't lend itself well for portraiture. It works fine for snapshots, but your goal here is to get beyond taking snapshots and move up to making quality images.

The easiest way to achieve a more natural-looking portrait indoors is to move your subject close to a window. This gives you more light to work with and the window acts as a diffuser, softening the light, giving your subject a nice glow. For example, in 6.38, I placed Melissa near an open garage door to allow the sunlight to stream in for the main light. I also fired the flash to add a little glint to her eyes. The glint is called a *catch light*.

Another easy way to get nice portrait lighting indoors is to use an additional light source. A traditional tabletop lamp with a lampshade on it can provide a nice, soft light source if you seat your subject right next to it.

If you're going for more of a studio-type setup, you can always buy a photographic light that you can use with accessories to soften the light or make it more directional.

Cross-Reference *For more information on lights and accessories, see Chapter 5.*

6.38 Melissa with natural light. Taken with a P5000 zoomed to 11mm, 1/125 sec. at f/3.5, ISO 100, Manual exposure mode, flash set to Anytime mode, exposure compensation -1 EV.

Outdoor

When you shoot portraits outdoors, the problems that you encounter are usually the exact opposite of the problems you have when you shoot indoors. The light tends to be too bright, causing the shadows on your subject to be too dark. This results in an image with too much contrast.

In order to combat this contrast problem, you can use your flash. I know that this

sounds counter-intuitive; you're probably thinking, "If I have too much light, why should I add more?" Using the flash in the bright sunlight fills in the dark shadows, resulting in a more evenly exposed image. This technique is known as *fill flash*. All of the current COOLPIX cameras have a fill flash setting, called the Anytime flash mode.

Another way to combat images that have too much contrast when you're shooting outdoors is to move your subject into a shaded area, under a tree or a porch. This helps block the direct sunlight, providing you with a nice soft light for your portrait. I placed Melissa underneath the shade of a tree to combat the harsh shadows of the sun in 6.39.

6.39 Melissa in open shade. Taken with an L5 zoomed to 29.8mm, ISO 79, 1/115 sec. at f/5, Portrait scene mode, flash off, exposure compensation -1 EV.

Night

Taking portraits at night also poses it's own difficulties. This is when the "deer in the headlights" situation can be very noticeable. When you use the flash, the person is over-exposed and the background goes completely black, and the subject looks like he is in a black hole.

Luckily, the COOLPIX cameras have a scene mode for doing night portraits that balances the ambient light and the flash, making your portrait look more natural. If you're more inclined to use the manual or semiautomatic settings, a flash mode allows your flash to fire in conjunction with a slow shutter speed to capture the available light. This flash mode is called *slow-sync,* because it syncs the flash to the slower shutter speed.

6.40 Marty, a portrait. Taken with the P5000 zoomed to 6.5mm, ISO 400, 1/60 sec. at f/2.7, Night Portrait Scene mode.

Portrait photography practice

6.41 Denny Mack. Taken with a P5000 zoomed to 6.5mm, ISO 64, 1/250 sec at f/2.7, Manual exposure, and flash set to Auto mode flash, exposure compensation -2EV.

Table 6.13
Taking Portraits

Setup	**Practice Picture:** In figure 6.41, I was shooting a promotional portrait for a musician, and I mounted the camera on a tripod.
	On Your Own: Not all portraits need to be traditional. Trying things that are out of the ordinary can sometimes result in a great portrait. Try to incorporate something personal of your subject's into the picture.

Continued

Table 6.13 *(continued)*

Lighting	**Practice Picture:** I placed an SB-600 on a light stand up and to the right of the subject. The SB-600 was connected to a Nikon SC-29 off-camera TTL hot-shoe cord, which was connected to the hot-shoe of the P5000. Next, I aimed a small halogen work lamp at the background, and I placed a red gel over the top of the light to give the background a red glow. I also had the camera's built-in flash fire at a lower power to provide some fill light.
	On Your Own: It's not necessary to buy expensive photography lights to achieve good portrait lighting. If you're just starting out, simple inexpensive clamp lights can work wonders.
Zoom Settings	**Practice Picture:** I set the zoom at 7.5mm, which is equivalent to a 36mm lens in traditional film cameras. I used a fairly wide-angle lens setting to be able to fit the whole subject in the frame.
	On Your Own: Use whatever zoom you need to fit your subject in the frame. Remember that using wider angles close up on a person can cause the person's features to distort a bit. This is usually undesirable.
Camera Settings	**Practice Picture:** I set the camera to Manual exposure mode with the flash set to Auto. I set the flash exposure compensation to -2 EV in order to not add too much light to the exposure.
	On Your Own: I prefer to set my camera settings manually, especially when working with flash; however, you can easily achieve great portraits using the portrait scene modes.
Exposure	**Practice Picture:** 1/250 sec. at f/2.7, ISO 64.
	On Your Own: If you're using the Manual or Aperture Priority settings, use a wide aperture to throw the background out of focus.
Accessories	A tripod was used to keep the camera steady.

Portrait photography tips

✦ **Plan some poses.** Take a look at some photos on the Internet and find some poses that you like. Have these in mind when photographing your models.

✦ **Use a tripod.** Not only does the tripod help you get sharper images, but it also can make people feel more comfortable when you're not aiming the camera directly at them. The camera can be less intimidating when it's mounted to a stationary subject.

Still Life Photography

In still life photography, lighting is the key to making the image work. You can set a tone using creative lighting to convey the feeling of the subject. You can also use lighting to show texture, color, and form to turn a dull image into a great one.

When practicing for product shots or experimenting with a still life, the first task you need to undertake is finding something to photograph. It can be one object or a collection of objects. Remember if you are shooting a collection, try to keep within a particular theme so the image has a feeling of continuity. Start by deciding which object you want to have as the main subject, and then place the other objects around it, paying close attention to the balance of the composition.

The background is another important consideration when photographing products or still life scenes. Having an uncluttered background that showcases your subject is often best, although you may want to show the particular item in a scene. An example of this is photographing a piece of fruit on a cutting board with a knife in a kitchen.

Diffused lighting is essential in this type of photography. You don't want harsh shadows to make your image look like you shot it with a flash. The idea is to light it so it doesn't look as if it was lit.

6.42 Apple. Taken with an L5 zoomed to 9.5mm, ISO 79, 1/700 sec. at f/5.6. Auto exposure mode, flash off, halogen light source reflected off of white foam coreboard.

Even with diffusion, the shadow areas need some filling in. You can do this by using a second light as fill or by using a fill card. A *fill card* is a piece of white foam board or poster board used to bounce some light from the main light back into the shadows, lightening them a bit. When using two or more lights, be sure that your fill light isn't too bright, or it can cause you to have two shadows. Remember, the key to good lighting is to emulate the natural lighting of the sun.

Inspiration

When searching for subjects for a still life shot, try using some personal items. Some ideas are objects such as jewelry or watches, a collection of trinkets you bought on vacation, or even seashells you brought home from the beach. If you're interested in cooking, try photographing some dishes you prepared. Fruits and vegetables are always good subjects, especially when they have vivid colors or interesting textures.

6.43 Still life with SRF. Taken with an L5 zoomed to 6.3mm. ISO 79, 1/1150 sec. at f/4.9. Auto exposure mode, flash turned off.

Sometimes you can find still life shots right out in the open, as in figure 6.43. I was photographing a racing event when I came across this Spec Racer car and the driver's helmet. By moving things around a little, I got a great still life image.

Still life photography practice

6.44 Small block 350. Taken with an S50c zoomed to 18.9mm, ISO 100, 1/125 sec. at f/8. Auto exposure mode, flash turned off.

Table 6.14
Taking Still life Pictures

Setup	**Practice Picture:** While at a racing event in Colorado I came across a vendor displaying a model of their newest engine shown in 6.44.
	On Your Own: A still life doesn't necessarily have to be set up; sometimes you can find them already on display for you.
Zoom Settings	**Practice Picture:** I stepped back and zoomed in to 18.9mm.
	On Your Own: Sometimes getting to close to the subject can cause unwanted shadows in your photo, so by stepping back and letting the zoom lens bring your subject closer you can get better lighting quality.
Camera Settings	**Practice Picture:** My S50c was set to Auto exposure mode with the flash turned off. I had the color option set to Black & White.
	On Your Own: Depending on the subject you're shooting, you may want to try a different color option to add interest to the image.
Exposure	**Practice Picture:** ISO 100, 1/125 sec. at f/8.
	On Your Own: When setting your own exposures make sure to use an aperture setting that will allow you to carry enough depth of field to get everything you want in focus.

Still life photography tips

✦ **Keep it simple.** Don't try to pack too many objects in your composition. Having too many objects for the eye to focus on can lead to a confusing image.

✦ **Use items with bold colors and dynamic shapes.** Bright colors and shapes can be eye-catching and add interest to your composition.

✦ **Vary your light output.** When using more than one light on the subject, use one as a fill light with lower power to add a little depth to the subject by creating subtle shadows and varied tones.

Street Photography

Sometimes just wandering around a city and photographing the interesting scenes and action can yield rewarding results. Urban environments can be packed with many exciting photographic opportunities: Pedestrians rushing by street vendors and interesting signs are among the many things you might be confronted with. The animals you may find may also surprise you. Urban settings abound with pigeons, as well as many other types of creatures.

One of the best parts of having a compact camera is while you wander through the city looking for subjects, you won't be encumbered with a bunch of heavy gear; this enables you to be quick on the draw, so you can capture any action that may pop up.

One thing to remember about street photography: It's more about the feeling the picture evokes than the technical quality of the picture. Sometimes a blurry picture can have more impact than one in sharp focus. In figure 6.45, the woman was running with her child to get out of the rain. The blur in the image suggests the motion of the woman and child and the urgency of the moment.

6.45 Mother with child. Taken with an L5 zoomed to 11.5mm, ISO 79, 1/8 sec. at f/3.5. Auto exposure mode, flash off.

Inspiration

Some photographers insist that street photography must focus on the people. While people can be an interesting aspect of street photography, there are many other subjects to focus on. These days not a lot of people are keen on having a stranger take their photograph, so it's best to get some kind of permission before snapping a recognizable photo of someone.

My favorite subjects to photograph while doing street photography are things that are associated with urban decay. Urban decay images include old buildings or structures in states of disrepair.

It really doesn't matter what the subject is as long as you find it interesting and compelling.

6.46 Alamo Draft House, Austin, Texas. Taken with an L5 zoomed to 10.5mm, ISO 79, 1/640 sec. at f/3.4, Landscape scene assist Architecture mode.

Street photography practice

6.47 13th and Hickory, Kansas City, Missouri. Taken with an S50c zoomed to 6.3mm, ISO 100, 1/60 at f/3.3.

Table 6.15
Taking Street Photography Pictures

Setup	**Practice Picture:** While I was passing through Kansas City, I stopped to stretch my legs and started wandering around what looked to be a deserted part of town. The old brick building in figure 6.47 with strange things in the window interested me enough to snap a quick shot.
	On Your Own: Find something that catches your eye and take some photos. Try different angles if your first pictures aren't working for you.
Zoom Settings	**Practice Picture:** The zoom was set to a wide-angle for this shot to capture the whole scene.
	On Your Own: Because you never know what you may come across, your zoom settings can run the gamut from wide to telephoto, depending on the subject matter.
Camera Settings	**Practice Picture:** I set the camera to Auto exposure mode. I converted the image to sepia later in Photoshop.
	On Your Own: The easiest way to be ready to snap a shot when doing street photography is to have your camera set to Auto exposure mode.
Exposure	**Practice Picture:** ISO 100, 1/60 at f/3.3.
	On Your Own: Your exposure will vary widely depending on the subject and the brightness of the day.

Street photography tips

✦ **Keep your eyes peeled.** You never know what type of interesting photo opportunity may come; be ready to catch it.

✦ **Get permission.** Be sure to get permission before taking someone's picture. Some people can get very aggressive when their photo is taken without permission. *Never* photograph a child without first asking the child's parent or guardian.

✦ **Be careful.** Make sure the area you are in is safe. Thieves and pickpockets can ruin your day.

✦ **Experiment.** Try using unusual techniques such as slow shutter speeds and different white balance settings to add interest to your images.

Sunset and Sunrise Photography

Sunset and Sunrise photography . . . on one hand it's very cliché; on the other hand, it looks so good that everyone does it. It doesn't matter where you are: The sun will rise and set, so anyone can have a chance to do this type of photography.

A sunset or sunrise can look equally good, whether you're looking out over the skyline of a city, in the middle of the desert, or in a forest. The colors can be amazing, from deep reds and oranges to cool blues and purples, with the clouds and landscapes reflecting all of the colors back to your camera lens.

Inspiration

Sunrise and sunset images can be captivating when taken at any time of the year, but the weather can be a big factor in what the sunset or sunrise looks like. For example, having a few clouds in the sky can add tremendous texture to the sky, but if the sky is completely overcast, seeing the sun may be impossible.

Shooting Silhouettes

Because sunrises and sunsets, by definition, are backlit, they're the perfect opportunity to shoot silhouettes. You can outline things at the horizon, or create silhouettes from closer subjects, such as people or buildings. Here are some things to consider:

✦ **Make underexposure work for you.** Silhouettes are black outlines against a bright background, so you usually have to underexpose from what the Alpha A100 considers the ideal exposure. Use the exposure value compensation to reduce exposure by two stops.

✦ **Shoot sharp.** Silhouettes usually look best when the outlined subject is sharp. Watch your focus, using the focus lock button or manual focus if necessary to ensure sharp focus.

✦ **Use imaginative compositions.** It's too easy to just find an interesting shape and shoot it at sundown in silhouette mode. Use the dramatic lighting to enhance your composition. For example, one favorite wedding shot is the bride and groom in profile facing each other, jointly holding a half-filled wine glass. Shot at sunset as a silhouette, the shapes of their faces contrasts beautifully with the non-silhouetted image of the transparent wine glass.

✦ **Use colored filters or enhanced saturation.** These techniques can make the sunset more brilliant, while retaining the dramatically dark outline of the silhouette.

6.48 Sunset at Big Bend National Park, Texas. Taken with an L5 zoomed to 31.4mm, ISO 79, 1/640 sec. at f/5, Dusk/Dawn scene mode.

Sunset and sunrise photography practice

6.49 Sunset at Enchanted Rock, Llano County, Texas. Taken with an S50c zoomed to 6.3mm, ISO 800, 1/60 sec. at f/5, Sunset scene mode.

Table 6.16
Taking Sunset and Sunrise Pictures

Setup	**Practice Picture:** While I was hiking in Enchanted Rock State Natural Area, the sun started going down. I noticed this gnarly old tree in figure 6.49 and thought it would look great silhouetted against the beautiful sunset sky.
	On Your Own: Find something that catches your eye and take some photos. Try different angles if your first pictures aren't working for you.
Lighting	**Practice Picture:** I set the zoom to a wide-angle for this shot to capture the whole scene.
	On Your Own: Because you never know what type of scene you may be photographing, your zoom settings can be from wide to telephoto, depending on the subject.
Camera Settings	**Practice Picture:** The camera was set to Sunset scene mode. I set the zoom to a wide-angle for this shot to capture the whole scene.
	On Your Own: The easiest way to be ready to snap a shot when doing sunset or sunrise photography is to have your camera set to Sunset Scene mode.
Exposure	**Practice Picture:** ISO 800, 1/60 at f/5.
	On Your Own: Since the light changes rapidly during a sunset or sunrise your settings will vary widely.
Accessories	Because the light is rather dim, having a tripod handy is usually a good idea when photographing a sunrise or sunset.

Sunset and sunrise photography tips

✦ **Not all sunrises and sunsets are created equal.** The light at sunset and sunrise can differ and be more pronounced a different times of the year. Cold nights when the ground is warm can yield a foggy sunrise, for example. If you plan to shoot a sunrise ahead of time, know the weather.

✦ **Capture the full range of colors.** The color of the sky before, during, and just after sunset and sunrise changes dramatically. Be sure to use all the time to capture the changes.

✦ **Get in position early.** If you are planning ahead, try to beat the sunrise by a solid window of time. Once sunset or sunrise begins, you have only about 10 or 15 minutes to get the shots you want.

✦ **Try a tripod.** You get sharper images by using a tripod or other surface where you can steady the camera.

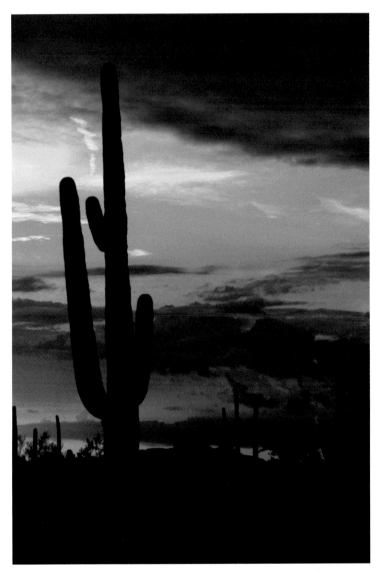

6.50 Sunset over Saguaro National Park, Arizona. Taken with an S7c zoomed to 6.3mm, ISO 100, 1/500 sec. at f/3.3, Sunset/Sunrise Scene mode.

Wildlife Photography

Photographing wildlife is a fun and rewarding pastime that can also be intensely frustrating. If you know what you want to photograph, it can mean standing out in the freezing cold or blazing heat for hours on end, waiting for the right animal to show up. But when you get that one shot you've been waiting for, it's well worth it.

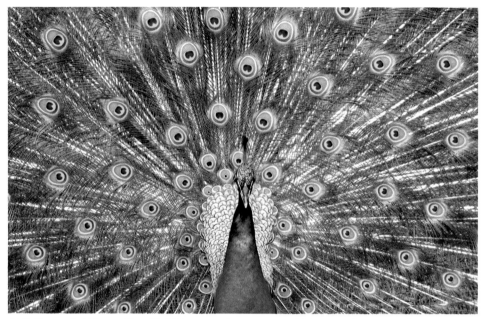

6.51 Peacock. Taken with a P5000 zoomed to 26.3mm, ISO 200, 1/40 sec. at f/5.3. Aperture Priority mode, flash set to Auto.

Wildlife photography is another one of those areas of photography where people's opinions differ on whether or not you should use flash. I tend not to use flash to avoid scaring off the animals. But, as with any type of photography, there are circumstances in which you might want to use a flash, such as if the animal is backlit and you want some fill-flash.

Opportunities to take wildlife pictures can occur when you're out hiking in the wilderness, or maybe when you're sitting out on your back porch enjoying the sunset.

With a little perseverance and luck, you can get some great wildlife images, just like the ones you see in *National Geographic*.

Inspiration

You can go to wildlife reserves, a zoo, or even your backyard to find "wildlife." I tend to go the easy route, focusing on places where I'm pretty sure to find what I'm looking for. For example, while driving through Louisiana recently, I saw a sign that advertised an alligator swamp tour. I was pretty sure I'd see some alligators if I went. And even though I'd missed the last tour, there were still plenty of alligators there.

 Caution *When photographing animals, be careful! Wild animals can be unpredictable and aggressive when cornered. Give them their space and try not to disrupt their routines.*

Even in the city or urban areas, you may be able to find wildlife, such as birds perched on a power line. A lot of cities have larger parks where you can find squirrels or other smaller animals. There's a park near my studio where you can see peacocks and armadillos running around.

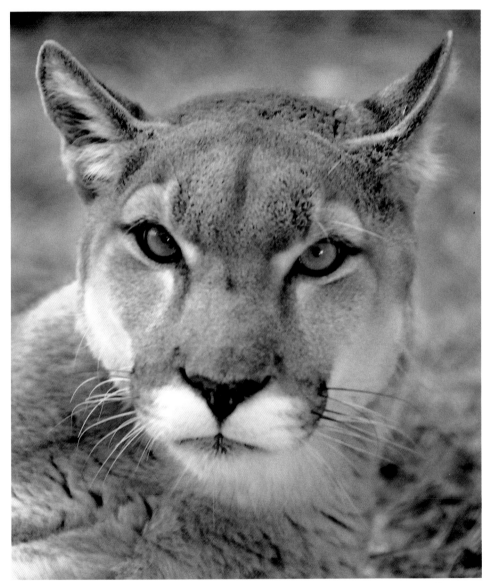

6.52 Mountain Lion, west Texas. Taken with an L5 zoomed to 31.4mm, ISO 640, 1/30 sec. at f/5. Auto exposure mode, flash turned off.

Wildlife photography practice

6.53 Great Horned Owl, Terlingua, Texas. Taken with an L5 zoomed to 31.4mm, ISO 320, 1/350 sec. at f/7.1, Auto exposure mode, flash turned off.

Table 6.17
Taking Wildlife Pictures

Setup	**Practice Picture:** For figure 6.53, I noticed this owl while hiking in the desert after taking some pictures of the sunrise.
	On Your Own: Wild animals are generally pretty skittish (they are called "wild" for a reason) so moving slowly and trying not to make any loud noises is best.
Zoom Settings	**Practice Picture:** Since the owl was pretty far away and I couldn't get much closer because I didn't want to scare it off, I zoomed in as close as I could.
	On Your Own: Using the telephoto setting is usually best for shooting wildlife. Long focal lengths help you get close-up shots without disturbing the animal.
Camera Settings	**Practice Picture:** Auto exposure mode.
	On Your Own: Auto exposure mode. If you're using a manual or semiautomatic mode, be sure you have a fast enough shutter speed to minimize blur from camera shake.
Exposure	**Practice Picture:** ISO 320, 1/350 sec. at f/7.1.
	On Your Own: Depending on how fast the animal is moving and how much light you have, you may need to adjust your ISO to achieve a faster shutter speed.
Accessories	A monopod can help you hold your camera steady when photographing animals at long focal lengths.

Wildlife photography tips

✦ **Use the telephoto setting.** Whenever possible, use the telephoto zoom position. This allows you to remain inconspicuous to the animal, enabling you to catch it acting naturally.

✦ **Seize an opportunity.** Even if you don't have the lens zoomed to the right focal length for capturing wildlife, snap a few shots anyhow. You can always crop them later if they aren't perfect. It's better to get the shot than not.

✦ **Be patient.** It may take a few hours, or even a few trips, to the outdoors before you have the chance to see any wild animals. Keep the faith; it will happen eventually.

✦ **Keep an eye on the background.** When photographing animals at a zoo, keep an eye out for cages and other things that look man-made—and avoid them. It's best to try to make the animal look like it's in the wild by finding an angle that shows foliage and other natural features.

6.54 Toad in my backyard, Austin, Texas. Taken with a P5000 zoomed to 7.5mm, ISO 100, 2 sec. at f/5.3. Manual Exposure mode. SB-600 Speedlight fired using an SC-29 off-camera ITL hot shoe.

Downloading and Printing

Once you've filled up your memory card or you're ready to e-mail or print your pictures, you need to get the images off of your camera and onto your computer. You can accomplish this several different ways. It is mostly a matter of personal preference. Some people have a highly organized method of storing their images and may prefer to use a card reader to download the images to a specific folder. Others may prefer to let the imaging software put the images in folders the program determines automatically. Either way works just fine; choose whatever method suits your workflow best.

Nikon PictureProject

Included with your Nikon COOLPIX camera is Nikon's entry-level image editing software, PictureProject. This software is perfect if you're new to digital cameras and editing digital images. It provides you with an easy way to import, organize, and perform some basic retouching and adjustments on the images you have captured with your COOLPIX camera.

PictureProject also allows you connect your Wi-Fi-compatible COOLPIX camera to your Wi-Fi-enabled computer to transfer your images wirelessly. You can also use it to burn your images to CD, view a slideshow of selected images, and share your pictures via e-mail.

Transferring images

Once you've installed Nikon PictureProject on your computer, you can set it to automatically launch when a camera or memory card reader is connected. If you prefer to use another program to transfer your images, you can turn off the auto launch by going into the program preferences and deselecting the Auto Launch box.

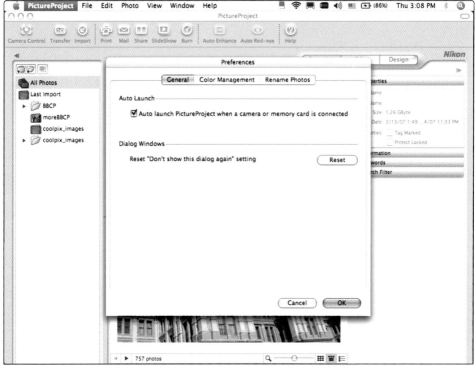

7.1 The Auto Launch feature in the preferences dialog box

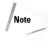 **Note** *Even if you turn the Auto Launch option off, you can still transfer images. You can use PictureProject by opening the program and clicking on the transfer button.*

When you click on the transfer button in PictureProject, the PictureProject Transfer dialog box appears. This is where you can choose which photos to download. Clicking Show thumbnails brings up small previews of the images that are on the memory card.

To select the images for transfer, you can use the buttons above the thumbnails. The buttons from left to right are as follows:

✦ **Select All.** This selects all images on the card for transfer.

✦ **Select Marked.** This button selects those images that are marked either by you or the camera for transfer.

✦ **Select Protected.** This button selects only images that you have marked protected within the camera.

✦ **Deselect.** This button deselects all selected images. There must be an image selected for this button to work.

✦ **Delete.** When you click this button, any selected images are deleted. For your protection you are asked to confirm whether or not you want to delete the selected images.

In addition to the quick buttons, you can also use the mouse and keyboard to select images for transfer. To select the photos manually

1. **Click on the thumbnail.**

2. **Ctrl/⌘+click additional photos to add to the selection.**

3. **Click the first photo in a series then Shift+click the last photo in the series to select them all in a row.**

4. **Ctrl/⌘+click a selected photo to deselect it.**

Transfer options and preferences

Opening the PictureProject Transfer Preferences dialog box allows you to customize the settings for the pictures you

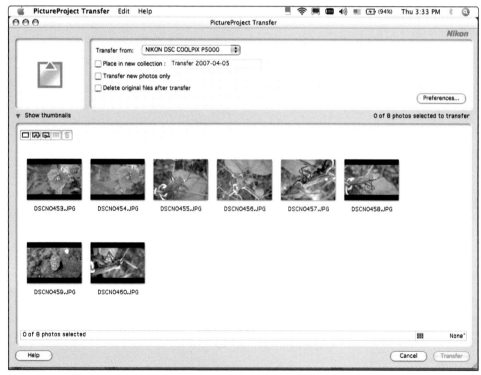

7.2 The PictureProject Transfer dialog box

transfer. The dialog box has three tabs for changing settings:

✦ **General.** Include the color profile information in the file, add a low-res preview image for NEF (RAW) files, and rotate the image for vertical shots with this tab. The tab also includes some options for transferring into collections. These include placing all photos in one new collection, separating photos by folders on the camera, or separating photos by the shooting date. You can also specify it to create the new collection within the Transfers folder. The last option is to sync the camera's date and time with your computer's date and time.

✦ **Transfer Destination.** Tell PictureProject where to place the folders with the images you are downloading in them by using this tab. Also, specify how you want the folders named.

✦ **Rename Photos.** Tell PictureProject if you want to rename the images and, if so, how you want them to be designated with this tab.

Note *Nikon COOLPIX cameras do not have the option of recording NEF (RAW) files.*

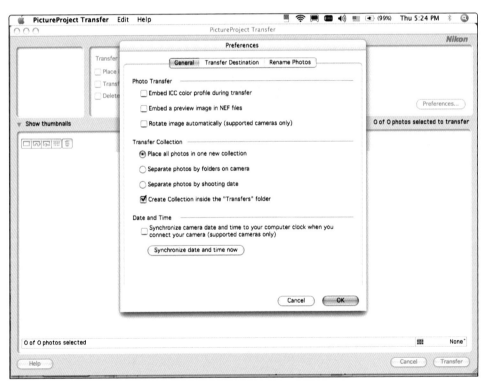

7.3 The PictureProject General Preferences dialog box

7.4 The PictureProject Transfer Destination Preferences dialog box

Viewing and organizing your images

You can use PictureProject to view individual images, divide your images into separate collections, and view them in a slideshow. You can also use PictureProject to import images that already exist on your computer's hard drive.

Picture collections

On the far left of the PictureProject window you find a list of the picture collections folders. Clicking on any of these folders allows you to view the thumbnails of all of the images that are contained within the folder. You can also select an image and drag and drop it to add the image to another collection folder.

Thumbnail area

In the middle of the PictureProject window is the Thumbnail area. This is where you can preview the images in the selected folder. At the bottom of the thumbnail area are some buttons for changing the viewing style of the thumbnail images. Using the magnifying glass slider, you can change the size of the thumbnails. The buttons to the right of the magnifying glass change the thumbnail preview layout. Clicking the button on the left shows only the thumbnails. Clicking the center button shows the thumbnails in a strip on top and also allows you select one image for a larger preview. Clicking the button on the right shows the thumbnails and also shows the image properties and shooting data. This information is also known as the *metadata.* The metadata includes the

7.5 The PictureProject Rename Photos Preferences dialog box

filename and image size as well as the camera information, including all of the settings.

Properties and Information area

The right side of the PictureProject window has four drop-down menus. When you click on the tab, a drop-down menu opens up. The menus are as follows:

✦ **Properties menu.** The top drop-down menu is the Properties menu. This menu allows you to change the filename as well as see the original filename, and the date and time the picture was taken. It also enables you to tag the image as marked and to lock it to protect it from further changes.

✦ **Information menu.** The second drop-down menu is the Information menu. This menu has another drop-down menu within it that allows you to choose what information is shown. Choosing show: shooting data allows you to view all of the metadata. Choosing show: File information allows you to view the filename, the location of the file on the computer, the size of the file, when the file was created, and the last time the file was modified. Choosing show: voice memo shows information, if any, on the memo recorded to the image file. Show: Collection information shows which collection or collections that image belongs to.

The last three options are for inputting International Press Telecommunications Council (IPTC) data. This allows you to add information to the file such as your name, the copyright information, and the title of the photograph. It also allows you to add where the photo was taken and headline information.

✦ **Keywords menu.** This next menu down allows you to add keywords to the file to help you find the file when you're doing a search.

✦ **Search Filter menu.** The bottom-most menu allows you to decide what criteria of the file are visible in a search.

Slideshow button

Clicking on the Slideshow button opens up a dialog box that allows you to change the settings to customize the slideshow. You can change the way the pictures transition between each other. You can even choose to add music to accompany your slide show.

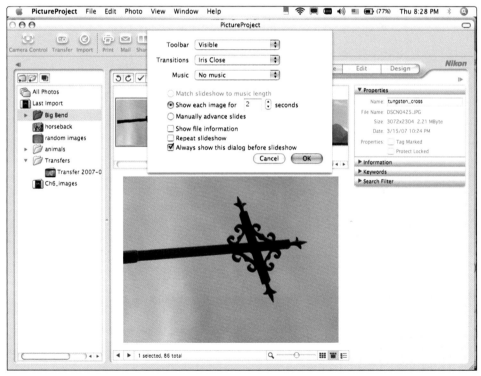

7.6 The PictureProject Slideshow dialog box

Retouching and enhancing images

PictureProject has a few features for enhancing and retouching your images. These are basic features such as boosting the color, removing red-eye, cropping photos, and straightening crooked pictures. These features are very basic and simplified, so if you are serious about doing photo-manipulation or heavy retouching, you will need to find a more advanced program to work with.

To edit an image in PictureProject, all you need to do is select an image and click on the edit button. You can also double click on an image to bring it up in the Edit menu. You also have the following menu items to choose from:

✦ **Auto Enhance button.** Clicking this button cause PictureProject to automatically make adjustments to fix the brightness, the color saturation, and the overall sharpness of the image.

✦ **Auto Red-Eye button.** Clicking this button automatically removes the red-eye caused by flash.

✦ **Photo Enhance section.** This drop-down menu provides you with image-enhancing options. The options include Brightness, D-Lighting (lighten shadows), Color Booster (increases color saturation), Photo Effects (black & white and sepia toning), Sharpening, and Straighten. Use the sliders to make adjustments to the image manually.

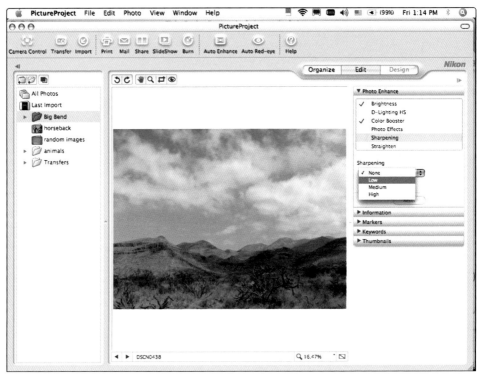

7.7 The PictureProject editing menu

✦ **Tool buttons.** These buttons are at the top of the image when it is in the editing menu. The tools allow you to rotate the picture, move it around, zoom in and out, and manually remove red-eye.

Other Software

If you'd rather use a different image-editing program, lots of options are available. Some programs are relatively simple and easy to use; others can be very time intensive to learn. There are programs that are available for free and some that cost hundreds of dollars. You should choose what works best for your needs. The following sections offer a brief overview to help you decide.

Freeware

There are many good free programs available on the Web. I haven't used them all, and I don't know that they will all work with every operating system. This is just a short list to get you started. Doing a search on the Web may find you many more results.

✦ **GIMP.** GIMP stands for GNU Image Manipulation Program. It's an open source code freeware program that resembles Adobe Photoshop. You can find it at http://gimp.org.

✦ **Picasa.** This is a free program by Google. It comes highly recommended as a simple, yet effective program.

✦ **IrfanView.** You can find it at www.irfanview.com.

Software for purchase

Most of the programs that are available for purchase are much more powerful than the freeware image editors.

✦ **Adobe Photoshop CS3.** This is one of the most powerful image editors available on the market today. If you're serious about editing your photos and want the full range of editing options, this may be the program you want to use.

✦ **Adobe Photoshop Elements 4.0.** This is a scaled-down version of Photoshop. It provides the power of Photoshop with a simpler, easy-to-understand interface. You can find it and other Adobe products at www.adobe.com.

✦ **Corel Paint Shop Pro Photo XI.** This is another powerful image-editing program. It has been compared to PS Elements. You can find it at www.corel.com.

✦ **Ulead PhotoImpact 12.** This program is reputed to be powerful, yet simple enough for beginners in digital image editing. You can find it at www.ulead.com.

Printing Your Images

In this day and age with the prevalence of digital cameras, there many different options for getting your digital images printed. You can choose from dropping off a CD of your images at the local camera shop or using one of the do-it-yourself photo

printing kiosks that most stores with photo processing services have. There are even thousands of places online that you can e-mail your images to and have them send you prints. You can even buy specialty photo printers and print the images yourself.

Photo labs and kiosks

Probably the easiest and best way to get your prints done is by taking your images to your local camera shop or photo-printing lab. The employees there are trained to do photographic printing and the quality is going to be very high (as long as you supply a good high-resolution image). Most of the people working at photo labs can look at your images and make some necessary color adjustments, should your image require it.

Most camera stores now have photo kiosks, which are stations with a computer monitor that you insert your memory card or CD/DVD of your images into, and then you can select some or all of the images for printing. These kiosks also usually offer minimal image editing tools, such as red-eye removal, cropping, color/black and white options, as well as choosing borders and adding text. Using these photo kiosks can be pretty handy, and if you run into trouble and need help, there is a clerk around to give you a hand. Depending on how the service is setup, you either receive your prints directly or pick up your prints later, often in just an hour.

Online printing services

There are literally thousands of online printing services. They require you to upload your photo files. Most of these services offer some minor editing options. A lot of these sites also double as photo sharing Web sites, so you can share your pictures with

friends or family around the world. Most photo labs are geared toward amateurs and therefore have very simple and easy to use interfaces. Although they are geared towards amateur photographers, the prints are still of a good quality. Some of these sites include the following:

✦ **www.kodakgallery.com.** This is Kodak's printing and photo sharing site. It is easy to use and you can have several galleries, and mark some as private for just those that you choose to invite.

✦ **www.shutterfly.com.** This is a photo sharing and printing site. It's fairly easy to use and has decent prices.

✦ **www.snapfish.com.** This site, sponsored by Hewlett Packard, is another photo sharing and printing site. It has good prices and also does film processing.

✦ **www.flickr.com.** This is primarily a photo-sharing site, but it has ties with companies that offer a multitude of different products from books and cards to t-shirts and framed prints. All of this is linked to your flickr account.

If you're an avid photographer and you want truly excellent image quality from your digital prints, you may want to try a professional quality online photo lab. These types of places usually charge a little more for the prints, but you get a much better quality. The pro-level labs print on the same type of paper that you would get with a traditional film print, so you don't need to worry about fading and the other pitfalls that accompany inkjet prints (more on this in the next section). The downside is that these labs usually don't provide any editing tools; your images are printed exactly as they are

uploaded (unless you pay extra for them to do the retouching). If you want to use one of these labs to print your image you should at least have some working knowledge of image editing software. A couple of pro-level labs to consider are

✦ **www.mpix.com.** This is a highly respected company that turns out top quality prints at a fair price.

✦ **www.printroom.com.** This company offers printing as well as a way to sell your photos online.

Inkjet Printers

By far the easiest way to get your printing done is to do it yourself with an inkjet printer. The inkjet technology has grown (and continues to grow) by leaps and bounds. The inkjet prints of digital photos that you can get today are just as good as traditional prints made from film. The great part is you can print them out right in your own house!

One of the best things about using an inkjet printer is the almost limitless amount of different types of paper surfaces that you can print on—from gloss to semi-gloss, semi-matte to matte, canvas, vinyl adhesive paper, and the list goes on. There are so many different types of surfaces that it's mind-boggling. What this means to you is that you are not limited to the types of prints you can make when using a photo lab. Today's photo labs usually only offer three types of paper surfaces at most (gloss, semi-gloss, and matte).

There are so many manufacturers of inkjet printers that I won't go into the specific companies and all of the models they sell. That being said, you can pick up a good photo-quality inkjet printer that prints 8- × 10-inch pictures for about $150, sometimes even less. If you're willing to spend more money you can get printers that print 13 × 19 inches or even larger. A quick Internet search for inkjet printers should give you a good idea of what there is to offer.

Appendixes

Resources

A lot of valuable information for photographers is available on the Internet. This appendix is a resource to help you discover some of the many ways to learn more about photography in general.

Informational Web Sites

With the amount of information on the Web, sometimes it is difficult to know where to look or where to begin. These sites are good ones to look at for reliable information about your Nikon COOLPIX camera or photography in general.

Nikon

When you want to access the technical specifications for Nikon Speedlights, cameras, lenses, and accessories, visit the Nikon Web site at http://nikonusa.com.

For more specific information and downloads, visit Nikon's COOLPIX site at www.nikon-coolpix.com.

Nikonions.org

This site is a forum where you can post questions and discussion topics for other Nikon users on a range of photography-related topics. Find it at www.nikonions.org.

Photo.net

The Photo.net site, at http://photo.net, is a large site containing resources, from equipment reviews, to forums on a variety of topics, to tutorials, and more. If you're looking for specific photography-related information and aren't sure where to look, this is a great place to start.

Photo Sharing and Critiquing Sites

Flickr

You can find this site at `http://flickr.com`. It is a site for posting your photos for others to see. The users range from amateurs to professionals, and there are groups dedicated to specific areas, including Nikon COOLPIX cameras.

Photoworkshop.com

This interactive community Web site allows you to participate in competitions with other photographers. You'll find assignments as well as a forum to receive feedback on you images. You can find this site at `http://photoworkshop.com`.

ShotAddict.com

This site has photo galleries, product reviews, contests, and discussion forums. It is located at `http://shotaddict.com`.

Online Photography Magazines and Other Resources

Some photography magazines also have Web sites that offer photography articles and often information that you won't find in the pages of the magazine. The following is a list of a few photography magazines' Web sites as well as some other photo-related sites where you may find useful content.

Communication Arts

`http://commarts.com/CA/`

Digital Photographer

`http://digiphotomag.com`

Digital Photo Pro

`http://digitalphotopro.com`

Flickr

`http://flickr.com`

Ken Rockwell

`http://kenrockwell.com`

Outdoor Photographer

`http://outdoorphotographer.com`

Photo District News

`http://pdnonline.com`

Popular Photography & Imaging

`http://popularphotography.com`

Shutterbug

`http://shutterbug.net`

Glossary

AE (Auto Exposure) A general-purpose shooting mode where the camera selects the aperture and shutter speed according to its metered reading.

AE/AF lock A camera setting that lets you lock the current auto exposure (AE) and/or autofocus (AF) setting prior to taking a photo.

AF-Assist illuminator An LED light that is emitted in low-light or low-contrast situations. The AF assist illuminator provides enough light for the camera's autofocus (AF) to work in the dark.

ambient lighting Lighting that naturally exists in a scene, both natural and artificial. Sometimes called available light.

angle of view The area of a scene that a lens can capture, determined by the focal length of the lens. Lenses with a shorter focal length have a wider angle of view than lenses with a longer focal length.

aperture Also referred to as the *f-stop setting* of the lens. The aperture controls the amount of light allowed to enter through the camera lens. The higher the f-stop numerical setting, the smaller the aperture opens on the lens. Wider f-stop numerical settings are represented by lower numbers, such as f/2. The wider the aperture, the less depth of field in the image; the smaller the aperture, the more depth of field in the image.

Aperture Priority A camera setting where you choose the aperture, and the camera automatically adjusts the shutter speed according to the camera's meter readings. Aperture Priority is often used by the photographer to control depth of field.

artifact Unintentional (unwanted) elements in an image caused either by an imaging device or as a byproduct of software processing. Flaws from compression, color flecks, and digital noise are all examples of artifacts.

artificial light The opposite of ambient light, this is light from an electric light or flash unit.

aspect ratio The proportions of length and width of an image when printed, displayed on a monitor, or captured by a digital camera.

autofocus The ability of a camera to determine and achieve the proper focus of the subject automatically.

backlighting A lighting effect produced when the main light source is located behind the subject. Backlighting can be used to create a silhouette effect, or to illuminate translucent objects. See also *front lighting* and *side lighting*.

blocked up Shadow areas in an image that lack detail because of excess contrast.

bounce flash Pointing the flash head in an upward position or toward a wall, thus softening the light illuminated off the subject. Bouncing the light often eliminates shadows and provides a smoother light for portraits.

bounce light Directing light toward an object, such as a wall or ceiling, so that it reflects (bounces) light back onto the subject.

bracketing A photographic technique in which you vary the exposure of your subject over three or more frames. By doing this, you can ensure you get the proper exposure in difficult lighting situations where your camera's meter can be fooled.

camera shake The movement of the camera when its handheld, usually at slower shutter speeds, which produces a blurred image.

catchlight Highlights that appear in the subjects' eyes.

center-weighted meter A light-measuring device that emphasizes the area in the middle of the frame to calculate the correct exposure for an image.

color temperature A numerical description of the color of light, measured in Kelvin. Warm, late-day light has a lower color temperature, whereas cool, early-day light has a higher temperature. Midday light is often considered to be white light (5,000 K), and flash units are often calibrated to 5,000K. See also *Kelvin*.

colored gel filters Colored translucent filters that, when placed over a flash head or light, change the color of the light emitted on the subject. Colored gels can be used to create a colored hue of an image. They're also often used to change the color of a white background when shooting portraits or still lifes: The gel is placed over the flash head and the flash is fired at the background.

compositing Combining all or part of two or more digital images into a single image using an image-editing program.

compression Reducing the size of a file by digital encoding, using fewer bits of information to represent the original. Some compression schemes, such as JPEG, discard some image information, which is called lossy compression. Others, such as TIFF, preserve all the detail of the original image, which is called lossless compression, and do not discard information from the original file, creating an original file without any data loss.

contrast The range between the lightest and darkest tones in an image. A high-contrast image is one in which the shades fall at the extremes of the range between white and black. A low-contrast image is one in which the tones are closer together.

contrasty A term used to describe a scene or image with great differences in brightness between light and dark areas.

D-lighting A camera function that fixes the underexposure that often happens to images that are backlit or in deep shadow without affecting the properly exposed areas of an image.

dedicated flash An electronic flash unit, such as the Nikon SB-600, SB-800, or SB-400, designed to work with the automatic exposure features of a specific camera.

default settings The factory settings of the camera.

depth of field (DOF) A distance range in a photograph in which all included portions of an image are at least acceptably sharp. It

is generally the area before and after the exact plane of focus.

diffused lighting A soft, low-contrast lighting.

digital SLR (dSLR) A single lens reflex camera with interchangeable lenses and a digital image sensor.

digital zoom Digital zoom reduces the overall file size of an image by making a subject appear closer, when it is actually cropping away the edges of the scene.

equivalent focal length Digital camera focal lengths that are translated into values that correspond for 35mm film.

exposure The amount of light allowed to reach the film or sensor, which is determined by the intensity of the light, the amount admitted by the aperture of the lens, and the length of time determined by the shutter speed.

exposure compensation The ability to take correctly exposed images by adjusting the exposure, typically in 1/3 stops from the meter reading of the camera. This enables you to make manual adjustments to achieve your desired results. See also *Exposure Value*.

exposure mode Camera settings that let the photographer take photos in Automatic mode, Shutter Priority mode, Aperture Priority mode, Manual mode, and Automatic Program mode. When the camera is set to Aperture Priority mode, the shutter speed is automatically set according to the chosen aperture (f-stop) setting. In Shutter Priority mode, the aperture is automatically set according to the chosen shutter speed.

When you use the Manual mode, you set both aperture and shutter speeds. When using Automatic Program mode, the camera selects the aperture and shutter speed. Some cameras also offer *scene modes*, which are automatic modes that adjust the settings to predetermined parameters, such as a wide aperture for the Portrait scene mode and fast shutter speed for Sports scene mode.

Exposure Value (EV) EV settings are a way of adding or decreasing exposure without the need to reference f-stops or shutter speeds. For example, if you tell your camera to add +1EV, it will provide twice as much exposure, either by using a larger f-stop, a slower shutter speed, or both. See also *exposure compensation*.

f-number A number that represents the maximum light-gathering ability of a lens or the aperture setting at which a photo is taken. Wide apertures are designated with small numbers, such as f/2.8, and narrow apertures are designated with large numbers, such as f/22. See also *aperture*.

f-stop See *aperture* and *f-number*.

fill flash A lighting technique where the Speedlight provides enough light to illuminate the subject in order to eliminate shadows, generally in an outdoor or backlit situation.

fill lighting In photography, it is the lighting used to illuminate shadows. Reflectors or additional incandescent lighting or electronic flash can be used to brighten shadows. One common technique outdoors is to use the camera's flash as a fill.

flash An external light source that produces an instant flash of light to illuminate a scene.

flash exposure compensation Adjusting the flash output by +/– three stops in 1/3 stop increments. If images are too dark (underexposed), use flash exposure compensation to increase the flash output. If images are too bright (overexposed), you can use flash exposure compensation to reduce the flash output.

flash modes Control the output of the flash by using different parameters.

flash output level The output level of the flash as determined by one of the flash modes.

focal length The distance from the optical center of the lens to the focal plane when the lens is focused on infinity. The longer the focal length is, the greater the magnification.

focal point The point on a focused image where rays of light intersect after reflecting from a single point on a subject.

front-curtain sync Front-curtain sync causes the flash to fire at the beginning of the period when the shutter is completely open, in the instant that the first curtain of the focal plane shutter finishes its movement across the film or sensor plane. See also *rear-curtain sync*.

front lighting The illumination that comes from the direction of the camera. See also *backlighting* and *side lighting*.

grain A term used to describe a speckled appearance in film photographs. In digital images, grain appears as multicolored flecks, and is also referred to as noise. Grain is most visible in high-speed film photos and in digital images that are captured at high ISO settings. See also *noise*.

hot-shoe The slot located on the top of the camera where the flash connects. The hot shoe is considered "hot" because it has electronic contacts that allow communication between the flash and the camera.

ISO sensitivity The ISO (International Organization for Standardization) setting on the camera indicates the light sensitivity setting. Film cameras need to be set to the film ISO speed being used (such as ISO 100, 200, or 400 film), whereas on digital cameras, the ISO settings can be set to any available setting. In digital cameras, lower ISO settings provide better quality images with less image noise; however, the lower the ISO setting, the more exposure time is needed.

Kelvin A scale for measuring temperature based around absolute zero. It is used in photography to quantify the color temperature of light. See also *color temperature*.

LCD panel (liquid crystal display) Where the camera's images display.

lossless File compression that discards no image data. TIFF is a lossless file format.

lossy Compression algorithms that discard image data, often in the process of compressing image data to a smaller size. The higher the compression rate, the more data that is discarded, and the lower the image quality. JPEG is a lossy file format.

manual exposure Setting the shutter and aperture manually rather than using the camera's internal light meter settings. Manual exposure is beneficial in difficult lighting situations where the camera's meter does not provide correct results. Switching to manual settings can entail a "trial and error" process of taking a series of photos until you see the correct exposure on the digital camera's LCD.

Manual mode Manually setting the exposure on the camera.

metadata Data that is embedded in image files by the camera including aperture, shutter speed, ISO, focal length, date of capture, and other technical information. Photographers can add additional metadata in image-editing programs, including name, address, copyright, and so on.

metering Measuring the amount of light using the camera's internal light meter.

Mode dial The dial on the P- series cameras that, when rotated, enables you switch exposure modes and enter the Set up menu.

noise In an image, pixels with randomly distributed color values. Noise in digital photographs tends to be more pronounced with low-light conditions and long exposures, particularly when you've set your camera to a higher ISO rating than normal.

noise reduction A technology used to cut down on the amount of random pixels in a digital picture, usually caused by long exposures at increased sensitivity ratings. Noise reduction typically involves the camera automatically taking a second blank or dark exposure at the same settings that contains only noise, and then using the blank photo's information to cancel out the noise in the original picture.

On/Off button The button that powers up the camera.

optical zoom Magnification of the subject that results from the lens contrasted with subject magnification achieved by cropping the image to make the subject appear closer.

overexposure Exposing film or an image sensor to more light than is required to make an acceptable exposure, resulting in a photograph that is too light.

panning A technique of moving the camera horizontally to follow a moving subject, keeping the subject sharp while creating a creative blur of background details.

pixel The smallest unit of information in a digital image. Pixels contain tone and color that can be modified. The human eye merges very small pixels so that they appear as continuous tones.

Programmed auto (P) On the camera, the shutter speed and aperture are set automatically when the subject is focused.

rear-curtain sync Rear-curtain sync causes the flash to fire at the end of the exposure, an instant before the second or rear curtain of the focal plane shutter begins to move. With slow shutter speeds, this feature can create a blur effect from the ambient light, showing as patterns that follow a moving subject with the subject shown sharply frozen at the end of the blur trail. See also *front-curtain sync*.

red-eye An effect from flash photography that appears to make a person's eyes glow red, or an animal's yellow or green. It's caused by light bouncing from the retina of the eye and is most noticeable in dimly lit situations (when the irises are wide open), and when the electronic flash is close to the lens and, therefore, prone to reflect the light directly back.

Red-Eye Reduction A flash mode controlled by a camera setting that is used to prevent the subject's eyes from appearing red. The Speedlight fires multiple flashes just before the shutter is opened.

resolution The number of pixels per side of a 1- × 1-mm square, or the number of pixels in a linear inch. The amount of information present in a digital image to represent detail in the image.

self-timer A mechanism that delays the opening of the shutter after the shutter release has been pressed for an amount of time that you set.

Shutter Priority In this camera mode, you set the desired shutter speed, and the camera automatically sets the aperture setting for you. It's best used when you're shooting action shots by using fast shutter speeds to freeze the motion of the subject.

Shutter Release button When you press this button, the camera takes the picture.

side lighting Lighting that comes directly from the left or the right of the subject. See also *backlighting* and *front lighting*.

silhouette A scene where the background is much more brightly lit than the subject.

speed The relative sensitivity to light of photographic materials such as film, digital camera sensors, and photo paper, which is indicated by the ISO number. It also refers to the ability of a lens to allow more light in by opening the lens to a wider aperture.

top lighting Light that strikes a subject from above, such as sunlight at midday.

tungsten lighting Common household lighting that uses tungsten filaments. Without filtering or adjusting to the correct white-balance settings, pictures taken under tungsten light display a yellow-orange color cast.

Vibration Reduction (VR) A function of the camera in which the lens elements are shifted to reduce the effects of camera shake.

viewfinder A viewing device on some cameras in the P Series that allows the photographer to see the scene that will be included in the final picture.

white balance The relative intensity of red, green, and blue in a light source. On a digital camera, white balance compensates for light that is different from daylight to create correct color balance.

Zoom button A two-way rocker switch, which you can use to zoom the lens in or out. To the left, the Zoom button is marked with a W for wide-angle, which allows you to fit a lot of the scene into the image; to the right, the button is marked with a T for telephoto, which allows you to zoom in close to capture faraway subjects or to focus in on a specific detail of a subject.

Index

Pack the essentials.

These aren't just books. They're *gear*. Pack these colorful how-to guides in your bag along with your camera, iPod, and notebook, and you'll have the essential tips and techniques you'll need while on the go!

0-470-11007-4 • $19.99
978-0-470-11007-2

0-470-03748-2 • $19.99
978-0-470-03748-5

0-471-78746-9 • $19.99
978-0-471-78746-4

0-470-05340-2 • $19.99
978-0-470-05340-9

0-471-79834-7 • $19.99
978-0-471-79834-7

0-7645-9679-9 • $19.99
978-0-7645-9679-7

Also available

PowerBook and iBook Digital Field Guide • 0-7645-9680-2 • $19.99
Digital Photography Digital Field Guide • 0-7645-9785-X • $19.99
Nikon D70 Digital Field Guide • 0-7645-9678-0 • $19.99
Canon EOS Digital Rebel Digital Field Guide • 0-7645-8813-3 • $19.99

Available wherever books are sold

'ey and the Wiley logo are registered trademarks of John Wiley & Sons, Inc. and/
. its affiliates. All other trademarks are the property of their respective owners.

Now you know.
wiley.com